Photography in Social Work and Social Change

Photography in Social Work and Social Change

Theory and Applications for Practice and Research

MATTHIAS J. NALEPPA
KRISTINA M. HASH
ANISSA T. ROGERS

OXFORD
UNIVERSITY PRESS

OXFORD
UNIVERSITY PRESS

Oxford University Press is a department of the University of Oxford. It furthers the University's objective of excellence in research, scholarship, and education by publishing worldwide. Oxford is a registered trade mark of Oxford University Press in the UK and certain other countries.

Published in the United States of America by Oxford University Press 198 Madison Avenue, New York, NY 10016, United States of America.

© Oxford University Press 2022

Library of Congress Cataloging-in-Publication Data
Names: Naleppa, Matthias J., editor. | Hash, Kristina Michelle, editor. | Rogers, Anissa T., editor.
Title: Photography in social work and social change : theory and applications for practice and research / Matthias J. Naleppa, Kristina M. Hash, Anissa T. Rogers.
Description: New York, NY : Oxford University Press, [2022] | Includes bibliographical references and index.
Identifiers: LCCN 2022000972 (print) | LCCN 2022000973 (ebook) | ISBN 9780197518014 (hardback) | ISBN 9780197518038 (epub) | ISBN 9780197518045
Subjects: LCSH: Photography in social service. | Photography in social change. | Social service—Research—Methodology. | Photography—Social aspects. | Social change—Technological innovations.
Classification: LCC HV11 .P5928 2022 (print) | LCC HV11 (ebook) | DDC 361.0072—dc23/eng/20220404
LC record available at https://lccn.loc.gov/2022000972
LC ebook record available at https://lccn.loc.gov/2022000973

DOI: 10.1093/oso/9780197518014.001.0001

1 3 5 7 9 8 6 4 2

Printed by Integrated Books International, United States of America

Contents

Preface

Sometimes things seem to just fall into place. During the past few years, the three authors of this book have individually explored the use of photography in social work research, practice, and education. This mutual interest was realized over lunch at a social work conference, and an exciting discussion began about collaborating on some projects. As we recognized our combined experience with different photographic methods, we decided to submit a proposal for a conference panel on our experiences using photography in social work. The next step, writing this book, seems to have naturally flowed from this conference presentation. All three of us had used photography, and although there was some overlap in the method we had employed, we also realized that we had different types of exposure to the different methods of photography in social work.

Anissa was never very good at taking photographs, but that did not stop her from appreciating the art and the beauty found in doing so. Whether it was taking photographs of the red rock in southern Utah, the steaming geysers of the Atacama Desert, or the playful action shots of her children and dogs, Anissa has always enjoyed capturing moments in nature and daily life that hold memories and shape the narratives of our lives. As a teacher of social work, as well as a therapist in private practice, Anissa found herself thinking of photography as a means through which to heal and teach. She brought photography into the classroom to help students express themselves and the journey of their learning. She brought photography into her private practice to help her clients reminisce about events and to heal from trauma and painful experiences. Anissa has found photography to be a powerful tool in the expression of the human experience, which can lead to profound growth and change.

Kris was the kid who was always asking her mom to stop at the "photomat" to pick up a batch of prints of photos she had taken. In college, she was the unofficial photographer of her friend group's "extracurricular" activities. She has always been interested in capturing moments, behavior, and feelings with a camera and took photography courses in high school and college. In recent years, in addition to capturing the lives of a daughter and several rescue

dogs, she has taken the opportunity to integrate her love of photography with her teaching, research, and service as a professor of social work. This has involved offering class assignments using photographs in oral histories, producing photomaps of communities, and creating digital case studies/digital stories. Her service and research are often interconnected, and photography has been utilized in reminiscence therapy for persons with mild to moderate cognitive impairment that focused on Appalachian culture and using historic photographs as part of oral histories with persons who grew up in a coal camp community during the Depression (which also resulted in a digital story). Recently, she has become fascinated with and has been trying out the method of rephotography, which presents a before and after photo of an event, group, or location and is described in Chapter 6.

Matthias had an on-and-off again relationship with photography. He never left home without a camera during his college years but then took a long hiatus from taking photographs. A few years ago, with a rekindled love for photography, he enrolled in the Prague School of Photography in Kefermarkt, Austria. While studying there, he spent countless hours in the school's extensive library of art and photography books, and he became interested in the historical aspects of photography and the connection between images and social change. As one of his class photography assignments, he chose to focus on people living in recreational vehicles (RVs), which led him to his current research on older adults retiring to full-time RV living. Matthias has led photovoice and photomapping projects in Germany and has taught several photographic methods courses during the past few years. His current photographic interests are in street and macro photography.

This book provides a comprehensive overview of the application of photography in social work practice and research. It features original applied content and includes multidisciplinary perspectives, state-of-the-art case examples, and user-friendly resources. The book introduces readers to the theory, methods, and technical aspects of photographic practice and research. It also bridges theory and knowledge with applications that can be replicated by students, practitioners, and researchers.

The book contains nine chapters, organized into three parts. Part I examines the historical role that photography has played in social work, from when photography was invented to today's applications of photography in the context of the growing realm of social media, and it introduces the role photography can play in social work research and practice. Chapter 1 examines the rich history of photography in social work. This chapter reviews

the development of the camera and photographs over time and the connection between photography and social change. In addition, the chapter discusses recent developments in the use of photography, such as the development of social media and its' shaping of the presence of photographs in daily life. From early prints to digital photos shared on social media, technology has influenced how photos can be used in social work research and practice. Today, increased ease of use, quality, affordability, and integration into the phone have made the camera a virtually omnipresent tool. Chapter 2 digs deeper into the topic of photography in social work practice and research, examining the photograph as a tool for change in practice at the individual, group, organization, and community levels. Photography has gained an increasingly prominent role as a method in social work research. Cultural sensitivity and ethical issues are addressed related to the use of photography in practice and research.

Part II focuses on five photographic methods used in social work: photo therapy, digital storytelling, photovoice, photomapping, and photo ethnography. For each method, chapters provide definitions and background information; a detailed description, case examples, step-by-step guidelines for planning and implementing a project; advantages and challenges; and best practices. Chapter 3 discusses methods and applications in which an existing photograph or the taking of a picture is used with a therapeutic goal in mind. It can be applied with individuals, families, and groups. The therapeutic applications can range from aiding the assessment and diagnostic processes to improving communication, relationship building, life review, and helping build or improve a person's self-esteem. Chapter 4 focuses on traditional storytelling techniques that are combined with digital media. At its center is a narrative that is often supported by digital images, text, animation, sound, and narrative voice. Although the images may take the form of a video, digital storytelling relies heavily on photos as the visual core. Digital stories aim to engage viewers by sharing knowledge, teaching skills, and imparting life experiences. Photovoice, discussed in Chapter 5, is a structured method that combines photography and grassroots social action. The focus of this chapter is on photography used to foster change on the community or larger societal levels. Photos are typically created by community participants for the purpose of change-oriented practice. Some overlap with participatory action research methods exists—that is, photographs can be used for either practice or research, depending on whether focus is on change or on change *and* research. In Chapter 6, we describe the use of geographic information system

data to map significant events or places or illustrate special connections within a community. Its goal is to identify assets, needs, and barriers in the environment by providing relevant geographic and spatial information. As a participatory method, it can give affected persons a voice. Finally, Chapter 7 highlights the use of photography for activist, humanitarian, and documentary purposes. The aim is not only to document but also for the photograph to serve as a starting point for change. Unlike other methods such as photovoice, the client or client group is not required to be an active participant in the process. A photographer creates and disseminates photos to highlight social or humanitarian issues. The photographer may or may not be directly affected by the issue. Furthermore, the level of active involvement in the change progress can vary substantially.

Part III discusses the options for presenting and disseminating photographs. Chapter 8 reviews the technical knowledge helpful for the generation of images for photographic projects. It includes information on the camera and the photograph as well as technical aspects of picture taking and composition. This is followed by a review of photo management and storage. Basic guidelines for preparing photographs for print and for exhibitions are also discussed. The intent of this chapter is to provide an overview of basic technical aspects to help in the planning and implementation of photography-based projects. In Chapter 9, we pull together and summarize the topics covered in this book. Future directions and considerations for the use of photography in social work conclude this chapter and the book.

As Kris summarizes our book project:

> In thinking about it on a summer hike, I came to an overlook. At this overlook, a very small lizard continued to creep up to the very edge, looked back at me a few times, and then seemed to stare at the view of the rolling mountain landscape. Like many who are interested in photography and who pay particular attention to images in life, I captured this moment mentally as well as physically with the camera on my cell phone. I connected that image with a desire to go to the edge and explore a more expansive landscape on the topic. This would involve the writing of our book in a way that it could be utilized by researchers, practitioners, and educators in social work and related fields.

The chapters of this book represent our knowledge of, experience with, and passion for the use of photography in social work and community social

service projects. We are excited to share this with the readers and hope to inspire a more expansive landscape for photography in our field.

Matthias J. Naleppa
Radford, Virginia
Kristina M. Hash
Morgantown, West Virginia
Anissa T. Rogers
Palm Desert, California

PART I

PHOTOGRAPHY IN SOCIAL WORK

1

History of Photography in Social Work

Introduction

Photography has become omnipresent in our lives. Due to the ease of taking photos on smartphones and other devices and publishing them through various social media apps and platforms, more photos are taken than ever before. At the same time, photos are much more than just depictions of everyday life. Indeed, photography has had a long history in promoting social change, as social work pioneers were using photography in the late 1800s and early 1900s to illuminate and ameliorate social problems (Squires, 1991). This early use of photography by social workers is not surprising given the fit between the tool and the profession.

The earliest application of photography in social work on the micro level can be traced to Hugh Welch Diamond, who began taking pictures to monitor psychiatric patient progress in the 1860s (Burrows & Schumacher, 1990). Social work pioneers such as Jane Addams already incorporated photography into macro practice in their quest for social change and social justice in the late 1800s, as photography was widely used by the settlement houses to document their services (Bryan & Davis, 1991). Continuing through the New Deal and Depression eras and the civil rights movement, photography played a role in social change (Bogre, 2012; L. Gordon, 2009; Hindman, 2002). More recent decades have seen the rise of the use of photography as a tool for therapy and other field-based interventions (e.g., Craig, 2009; Wang & Burris, 1994).

This chapter examines the rich history of photography in social work. It reviews the development of the camera and photographs over time and the connection between photography and social change. In addition, the chapter discusses recent developments in the use of photography in social work practice and research.

Photography in Social Work and Social Change. Matthias J. Naleppa, Kristina M. Hash, and Anissa T. Rogers, Oxford University Press. © Oxford University Press 2022. DOI: 10.1093/oso/9780197518014.003.0001

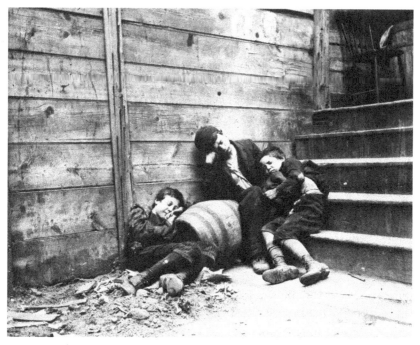

Image 1.1 Poor boys by Jacob August Riis (1849–1914), social reformer and documentary photographer whose work focused on the squalid living conditions in the slums of New York City. He is best known work is How the other half lives: Studies among the tenements of New York (1890).

Brief History of Photography

Before examining the progression of photography in social work, it is important to review the history of photography as a tool and technology. This history is intertwined with the technical possibilities that have continuously improved since Joseph Nicéphore Nièpce first succeeded in creating a fixed photograph (Gustavson, 2009). The idea of projecting pictures onto a surface dates back to the camera obscura, a device in which light that "passes through a small hole into a darkened chamber projects an inverted image of the outside scene upon the opposite wall" (Gustavson, 2009, p. 4). The oldest known use of this process is by Chinese philosopher Mo Ti in the 5th century BC, when he traced a projected upside-down image for a drawing (Gustavson, 2009). Aristotle also had written about the way such a camera obscura functions. Later, 13th-century astronomers used it in their research

of the planets, and 15th- and 16th-century artists used the camera obscura to project pictures on a wall or a canvas that then would be painted (Gustavson, 2009).

However, efforts to create a permanent "picture" were unsuccessful until 1816, when the French inventor Nièpce developed the first procedure to temporarily fix prints (Hirsch, 2017). In 1827, he succeeded in developing a fixed permanent picture, creating the oldest still existing photograph. Another French inventor, Louis Daguerre, was conducting similar experiments at approximately the same time. Nièpce and Daguerre began to partner in improving the technique of fixing photographs. When Nièpce died in 1833, Daguerre went on to perfect the technique and developed the so-called Daguerreotypes (Newhall, 1964). This created the first opportunity for photography to become more widely available. During the 1830s to 1860s, Daguerreotypes were used for portraits, landscapes, and Cartes de Visite, a form of a personal business card that included a portrait (Gustavson, 2009).

Photographic equipment as well as developing and printing pictures improved significantly during the mid-19th century. However, the process relied on wet plates and heavy equipment until George Eastman developed a process in 1879 for developing photographs using a dry plate (Gustavson, 2009). Together with businessman Henry Alva Strong, Eastman founded the Kodak Company in 1880. By 1888, their company began selling the Kodak Camera, which came preloaded with 100 pictures and was returned to a lab for processing, printing, and restocking with another film. The Kodak Brownie, introduced in 1900, made the camera more affordable, easy to use, and widely available. Many of the frontline pictures taken during the two World Wars were made using Kodak Brownies (Gustavson, 2009). Not since its integration into cell phones has a camera contributed more to the growing use of photos by the general population.

The 20th century saw a range of variations and improvements to cameras, film, and printing. The Kodachrome process made films and prints less expensive and more accessible for the average user. Cameras became smaller and more "powerful." While the first single lens reflex (SLR) camera was already built by English photographer Thomas Sutton in 1861, the first mass-produced SLRs were introduced in the 1930s. They became a main staple in amateur photography starting in the 1960s and 1970s (Gustavson, 2009).

The next major revolution in terms of photography started in the 1980s when the development of digital images set the stage for a media transformation. Engineers at Kodak developed a camera using a digital image sensor in

1975 (Gustavson, 2009). The picture quality was low, similar to that of photos taken 130 years earlier by the pioneers of photography. In 1986, the Megapixel sensor was invented, enabling the development of digital cameras that took high-quality photographs (Anthony, 2011). Combined with improved data storage, this invention made today's unlimited picture taking a reality.

Finally, the year 2000 saw the first time a camera was integrated into phones. The so-called J-phone, produced by Sharp and only sold in Japan, can be viewed as the predecessor to today's mobile camera phone (Anthony, 2011). It was derided at first but quickly became accepted. By 2004, half of the cell phones sold globally had an integrated camera (Anthony, 2011). Today, a camera is standard on smartphones, leading to the omnipresence of cameras, picture taking, and media sharing. The technology, whether on phones or stand-alone cameras, continues to improve and progress beyond imagination.

Photography in Social Work

Utilizing photography for social work and social change began soon after the ability to create permanent pictures was invented by Nièpce and made widely available through the Daguerreotype process. From the beginning, people were at the center of photography. Next to landscape photography, portraits showing humans in various contexts were the most common themes. The way photography was used changed throughout the years, based on the changes in photographic technology and the prevailing practice modalities. In the following sections, we highlight social changes in which photography played a role. Some of these, such as the social survey movement or the Photographic Unit at the Farm Security Administration (FSA), were coordinated and systematic efforts to include the picture as a medium to highlight the respective narrative. At other times, photography played a role but was not part of systematic change. Examples of this are the pictures taken and published during the civil rights movement. Table 1.1 summarizes the timeline of the use of photography in the profession, the respective movements or pressing themes, as well as contributing factors, organizations, or individuals.

We begin our discussion with two periods in social work history with large-scale and systematic use of photography to foster change—that is, the Progressive Era, with the child labor and social survey movements, and the Great Depression and New Deal, with the work of the Photographic Unit of the FSA. These efforts and their effects on social change are unparalleled in

Table 1.1 Timeline of Social Work and Photography

Time Period	Movement/Theme	Factors, Organizations, and Individuals
1890s–1920s	Progressive Era	Settlement houses, Charities Organization Society
	Social survey movement	Pittsburgh Survey, P. Kellogg, L. Hine
	Child labor movement	Child labor laws, L. Hine
1929–1941	Depression and New Deal	Farm Security Administration
	Loss of farming existence	R. Stryker, D. Lange, W. Evans
	Rural poverty	
1950s and 1960s	Civil rights movement	J. Moebes, C. Moore
1970s–1990s	Individualized methods	Therapy, group work, storytelling
1990s–today	Participatory methods	Photovoice, photomapping
	Visual turn and social media	Smartphones, internet, social media apps

the history of integrating photography in social work, social welfare, and social change.

Progressive Era: Social Survey Movement, Settlement Houses, and Charities Organization Society

The Progressive Era lasted from 1890 to the end of World War I in 1917. It was a time of social activism and political reform. Numerous significant laws and regulations were passed during the Progressive Era, including protections for women, children, and immigrants; regulations of the food and drug industry as well as public health; and changes in working hours for women, children, and federal employees (Jansson, 2005). The Progressive Era was the time period in which social work started to develop as a profession. Both the Charities Organization Society (COS) and the settlement movement were coming of age and were active forces in social change.

It was during this time of social activism and political change that photography was systematically applied in a social work–related project for the

first time, when Paul Underwood Kellogg conducted the Pittsburgh Survey. Born in Kalamazoo, Michigan, Kellogg started his career as a journalist at the *Kalamazoo Daily Telegraph*. He went on to study journalism at Columbia University in New York. In 1902, he participated in the New York Charity Organization Society's (NYCOS) Summer Program in Applied Philanthropic Work (Lanza, 2016). Under the mentorship of Edward Devine, Kellogg became editor of the NYCOS journal *Charities* (Chambers, 1971).

Funded by the Russell Sage Foundation, the Pittsburgh Survey was a systematic study and description of the conditions in the city, focusing on working-class life, immigration, and the effects of industrialization. It is considered a hallmark study within the social survey movement, which was "characterized not only by a previously absent concern with the understanding of the total community by empirical means, but also by a search for the source of social problems which looked not to the individual but to the larger society" (M. Gordon, 1973, p. 284). The social survey method was a conventional method in sociology and social work from 1880 to 1940 (Bulmer et al., 1991).

Kellogg and his collaborators used a "multi-method, multidisciplinary approach to data collection, an emphasis on community engagement, and the use of visual media as mechanism for community mobilization and public education" (Lanza, 2016, p. 2). Kellogg insisted that visual media such as maps, graphs, and photography would be the best way to effect community change, stating that findings could best be communicated via the eye. Thus, he followed an approach of combining media and social work into a form of social work journalism (Lanza, 2016).

According to Kellogg (1912), the most important features of a social survey include the following:

1. To bring a group of experts together to cooperate with local leaders in gauging the social needs of one city.
2. To study the needs in relation to each other, to the whole area of the city, and to the civic responsibilities of democracy.
3. To consider at the same time both civic and industrial conditions, and to consider them for the most part in their bearings upon the wage-earning population.
4. To reduce conditions to terms of household experience and human life.
5. To devise graphic methods for making these findings challenging, clear, and unmistakable. (pp. 2–3)

To help bring the visual aspect into the project, Kellogg worked closely with documentary photographer Lewis Wicker Hine (Macieski, 2015). Hine was charged with incorporating photographs and graphics into the survey (Trachtenberg, 1990). Approximately one-third of all photographs in the six volumes of the published Pittsburgh Survey were taken by him (Lanza, 2016). Hine was a strong believer in photography as an instrument for social work and "advocated that social workers also wield cameras on a daily basis as a tool of their practice: to document their work and let their opinions be known in order to influence public policy" (Lanza, 2016, p. 77).

Despite some tension and different ideas about social work practice between the COS and settlement houses, Kellogg managed to work with both and bridge some of their differences (Lanza, 2016; Reisch & Andrews, 2014). In fact, Kellogg was editor of both movements' journals, *Charities* (COS) and *The Commons* (settlement houses), and merged them into a new journal titled *Charities and Commons*. In 1909, it was renamed *The Survey* and continued to publish until 1952.

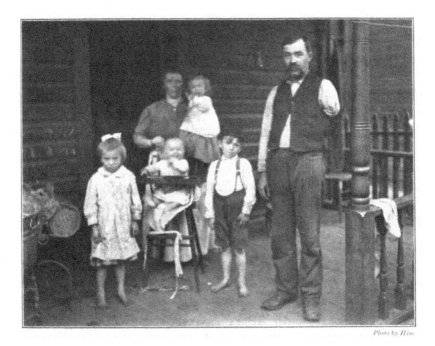

Photo by Hine

Image 1.2 One arm and four children.

Child Labor and Child Welfare

Lewis Hine also played a prominent role in the movement to improve children's rights and pass child labor laws. His pictures of children working under harsh conditions helped the National Child Labor Committee (NCLC), a key player in the campaign against child labor, in lobbying for the creation of child labor laws. Hine worked as an NCLC photographer from 1910 to 1918, documenting children's poor working conditions and traveling more than 50,000 miles in this endeavor (Bogre, 2012; Macieski, 2015).

Child labor was not a uniquely American issue but, rather, one faced by children in early industrialization of many other countries as well. As industrialization proliferated and an increasing number of laborers were needed, some industries began relying heavily on children, including agriculture, glasshouses, coal mines, sweat shops, and street trade (Hindman, 2002). Child labor has always been linked to poverty. As such, child labor laws fought against not only the use of children for labor and poor working conditions but also poverty (Hindman, 2002). This is why the photographs of Hine had such an impact. He depicted poverty and poor working conditions in a brilliant and effective way. Furthermore, because employers often denied outsiders access to the inside workings of factories, Hine often used means such as lying and bribing to gain entry (Bogre, 2012).

Hine was meticulous in recording the details of each photograph. He wanted to expose the realities of situations, but he also wanted to remain truthful, stating that "while photographs may not lie, liars may photograph" (as cited in Bogre, 2012, p. 31). Thus, Hine used the approach of combining "objective fact with subjective emotion" (p. 34). As such, two things stood out in Hine's work: He was skillful at capturing the synergy between the photo and the story, and his pictures built upon each other and added to the storyline about child labor. As Viki Goldberg (1991) describes it in the context of Hine's work,

A single photograph seldom does the job alone. Pictorial influence tends to be cumulative, like the Chinese water-drop torture: image after image of tenements, of child labor, of civil rights outrages load down the mind until its snaps under a particular sharp assault. Time and prepetition are photography's greatest allies in the battle for influence. (p. 175)

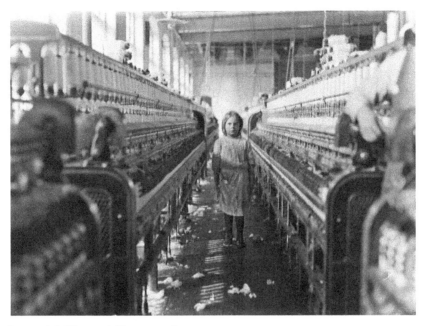

Image 1.3 Young girl in cotton factory.

The Great Depression and the New Deal

While the Pittsburgh Survey and the child labor movement (and their photographers) were supported through foundations and organizations such as the Russell Sage Foundation and the NCLC, respectively, the Great Depression and New Deal era saw the federal government enlisting photography for its cause. Following the Great Depression, President Franklin D. Roosevelt established the Resettlement Administration, later renamed the Farm Security Administration. The goal of the FSA was to assist farmers and poor people living in rural areas of the country whose lives were shattered by the Great Depression. The FSA and its programs were constantly attacked by the right for being ineffective and expensive. Like other federal agencies at the time, the FSA began to use photography to highlight its accomplishments (L. Gordon, 2009). Thus, Roy Stryker was hired to "help neutralize or counteract the inevitable conservative attacks" (L. Gordon, 2009, p. 196) and charged with establishing the Photographic Unit to support and document the work carried out by the FSA. As such, the pictures of the FSA photographer were also propaganda for the FSA and its cause (Bogre, 2012).

The now famous pictures depicting the plight of people living in rural Appalachia and the Dust Bowl–stricken American West helped increase awareness of and draw attention to the extreme poverty in those regions. Many of them, such as *Migrant Mother* by Dorothea Lange or *Farmer and Sons Walking in the Face of a Dust Storm* by Arthur Rosenstein, have become iconic photographs in their own right. However, the purpose of the Photographic Unit was not to create alluring aesthetic pictures but, rather, to highlight the work of the FSA and to convince urban Americans of the importance of supporting farmers and reducing rural poverty. Although the Photographic Unit operated on a limited budget, Striker was very adept at hiring the right photographers and in feeding the newsprint with a constant stream of photographs (L. Gordon, 2009).

The FSA photo project included more than 20 photographers. They took more than 270,000 photographs from 1935 to 1944 (Bogre, 2012). The most recognized photographers at the FSA are Walker Evans, who focused on depicting the living conditions in rural Appalachia, and Dorothea Lange, who is most known in this context for her photographs of Dust

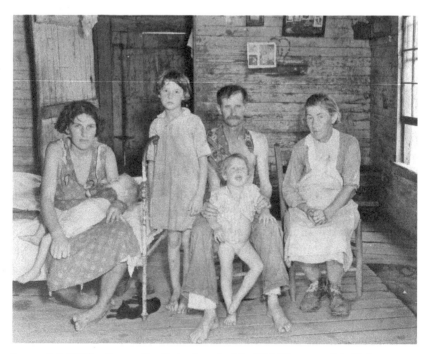

Image 1.4 Walker Evans, family in Appalachia, FSA Photographic Unit.

Bowl–stricken California. Other photographers in the FSA Photographic Unit included Esther Bubley (who also worked at the Children's Bureau), Arthur Rosenstein (who took some well-known Dust Bowl pictures), and African American photographer and moviemaker Gordon Parks (who took the iconic photograph *American Gothic*). Whereas the Pittsburgh Survey used a more technical, research-focused approach by combining text, maps, graphics, and photos, the FSA photographs can been seen as a method in their own right, showing more emotion and the plight of the people.

The Civil Rights Movement

The use of photography for social change was less systematic during the civil rights movement than in the social survey movement or at the FSA, but it was just as effective. In fact, because many in power wanted to suppress the civil rights movement, they were not keen on documentation and photographs that highlighted civil rights abuses. Some of the now famous pictures, such as of the Greensboro Four discussed below, almost were not published or printed. But despite this, photography played an important role in the civil rights movement. There are numerous examples of photographs that influenced public discourse and opinion, from pictures of lynchings carried out by members of the Ku Klux Klan to pictures of civil rights movement leaders such as Martin Luther King, Jr., and the picture of a young girl entering a desegregated school. To illustrate the historical role and impact of photography during the civil rights movement, we discuss two exemplars: the sit-in at a Woolworth counter in Greensboro, North Carolina, in 1960 and the harsh treatment of the participants of the Children's Crusade of 1963 in Birmingham, Alabama.

The first example includes the photos by Jack Moebes of the Greensboro Four. On February 1, 1960, Ezell Blair, Jr., David Richmond, Franklin McCain, and Joseph McNeil—students at North Carolina Agricultural and Technical College—refused to get up after being denied service at the Woolworth lunch counter in Greensboro (Sykes, 1960). The editor of the Greensboro newspaper and the writer assigned the story asked Jack Moebes to take pictures of the sit-in. Out of fear of being arrested at the scene, the photographer only reluctantly agreed. One of the pictures he took on the second day of the sit-in, depicting two of the Greensboro Four and two others who had joined the sit-in the following day, was published. The sit-ins continued

and grew in strength and numbers, eventually leading to the closure of the Woolworth counter and reopening a few months later as an integrated establishment. The sit-in of the Greensboro Four is considered a milestone in galvanizing the protests of the civil rights movement and inspiring sit-ins by others in towns throughout the South (Ely, 2008).

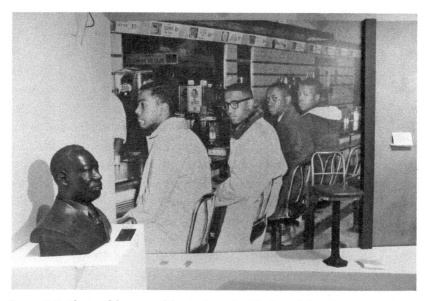

Image 1.5 Photo of day two of the sit-in at the Woolworth lunch counter taken in 1960 by Jack Moebes (1911-2002), photographer for the Greensboro Record. The photograph shows two of the Greensboro Four and two other students that joined the sit-in.

The second exemplar is the Children's Crusade on Birmingham in 1963. In April 1963, Martin Luther King, Jr., Ralph Abernathy, and Fred Shuttlesworth led protests in Birmingham. When they were arrested on April 12, Charles Moore, a young photographer and native of Alabama, took pictures of the rough treatment that Martin Luther King, Jr., received during the arrest. These pictures were viewed by people throughout the world and established Moore as a photojournalist (Durham, 2005).

Southern Christian Leadership Conference leader James Bevel and Martin Luther King, Jr., later started coordinating their efforts. Bevel was not satisfied with the impact of the protests and decided that including children in their efforts would be more convincing and would be more

effective at swaying public opinion. When Bevel developed his plan for the Children's Crusade, a march of children and youth through the streets of Birmingham, King initially was against it. However, Bevel eventually convinced King to move ahead with the Children's Crusade. Before the march, children received extensive training on tactics of nonviolent demonstration. When they started marching through Birmingham, they were met with harsh resistance (water hoses, police dogs, and batons) and mass arrest. However, despite the violent crackdown, the children continued with their protests. Charles Moore's photos depicting the harsh treatment that the children received led to an outcry throughout the country (Durham, 2005). The threat of the crusade marching on Washington, DC, influenced John F. Kennedy's drafting of the Civil Rights Bill, later passed as the Civil Rights Act of 1964. As in the first example, the combination of the protests and the use of photography brought attention to the issue in a way that a narrative in newspaper print without the pictures could not have achieved. These pictures by Moore are considered among the most influential and iconic photographs of the civil rights movement (Durham, 2005; Tougas, 2011).

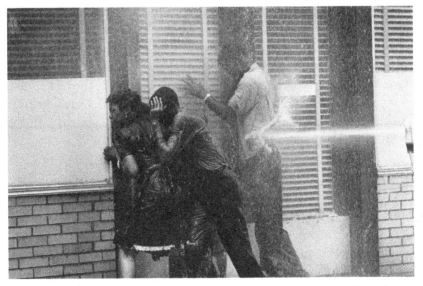

Image 1.6 Photo of the rough treatment of non-violent children and youth marchers during the 1963 Birmingham Children's Crusade.

The 1960s Through the 1980s

Starting in the 1960s and continuing in the 1970s, a move from documentary and activist community-based approaches to applications in direct practice with individual, families, and groups occurred. This move to phototherapy, storytelling, and similar methods parallels the developments in social work that witnessed a change from the outdoors (community) to the indoors (clinical social work, therapy, and counseling). Although community-based and participatory photographic methods such as photovoice were also developed during this time, it is really a shift in the focus on community and environment in parts of social work practice that led to an increased interest in these methods.

One methodological approach coming out of the 1970s is phototherapy. Utilizing pictures for therapy is almost as old as photography. Approximately 20 years after Nièpce created the first stable photograph, a British psychiatrist discussed the benefits for female mental health patients when having their picture taken (Gilman et al., 1976). The more systematic use of photos as a therapeutic method dates back to the early 1970s (Weiser, 2001). Within this method, two traditions exist: photography as a tool in therapy and the act of taking photographs as part of the therapeutic process. Examples of the first tradition are using photography in group work and incorporating pictures to discuss personal issues in reminiscence therapy. An example of the second tradition is exploring the self through taking photographs as described by authors such as Craig (2009). The *Phototherapy Newsletter*, scientific conferences on phototherapy, and a formal journal titled *Phototherapy* followed in a few short years (Weiser, 2001). Although *Phototherapy* stopped publishing a few years later in 1987, mainstream professional journals, including those in social work and social welfare, started publishing articles that included phototherapy (Weiser, 2001).

1990s to Today

As described previously, the invention of digital photography and easy storage of large amounts of data led to a proliferation of picture taking and sharing. The term *visual turn* was coined for the increased use of photography and the visual starting in the 1990s, a development that was based on the changing technology of digital photography, the integration of the

camera into the smartphone, and the ability to share via social media apps and the internet. Following the so-called linguistic turn described by the philosopher Richard Rorty (1967), a turn to the increased role of the visual medium has changed our reality, perceptions, and scientific analysis (Jay, 2002; Mitchell, 1992). Jay argues that after basing our scientific endeavor on a science of language for a long period of time, we are now beginning to use the visual as a new foundation for discourse. The visual, created with smartphone and shared via social media, is gaining an increasingly important role in this discourse. If one follows their line of reasoning, it is not a far stretch to connect the current role of photography back to the early days of the scientific photographic methods of social work. However, despite its rich history of photography and visual methods in the survey research movement and the Photographic Unit at the FSA, as well as the recent increase of photographic methods in social work practice, one could argue that social work has been slow to accept the visual turn and the increased role visual social media plays in the professional realm. Indicative of this is a review by Shaw et al. (2013) on published articles in qualitative research showing that only 3% of the reviewed studies used visual research methods. Yet although the application of photography and visual methods in social work is experiencing a renaissance, the profession remains slow to fully embrace the visual turn.

Digital storytelling is one of the more recent methodological developments for practice with individuals that includes a focus on photography. Passing on knowledge, experience, and history through oral storytelling is as old as humankind. Digital storytelling builds on this tradition by interweaving personal stories with digital photos, short videos, or other media. In its current form, it dates back to the early 1990s and the movement started by the *Digital Storytelling Cookbook* (Lambert, 1996). *Digital Storytelling: Capturing Lives, Creating Community* (Lambert, 2013) continues to be the go-to publication for digital storytelling projects.

While several of the more recent developments of combining photography with social work practice have focused on practice with individuals, families, and groups, there also has been a renewed interest in the community and the environment. A method that puts these contexts at the center is *photovoice*. Building on Paolo Freire's (1968/1970) empowerment education theory, Caroline Wang and Mary Ann Burris (1994, 1997) developed a method that provides a process by which people can "identify, represent, and enhance their community through a specific photographic technique" (Wang & Burris, 1997, p. 369). Photovoice has been used across a wide range of social

Image 1.7 Before and after photos from a Photovoice and Photo Mapping project focusing on making public spaces more accessible and safer for older adults. The photos of the improperly lighted walkways were used to successfully convince a community council to add more lights and increase the safety of older adults and other community members alike.

work settings and with a variety of client groups, such as families (Schwartz et al., 2007), communities (Wang et al., 2004), older adults (Rush et al., 2012), rural communities (Neill et al., 2011), assisted-living facilities (Lewinson et al., 2012), and children with autism (Ha & Whittaker, 2016). Wang and her collaborators have conducted several photovoice projects to educate students and inform policymakers on public health issues and concerns such as health care delivery, community violence, and international women's issues (Wang, 1999, 2006; Wang et al., 2004). The growing number of practices and research projects utilizing photovoice as well as a recent book focusing solely on photovoice in social work (Moxley et al., 2017) highlight the broad acceptance of this method.

Another community-focused approach that is gaining renewed attention is *photomapping*. We described its roots in the survey movement at the beginning of this chapter. Newer iterations of this method combine the possibilities that the easy access of special data through geographic information systems provide in mapping communities and environment.

The continued role that photography plays in social work practice is underscored by efforts to examine the empirical evidence of photographic methods in social work and to validate its effectiveness. A systematic review of the social work literature by DeCoster and Dickerson (2014)

revealed more than 80 articles covering photography in social work. Their review culminated in the inclusion of 28 publications that met selection criteria for evidence-based practice in a meta-analysis of photographic methods in social work. Results of their analysis indicate that photographic methods are "adaptable, uncomplicated, theoretically based, and supported by mostly case study evidence" (p. 11). While highlighting the benefits of photography in social work practice, they also caution that more refined and rigorous research is needed.

Conclusion

This chapter provided an introduction to the use of photography in the field of social work. The historical roots in social change and their contributions of current applications in social work practice were examined. As photography continues to gain ground as a tool in social work, students, practitioners, researchers, and educators benefit from being familiar with the various methods and uses of photography in the field. Indeed, the use of photography is one way that social workers can increase their competence and expertise in practice. Built on a rich historical foundation and a growing contemporary use, the focus of Chapter 2 is on illustrating and illuminating ways to integrate photography into contemporary social work practice and research.

References

Anthony, S. (2011). The history of Kodak: Pioneer of film and digital photography. *ExtremeTech*. Retrieved May 25, 2018, from https://www.extremetech.com/extreme/99281-the-illustrious-history-of-kodak-inventor-of-the-snapshot-digital-cameras-oled-and-more/8

Bogre, M. (2012). *Photography as activism: Images for social change*. Focal Press.

Bryan, M. L., & Davis, A. F. (Eds.). (1991). *100 years at Hull House*. University of Indiana Press.

Bulmer, M., Bales, K., & Sklar, K. K. (Eds.). (1991). *The social survey in historical perspective, 1880–1940*. Cambridge University Press.

Burrows, A., & Schumacher, I. (1990). *Portraits of the insane: The case of Dr*. Diamond. Quartet Books.

Chambers, C. A. (1971). *Paul U. Kellogg and the survey: Voices for social welfare and social justice*. University of Minnesota Press.

Craig, C. (2009). *Exploring the self through photography: Activities for use in group work*. Kingsley.

DeCoster, V. A., & Dickerson, J. (2014). The therapeutic use of photography in clinical social work: Evidence-based best practices. *Social Work in Mental Health, 12*(1), 1–19.

Durham, M. (2005). *Powerful days: Civil rights photography of Charles Moore.* University of Alabama Press.

Ely, J. W. (2008). Greensboro sit-ins. In J. W. Ely & B. G. Bond (Eds.), *The new encyclopedia of Southern culture* (pp. 98–99). University of North Carolina Press.

Freire, P. (1970). *Pedagogy of the oppressed.* Herder & Herder. (Original work published 1968)

Gilman, S. L., Diamond, H. W., & Conolly, J. (1976). *The face of madness: Hugh W. Diamond and the origin of psychiatric photography.* Brunner-Routledge.

Goldberg, V. (1991). *The power of photography: How photographs changed our lives.* Abbeville.

Gordon, L. (2009). *Dorothea Lange: A life beyond limits.* Norton.

Gordon, M. (1973). The social survey movement and sociology in the United States. *Social Problems, 21*(2), 284–298.

Gustavson, T. (2009). *Camera: A history of photography from Daguerreotype to digital.* Fall River.

Ha, V. S., & Whittaker, A. (2016). "Closer to my world": Children with autism spectrum disorder tell their stories through photovoice. *Global Public Health, 11*(5–6), 546–563.

Hindman, H. D. (2002). *Child labor: An American history.* Sharpe.

Hirsch, R. (2017). *Seizing the light: A social & aesthetic history of photography* (3rd ed.). Routledge.

Jansson, B. S. (2005). *The reluctant welfare state: American social welfare policies—Past, present, and future.* Brooks/Cole.

Jay, M. (2002). Cultural relativism and the visual turn. *Journal of Visual Culture, 1*(3), 267–278.

Kellogg, P. U. (1912). The spread of the survey idea. *Proceedings of the Academy of Political Science in the City of New York, 2*(4), 1–17. Retrieved May 1, 2018, from http://www.jstor.org/stable/1171957?seq=1#page_scan_tab_contents

Lambert, J. (1996). *Digital storytelling cookbook.* Retrieved May 1, 2018, from https://www.storycenter.org/inventory/digital-storytelling-cookbook

Lambert, J. (2013). *Digital storytelling: Capturing lives, creating community.* Routledge.

Lanza, C. A. (2016). *"Truth plus publicity": Paul U. Kellogg and hybrid practice, 1902–1937* [Unpublished doctoral dissertation]. Retrieved May 1, 2018, fromhttps://digital.lib.washington.edu/researchworks/handle/1773/38214

Lewinson, T., Robinson-Dooley, V., & Grant, K. W. (2012). Exploring "home" through residents' lenses: Assisted living facility residents identify homelike characteristics using photovoice. *Journal of Gerontological Social Work, 55*(8), 745–756.

Macieski, R. (2015). *Picturing class: Lewis W. Hine photographs child labor in New England.* University of Massachusetts Press.

Mitchell, W. J. (1992). *The reconfigured eye: Visual truth in the post-photographic era.* MIT Press.

Moxley, D., Bishop, J., & Miller-Cribbs. J. (Eds.). (2017). *Photovoice methods in social work: Using visual and narrative techniques in participatory research and practice.* Springer.

Neill, C., Leipert, B. D., Garcia, A. C., & Kloseck, M. (2011). Using photovoice methodology to investigate facilitators and barriers to food acquisition and preparation by rural older women. *Journal of Nutrition in Gerontology and Geriatrics, 30*(3), 225–247.

Newhall, B. (1964). *The history of photography from 1839 to the present day*. Museum of Modern Art.

Reisch, M., & Andrews, J. (2014). *The road not taken: A history of radical social work in the United States*. Routledge.

Rorty, R. (1967). *The linguistic turn*. University of Chicago Press.

Rush, K. L., Murphy, M. A., & Kozak, J. F. (2012). A photovoice study of older adults' conceptualizations of risk. *Journal of Aging Studies, 26*(4), 448–458.

Schwartz, L. R., Sable, M. R., Dannerbeck, A., & Campbell, J. D. (2007). Using photovoice to improve family planning services for immigrant Hispanics. *Journal of Health Care for the Poor and Underserved, 18*(5), 757–766.

Shaw, I., Ramatowski, A., & Ruckdeschel, R. (2013). Patterns, designs and developments in qualitative research in social work: A research note. *Qualitative Social Work, 12*(6), 732–749.

Squires, C. (1991). The long search for hope: The unending idealism of the committed photojournalist is as strong as ever. *American Photo, 2*, 58–61.

Sykes, M. (1960, February 2). Woolworth made target for demonstrations here. *Greensboro Record*. Retrieved May 20, 2018, from http://cms6ftp.visioninternet.com/greensboronc/Docs/library/sitins/19600202ATStudentsLaunchSitDownDemandFor ServiceAtDowntownLunchCounterGR.pdf

Tougas, S. (2011). *Birmingham 1963: How a photograph rallied civil rights support*. Capstone.

Trachtenberg, A. (1990). *Reading American photographs: Images as history—Mathew Brady to Walker Evans*. Macmillan.

Wang, C. (1999). Photovoice: A participatory action research strategy applied to women's health. *Journal of Women's Health, 8*(2), 185–192.

Wang, C. (2006). Youth participation in photovoice as a strategy for community change. *Journal of Community Practice, 14*(1–2), 147–161.

Wang, C., & Burris, M. A. (1994). Empowerment through photo novella: Portraits of participation. *Health Education Quarterly, 21*(2), 171–186.

Wang, C., & Burris, M. A. (1997). Photovoice: Concept, methodology, and use for participatory needs assessment. *Health Education & Behavior, 24*(3), 369–387.

Wang, C., Morrel-Samuels, S., Hutchison, P., Bell, L., & Pestronk, R. (2004). Flint photovoice: Community building among youths, adults, and policymakers. *American Journal of Public Health, 94*(6), 911–913.

Weiser, J. (2001). Phototherapy techniques: Using clients' personal snapshots and family photos as counseling and therapy tools. *Afterimage, 29*(3), 10–15.

2

Practice, Research, and Ethical Issues in Photography

Introduction

Is the practice of social work art or science? This question has been debated in the profession during the past five decades (Bent-Goodley, 2015; Boehm, 1961; Chambon, 2009; England, 1986; Gray & Webb, 2008; Martinez-Brawley & Zorita, 1998; Sinding et al., 2014). In recent years, social work has joined other professions, such as medicine and psychology, to promote the use of evidence-based interventions. Such empirically based interventions, vetted by the scientific method, are critical for the delivery of services that produce sound outcomes. The profession has valued what is described as the art of social work. As noted by Bent-Goodley (2015), "to continue to be relevant, social work must embrace the art and science of practice" (p. 189). Photography also involves an art and a science, and incorporating it in social work can bridge these polarities by applying a creative process built upon a scientific foundation that can be applied to all levels of professional practice. It can also serve as a tool for research. This chapter examines more closely the photograph as a tool for change in practice at the individual, group, organization, and community levels. This is followed by an overview of common applications of photography in research and a review of ethical issues as they pertain to photography practice.

Theoretical Underpinnings of Photography

Before examining the applied methods of photography as they relate to social work, it is important to understand their theoretical basis and key principles and assumptions. According to Kriebel (2007), in considering the how and why of photography, one might question, "What is photography?" or even "What is a photograph?" This can be a challenge because the method and

Photography in Social Work and Social Change. Matthias J. Naleppa, Kristina M. Hash, and Anissa T. Rogers, Oxford University Press. © Oxford University Press 2022. DOI: 10.1093/oso/9780197518014.003.0002

products of photography have changed with the evolution of time and technology, and photography is used for a wide range of purposes and functions (personal, research, journalism, art, etc.). Kriebel (2007) describes the theories that exist as addressing the science, the art, and/or the commerce related to photography. Culture and the political aspects of the medium are also prominent in many theories of photographic art. In this section, we introduce a few photographers and theorists that played a prominent role in discussing the medium of photography.

The German philosopher Walter Benjamin's 1931 essay *Kleine Geschichte der Photographie* (*A Short History of Photography*) is one of the earlier theoretical discussions of photography (Köhn, 2006). Benjamin writes about the emergence and development of photography during the first 100 years. However, rather than reviewing the technological changes of photography over time, he discusses the cognitive and political ramifications of the medium. One of the topics of his essay is the concept of **optical consciousness**. When we move physically, we are not aware of what exactly is going on during that fraction of a second. Through taking a series of photographs, we are able to capture slow motion, enabling us to make visible our optical unconsciousness. Another concept he discussed in depth is that of time travel through the use of photographs. Benjamin does not view time as one-dimensional. We go back and forth between current, past, and future, he says. A photograph captures one moment in time. By creating a stable image, it now helps us time travel back in time (Köhn, 2006).

Susan Sontag's *On Photography* (1973), one of the most influential publications on photography, is more of a collection of ideas than a theory of photographic art. Her ideas have been widely discussed and have had a significant impact on the discourse of photographic practice. Sontag is highly critical of the trustworthiness of photographs. To her, they do not reliably depict reality and "truth." Rather, photographs need to be interpreted and reinterpreted. She also questions whether photographs contribute to a deadening of our senses, suggesting that the more we see photographs of atrocities, the more we become accustomed to them and lose our conscience and sense of right and wrong.

Roland Barthes, author of the famous work *Camera Lucida* (1980), describes the "having been there" feeling of viewing a photograph that was a specific moment captured at a certain time and place. In this regard, the photograph represents something from the past that is viewed and experienced in the present. Barthes identifies two types of messages that can be

extracted from photographs, the denoted and the connoted. The **denoted message** is the subjective message of the photograph, the "having been there" aspect, whereas the **connoted message** is the subjective meaning that the viewer gives to it. This meaning will vary by the viewer. Similar to the subjective message of a photograph, which varies from viewer to viewer, the author describes the concept and quality of **punctum**, or the detail in a photograph that "pricks" or "bruises" the viewer and results in a visceral reaction. Barthes also describes **studium**, which is the element that creates interest in the photograph and includes the intended meaning of the photographer.

Photographer Stephen Shore's *The Nature of Photographs* (2007) discusses the physical, depicted, and mental levels of viewing and understanding a photograph. The physical level includes the settings used to capture the photograph, the chemicals used to print it, and other material aspects. The depictive level involves the photographer's use of flatness (taking something that is three dimensional and making it two dimensional), as well as frame, time, and focus. The mental level is dependent on the depictive level and involves the viewer's interpretation of a photograph.

Marvin Heiferman, curator, writer, and editor of *Photography Changes Everything* (2012), was curator of the Click! Photography Changes Everything project created by the Smithsonian Photography Initiative. Photographic images have become so prevalent and pervasive in today's world that they have an impact on every corner of society. The Smithsonian Institute, which holds more than 14 million photographs, tasked the project with examining the reach and power of photography and its impact on history, culture, and everyday life (Heiferman, 2014). Heiferman worked with close to 100 individuals to take pictures to answer the question, "How did photography change things for you?" Heiferman illustrates this task using the example of how photography changed adoption practice in the United States. He describes his interview with a project member who ran the Adoption Services for the State of New Mexico and had a difficult time placing sibling groups and children who were aging out of the system. When the agency hired local photographers to take high-quality portraits of the children and exhibit them in a gallery, they were suddenly finding placements. Thus, using photographs made the children adoptable (Heiferman, 2014). When Heiferman talks about photography changing everything, he reminds us that 60–80% of our brain activity is consumed by visual sensory (MoMA, n.d.). Addressing the topic of visual literacy and the ways a photograph can be made, used, and understood, he cautions us that it is a complex undertaking.

This is similar to Sontag's caution of the need to constantly interpret and re-interpret photographs. If you want to get the complete picture, Heiferman states (as cited in MoMA, n.d.), you would need to know

> how images are constructed, who made the picture, why did they make the picture, who edited the picture, who cropped the picture, who captioned the picture, what pictures did they leave out, what pictures are being censored, it is a malleable media.

Photography in Macro, Mezzo, and Micro Practice

Given its theoretical basis and the potential to attend to both the art and the science of social work, photographic methods can be utilized on all levels of practice. At the macro level and at the core of the social work profession is social justice, which can be advanced through the use of documentary photography. This tool can assist social workers in policy advocacy and practice by imaging discrimination, oppression, and injustices. In fact, one could argue that photos documented most of the major societal changes since photography was invented.

Photos can bear witness to as well as affect change on macro, mezzo, and micro levels, augmenting and enriching social work with individuals, families, groups, organizations, and communities. Photos can be used in community-based participatory action research with photovoice groups, where participants initiate the photo-taking process, or photos can be taken to affect change, where documentary photographers illustrate the plight of a community or pressing social issue. Photographic tools also can give voice to the Code of Ethics [National Association of Social Workers (NASW), 2017] by providing powerful means through which to document and work with issues surrounding social and economic justice and barriers to promoting the dignity and worth of people and the importance of human relationships. Finally, photography in social work can offer a tool through which educators and practitioners can address many of the Council on Social Work Education's (2015) competencies, making them come alive in the classroom and in practice.

Photos are a powerful tool for providing context to problems; thus, photos can give voice to the person-in-environment focus of social work. This context can include environmental conditions faced by clients or even evidence

of historical and political influences on groups, communities, or the larger society. For example, Teixeira and Gardner (2017) used participatory photomapping to uncover the perspectives and experiences of urban youth regarding vacant properties through photography, mapping, and interviews. In their project, a group of inner-city Pittsburgh high school students organized neighborhood tours to take photos with a focus on empty and abandoned properties and how they impacted the students' daily lives. Their focus on group-style discussions of the photos combined with systematic photomapping of the pictures created an impetus for participant-generated changes in the immediate environment in which they lived.

At the mezzo level, photos can be helpful in depicting group and family life as well as relationships. A practitioner conducting an in-home assessment may take advantage of photos hanging on the wall to talk about the client's family or life events. A post-adoption social worker creating a life book may use photos to help a child create a self-identity, and photos may also act as memory aides when talking about the child's past and new families. A social worker affiliated with a neonatal unit may develop a photographic scrapbook for parents who have limited access to their premature infant in the first months of life.

The use of photography can also highlight the importance of human relationships. Pictures are often included in practice with older adults as a way of gathering assessment-related information, talking about family relationships, reviewing major life events, or creating a narrative of the individual. A photo can serve as a memory aid in mezzo-level practice, for example, by creating a visual context and promoting self-reflection of group or community members. Examples of this include employing methods such as photovoice to reflect on issues faced by community members or photomapping to highlight areas in the environment that would benefit from increased social programming.

Photography has a wide range of micro-level uses in social work, and much has been written about its potential for work with individuals. For example, photography can play an important role as a tool for communication between clients and therapists (Craig, 2009). Photos allow for the sharing of information and providing a "universal" language between individuals. Clients with emotional or cognitive challenges may have difficulty communicating verbally. Yet, they may be able to communicate with the aid of pictures or other visual props. Furthermore, emotional topics may be easier to approach when one offers a narrative about a picture instead of relying solely on words

to convey feeling, and photos can even transcend language barriers, allowing for the sharing of images instead of words.

According to Lemon (2007), the use of photos in these ways can help construct, deconstruct, and reconstruct a person's story, thereby fostering self-esteem, clarifying identity, promoting self-reflection, and respecting the dignity and worth of individuals. Furthermore, the act of selecting a subject matter and taking photos of it can be beneficial to the photo-taker because it involves creativity and promotes a different way of thinking about problems, issues, and solutions. The care that goes into selecting the photograph, the act of working on the quality of the picture, the emotions evoked in talking about the picture, and being able to learn new skills and approaches to problems all can contribute to an increased self-esteem of a person (Craig, 2009).

We conclude this section with Table 2.1, which presents a list of the methods discussed in Part II and the levels of social work practice for which the methods are most effective.

Table 2.1 Overview: Photographic Methods and Level of Practice

Method	Primary Focus
Phototherapy	Individuals, families
Digital storytelling	Individuals, families, groups, organizations, communities
Photovoice	Groups, organizations, communities
Photomapping	Organizations, communities
Photo ethnography	Communities

Common Applications of Photography in Research

Photography can be an effective tool for social research. Several research-focused applications have already been mentioned as applied to practice. The following is a brief introduction to photography in research; a more detailed discussion of how research can be used with each method is provided in Part II of the book. Important to emphasize is the distinction between photography as a tool for practice and as a tool for research. If activities fall into the first category, one's practice is held accountable to the Code of Ethics, licensing oversight board, and other rules governing practice in the field. If photography is used as a tool for research, ethical concerns need to be addressed, including the possible review by an institutional review board

(IRB). Table 2.2 offers a list of methods discussed in Part II and the type of practice they are frequently used.

Table 2.2 Overview: Photographic Methods by Practice and Research Focus

Method	Primary Applications
Phototherapy	Practice
Digital storytelling	Practice
Photovoice	Practice and research
Photomapping	Practice and research
Photo ethnography	Practice and research

Visual methodologies, including photography, are becoming more common in our increasingly digital societies (Coemans et al., 2019). Although photography can be used in the context of quantitative research, it is primarily used in qualitative research, especially by researchers using participatory-, empowerment-, and feminist-based approaches to research. Reviewing the application of visual methodologies in social work research during the past decade, Clark and Morriss (2017) distinguish between using pre-existing and researcher-instigated materials. Creating new photographic materials as part of the research process is more prevalent. Most photovoice and photomapping research projects use this approach. There is also a method known as **rephotography** or repeat photography that often uses both existing and created materials. This involves taking or accessing an existing photograph and then capturing another photograph of the same subject at a later point in time, with the intention of showing change (Rieger, 2011).

As a tool for research, photography introduces a range of advantages that can aide in the process of collecting and analyzing data and presenting and disseminating findings. Photographs help contextualize what one is studying. Just like a bar graph or histogram can contextualize numbers in quantitative research, photographs can achieve the same for qualitative data. Photographs help make visual what one is studying. Although much of social science research relies on numbers and spoken and written words, "visuality remains a key aspect of engaging and understanding the social world" (Novak, 2010, p. 293). In other words, much of the research conducted, both quantitative and qualitative, misses this way of approaching our world.

Difficulties of including images in the majority of research journals only exasperate this dilemma.

Photographs help humanize research findings (Russell & Diaz, 2013). When photographs are presented as research data, supplemental to other types of data or on their own, they add emotions in a way that is difficult to achieve by text or numbers. Photography gives a voice to those affected by an issue. In this context, it can bridge the insider versus outsider positionality between researcher and researched because both, at least to some extent, become co-equals in parts of the data collection and data analysis process. Sitter (2017) refers to this as a critical component of photographic research methods, such as photovoice.

Research projects involving photography are often more collaborative in nature. It can help democratize the research process (Novak, 2010) or, as Sitter (2017) states, "Researchers and participants are engaged in emancipatory praxis that attends to minimizing power differentials" (p. 37). Furthermore, visual materials can "help to reveal the client's own hermeneutic understanding (Huss, 2012, p. 1441). Photographs are culturally embedded, but compared to a spoken language, that of an image is *more* universal (Huss, 2012). Photographs are not able to compensate for all cultural difference, but they can provide a more level field of interpretation and understanding.

Using photographs in research helps reach individuals and groups that are sometimes difficult to reach. A good example of this is a community-based participatory action research project by Castleden, Garvin, and Huu-ay-aht First Nation (2008) in which photography was used to include members of a First Nation in western Canada. These researchers state that participant-employed photography "effectively balanced power, created a sense of ownership, fostered trust, built capacity, and responded to cultural preferences" (p. 1393).

As discussed in Chapter 1, Paul U. Kellogg and the social survey movement relied heavily on graphics and photographs as data. The Pittsburgh Social Survey included more than 300 photographs (Lanza, 2016). Similarly, Roy Striker and the Farm Security Administration used photographs as data to describe the plight during the Great Depression. Together, the photographers of this project took more than 77,000 photographs. Chapter 7 introduces the reader to several research approaches used at the levels of individual, organization, and society. Often designed as mixed-method studies, today's photo ethnographic research is usually not depicted by a lifelong immersion of the researcher in a culture or environment.

Another method, photomapping, offers itself to research in a number of ways. As discussed in Part II, photomapping's research applications range from creating a better understanding of environment to health care research. Research that includes photomapping is often participatory in nature, including affected individuals or groups in developing photo maps and creating understanding and meaning on a particular topic.

Chapter 5 focuses on photovoice, a method that falls squarely into participatory action research. Probably being the most used photographic approach in social work, it is both a method for practice and a method for research. Because elements of participatory action research are at the heart of photovoice, it is difficult to conceive of projects that do not have research elements embedded in them. As discussed further in Chapter 5, the method has its roots in Freirean methods of including those affected by an issue as participants in the process of creating research data (photographs), analyzing the images, and actively participating in efforts of change. Thus, photovoice participants become co-researchers and change agents alike. The method also embraces elements of empowerment and feminist research.

Finally, phototherapy and digital storytelling are less likely to be used as a research approach. As discussed in the respective chapters, both have been the focus of research. Next, we turn to ethical issues in photography.

Ethical Issues in Photography

There are many ways to view ethics. In the context of this book, we explore at least two angles from which to approach ethics: from a social work perspective and from a photographic perspective. As an applied discipline, any intervention, tool, or research process must align with the ethical standards of the profession. Social work benefits from the Code of Ethics (NASW, 2017) to guide decision-making and practice. The original Code was developed in 1960, with major revisions in 1996 and 2017. The most recent revisions concern the uses of technology in the field. Photographers, too, have been faced with decisions around ethics in the context of taking, working on, and distributing photographs. Today's discussion of manipulation of images, for example, is nothing new in the field of photography. What is new, however, is that Photoshop and similar tools for digital photography have made it easier to work on and change images. In the following discussion, you will notice

that there are many similarities and overlap in ethics applied to social work and to the medium of photography.

The Photography Perspective

The field of photography has grappled with issues of ethics in using the medium from the very beginning. One of the most significant issues of concern is the vulnerability of and need to protect the subjects of photographs. The writer and filmmaker Susan Sontag (1977) was one of the first to discuss the ethical challenges involved in photography, and her reflections are often cited in the field. She takes a strong stance in comparing taking a photograph of an individual to mistreating them: "To photograph people is to violate them, by seeing them as they never see themselves, by having knowledge of them that they can never have; it turns people into objects that can be symbolically possessed" (p.10). To protect subjects, Sontag and others stress the importance of providing more context or narrative for photographs so that the viewer can understand the situation and take action on an issue if necessary (Sontag, 1977; Stern, 2012). It is particularly true for photographs that depict suffering or violence (Stern, 2012). This is important because, as Sontag notes, we are so bombarded by images (mostly from photojournalists) that we have become numb to what they depict.

The protection of individuals is paramount in research ethics and in research that utilizes photographic methods. As with all research, visual research must include an informed consent process. This is discussed in further detail in light of social work ethics. Langmann and Pick (2014), however, assert that ethics in research involving photography involves much more than assuring informed consent and confidentiality because "rather than recording a voice, observing behaviour or collecting survey data, the photographic researcher captures a person's image and with it intimate elements of their identity that other data collection methods cannot access" (p. 709). This adds an extra layer of ethical responsibility to protect research subjects, which the authors conceptualize as preserving dignity. In preserving dignity, a photographer must consider such issues as whether to photograph a subject based on its potential benefit, whether one can ensure that the subject will not be demeaned, and how to photograph a subject (choosing the right angle, etc.) to give the appropriate impression to the viewer. To ensure this dignity,

photographers must have open communication and build relationships with subjects before capturing images.

The photovoice method has attracted a great deal of attention in the literature in terms of ethical practices. Johnston (2016) raises issues with and reviews the literature related specifically to the use of photovoice. The method is community-based and participatory in nature, and it invites participants, who are often vulnerable or disadvantaged in some way, to share their view of a certain issue or environment through photographs and narratives. The goal of many photovoice projects is to empower participants and impact social change and social policy in participants' favor. The social action component can be a bit vague and lack evidence to attest to its actions and outcomes. Ozanne et al. (2013) engaged in a review of what they call "transformative photography" studies and found very few researchers who reported true social or policy change as a product of their projects. Furthermore, Johnston (2016) suggests that the method may also lead to false hopes on the part of the participants that changes will actually be made. It is possible that failed changes may also cause the participants to feel even worse and disempowered about their situation and the future. Concerning this issue, the group Photovoice.org (n.d.) has established ethical guidelines. Included in their Statement of Ethical Practice are the principles of partnership and sustainability. These principles direct those conducting research to partner with organizations that are involved in and committed to their communities and their unique issues. Furthermore, the principles guide researchers to involve other networks and resources to ensure sustainability of the change efforts.

Wang and Redwood-Jones (2001) outline ethical considerations and best practices in utilizing participatory photo methods such as photovoice. They propose the use of three types of consent forms to counteract the invasion of privacy. The first form is for the project staff and lists the rights and responsibilities of participants, which is similar to the information provided to an IRB. The second form is a photo release and is signed by the subject of a photo giving permission to have their image captured. Wang and Redwood-Jones also suggest that individual subjects receive copies of the photographs. The third form is used after all photos are discussed and grants permission to publish images. The authors advise that thorough training and continued mentoring of the staff and participants on the method and its ethical use are critical for photovoice projects. This includes how to ensure the safety of all involved and not portraying subjects in a false light. Written materials that

state project goals, how photographs will be used, and contact information for project directors should also be distributed to staff, participants, and community members.

O'Hara and Higgins (2019) go a step further and offer ethical considerations to ensuring the safety of participants and researchers when examining sensitive issues. In their example of a project involving youth and substance abuse, O'Hara and Higgins state that all research participants need to preserve anonymity of individuals in photographs, particularly when illegal activities are implicated and the possibility of law enforcement involvement exists. A related concern is that participants may also encounter community members who are suspicious of their taking photographs of these activities. For these reasons, O'Hara and Higgins provide guidelines for taking photographs and gaining consent from participants and community members. When photos include images of individuals, software can be used to blur or black out faces and other identifying features. As an additional safety measure, on the informed consent form, participants also can agree to a clause that requires disclosure to law enforcement or other authorities if it were believed that they were at risk for harm. The authors found that volunteering in a youth center and having staff give them a tour of the community to become familiar with the surroundings were instrumental in their feeling safe in the environment.

Areas of Ethical Concern in Photography

Paul Martin Lester has extensively written on the topic of photography and ethics. In his book *Visual Ethics* (2018), he describes typical ethical concerns that one may encounter in photography and work with visual media. When taking a photograph, one has to consider the person's right to privacy. In this context, a difference is made between the private and public person. The right to privacy is regarded higher for the private person than for someone who is in the public spotlight. We regularly hear of public figures complaining about pictures being taken without their consent, but the courts usually side with limitations to public figures' privacy. At the same time, one should always ask oneself whether taking a picture is worth the potential conflict with someone's privacy. As Lester states, "Ethics should always trump legal considerations" (p. 4). In photovoice, for example, a participant might take pictures in the community that include recognizable people. These photographs could be used for the group's work, but one might decide that the photographs should not be made public and thus be excluded from a later exhibition.

A second area of ethical concern is the manipulation of subject, photograph, or the context in which a photograph is taken. Discussions regarding manipulation of the photograph have been around as long as photography has existed. What has changed during the past few years is that it is becoming increasingly easy to manipulate a digital photo in a way that makes it impossible to distinguish the "real" from the "fake" photo. When we talk about manipulation, it goes beyond the manipulation of the picture to include the subject (e.g., placing someone in a picture to bring a certain point across or taking the picture out of context, such as cropping out certain parts of the photo). Also, when a photographer points the camera at someone, that person's behavior may change. Lester (2018) discusses the unwilling stage managing by photographers. Twenty photographers pointing their lenses toward a group of demonstrators, he says, may be experienced as a "tacit agreement of action," thereby influencing the way this group may behave.

Another ethical concern is persuasion. When we show a photo, be it to a person, by posting it on the internet, or any other way, there is always an element of persuasion involved. Whether you use a picture in a photovoice exhibition or as a photojournalist, you are trying to convey a message and persuade the person looking at it to view it a certain way. The same holds true when a photo is used in advertising. The aim is to persuade the viewer that the product should be bought. Although persuasion is pervasive, we need to attend to what we do and how we use it.

The medium of photography is full of stereotypes and clichés. It is part of the course of this medium. Stereotypes and clichés have a place in photography. Think of a wedding picture. When we take a photograph of the newlywed couple, we try to capture them in a way that fits with the stereotypes we and our culture have about weddings and happy couples. At the same time, using stereotypes and clichés can perpetuate injustice and negative portrayal of a group. We need to ask ourselves whether our images present ethnic, cultural, or religious groups in a way that stereotypes them.

The final overarching ethical concern that Lester (2018) describes is the taking and using of pictures of victims of violence, which pushes the boundaries of photography ethics. In the context of the approaches of photography in social work, and in light of the Code of Ethics that guides practice behavior or IRB boards that guide our research behavior, we suggest that photography of victims of violence should be considered off limits except in very rare circumstances.

Ethics Decisions in Photography

With changes in technology, the distribution of images on a global level has become commonplace. Thus, one needs to consider the reach of one's work and how it may interface with different ethical rules. Taking the example of an image of someone who has committed a crime, it is not uncommon to see a picture and the name of the person published in a U.S.-based newspaper. However, in many areas of the world, this would be considered a breach of the person's right to privacy that prohibits the use of a photograph and name until one is proven guilty by a court of law. The discussion of ethics in photography includes a range of rules that are mostly based on Western philosophy.

The **golden rule** can best be described as an ethic of reciprocity (Lester, 2018). As one of the most basic approaches to making ethical decisions, it asks you not to do something to another person that you would not want to be done to yourself. In the context of photography, it asks the photographer to consider, for example, whether one would want that particular image of oneself published or not. The **golden mean**, a second widely cited rule of photography ethics, is based on Confucianism and was discussed by the Greek philosopher Aristoteles more than 2,000 years ago. It is concerned with finding the middle ground between two extremes. Aristoteles was not propagating a mathematical mean or finding the average as a solution. Rather, he was describing a process of steering clear of the extremes and finding the point in the middle that avoids excess *and* avoids deficiency.

The **categorical imperative**, another ethical consideration used in photography, is based on 17th-century German philosopher Immanuel Kant. It is concerned with right versus wrong, in which we have only one path to choose. Kant states that there are things that are unconditional (categorical in his terms) and absolutely require one to act (imperative in his terms). In other words, sometimes we have to act in a certain way to fulfill our duties. As a social worker, we have to report potential child abuse. As a photographer, we have to make pictures of abuse available (this does not mean distribute them to a public audience). In both cases, the categorical imperative guides our decision.

John Stuart Mill's **principle of utility** postulates that we seek the greatest happiness for all. Following the principle of utility, we base our ethical decision on which of several actions or decisions would most benefit the welfare of all beings. This requires us to evaluate the consequences of every potential course of action involved, considering the benefits and negative consequences for everyone affected, and then choose the one that

minimizes harm and maximizes benefits. This is the opposite of the concept of hedonism. In today's interpretation, **hedonism** refers to following through with acts because they are pleasurable, without giving thought to the consequences. Lester (2018) considers hedonism a common reason for unethical decisions made by photographers.

Ethical Analysis in Photography

A number of approaches to ethical analysis are presented in the literature. Lester (2018) describes a 10-step systematic ethical analysis tool for photography. This method includes

- knowing significant facts and the ethical dilemma;
- reviewing the moral agents and stakeholders;
- evaluating their respective roles, loyalties, role-related responsibilities, and positive and negative values;
- applying the rules governing ethics; and
- reviewing alternatives to resolve the issue.

The decision-making checklist by Kidder (1995) uses a similar 10-step approach but focuses more on comparing different paradigms and resolution principles in the decision-making process.

A more straightforward tool for photographers is the so-called Potter Box (Table 2.3). The tool was developed by Harvard University professor of ethics Ralph Potter. It consists of four steps undertaken in the ethical analysis of a situation that a photographer might encounter. It includes an analysis of (1) facts, (2) values, (3) principles, and (4) loyalties (Christians, 2012). Making an ethical decision using the box is based on a systematic process and includes reasoning and making judgments in the process of arriving at a decision.

Table 2.3 Potter Box

1. Facts	3. Principles
2. Values	4. Loyalties

The first step focuses on the facts and asks the photographer to define and describe all facts and issues of the situation, the context, who is affected, and other relevant issues. Examining the facts should be accomplished as neutral

and free of judgment as possible. The second step is concerned with values. The photographer is asked to evaluate implicit and explicit values, beliefs, and conventions. For example, we may compare our morals to our professional values. Based on our moral values, we may want to refrain from taking a picture. At the same time, based on our professional values and the categorical imperative of photography, we may consider taking the image. In the third step of the Potter Box, one evaluates the ethical principles involved that we described in the previous section. In the fourth step, one is concerned with loyalties. For whom is the decision-maker responsible? What are the person's loyalties? Who is acting, who is affected, and who is responsible? Which of the various approaches to make an ethical decision should a photographer take? Kidder (1995) sums it up well when she suggests to "locate the line of reasoning that seems most relevant and persuasive to the issue at hand" (p. 185).

The Social Work Perspective

The Code of Ethics of NASW (2017) can also provide direction for the ethical use of photography in the field. The Code includes core values of service, social justice, dignity and worth of the individual, importance of human relationships, integrity, and competence. This set of values is unique to the profession and serves as the foundation for its mission to "enhance human well-being and help meet the basic human needs of all people, with particular attention to the needs and empowerment of people who are vulnerable, oppressed, and living in poverty" (NASW, 2017, Preamble). The Code also provides ethical principles and standards related to these values. The ethical standards of the profession are designed to guide the practice and decision-making of social workers and concern the ethical responsibilities of clients, colleagues, practice settings, the profession, and the greater society as well as their ethical responsibilities as professionals (NASW, 2017). In terms of the use of photography, standards directed at the ethical responsibilities to clients, the profession, and the greater society appear to be the most relevant.

Ethical Responsibilities to Clients
In terms of social workers' ethical responsibilities to clients, social workers are to protect the privacy and confidentiality of and provide informed consent for clients and research participants. Professionals are expected to

maintain the privacy of those with whom they work and engage in research. When private information (e.g., a mental health diagnosis) is disclosed, it should be solely for professional purposes. When information is shared, the issue of confidentiality is raised and involves the safeguarding of private information against unauthorized view or use. As applied to client records, this typically includes securing files in locked filing cabinets or on a firewalled, encrypted electronic server. An image of a client or a research participant can be considered private information, and in revealing a photograph, confidentiality needs to be negotiated. If photography will be used in social work practice or in a research project, an additional measure of informed consent is needed. The inclusion of a description of the process of informed consent and the planned uses of images is necessary. Clients and participants should retain the right to determine how their images will be used, and the purposes of the images should be explained in writing as well as verbally. A related standard in the Code is the importance of avoiding conflicts of interest, particularly ensuring that the use of a client or research participant's image is not exploitive in any way.

In light of the increasing use of technology in practice and research, the most recent revision of the Code (NASW, 2017) includes changes to the informed consent process. Under section 1.03 Informed Consent, (e) "Social workers should discuss with clients the social workers' policies concerning the use of technology in the provision of professional services" (para. 5). New to this version and particular to the subject of this book, (h) "Social workers should obtain clients' informed consent before making audio or video recordings of them or permitting observation of services to clients by a third party" (para. 8). Also, under 5.0 Evaluation and Research, (f)

> When using electronic technology to facilitate evaluation or research, social workers should ensure that participants provide informed consent for the use of such technology. Social workers should assess whether participants are able to use the technology and, when appropriate, offer reasonable alternatives to participate in the evaluation or research. (para. 6)

Let us examine how ethical issues, particularly those involving privacy, confidentiality, and informed consent, might arise in the use of photography for practice and research. An activities department in a skilled nursing facility partners with a social work faculty member to pilot test a reminiscence therapy group for residents with mild to moderate dementia. The team

members would like to disseminate the results and promote the use of their special focus on activities related to the regional culture. In this process, they may wish to take and share photographs of the group members engaging in these unique activities as well as crafts or other products that they create in the group. The question is how to best acquire informed consent for the photographs from the group members (who have some degree of cognitive impairment). The issue of informed consent for this population is one for which researchers often take extra precautions. When the capacity to consent is in question, often a guardian, power of attorney, or legally authorized representative can provide consent for the individual. As with any other consent form, the purpose, risks and benefits, and other information would be provided. If a legally authorized representative provides consent on behalf of an individual, it is also important to obtain verbal consent from the participant before a photograph or video is taken.

Competence is a core value of the profession and involves the duty to practice only within areas of one's professional competence or to seek training or other ways of achieving competence in a particular practice realm. As applied to the use of photography, social workers wishing to implement this tool into practice or research should acquire a working knowledge of the method of interest before involving clients. This includes projects or interventions including individuals, groups, or communities. For example, a social worker employed at an organization that serves persons with physical disabilities may be interested in understanding the challenges faced by clients in navigating the downtown area of their community. The idea may be, using a photovoice approach, to ask clients to take photos of barriers that they face in accessing stores and restaurants in that segment of the community and share those photos along with narrative descriptions of the associated challenges. In this case, it would be beneficial for the social worker to read the professional literature on the use of photovoice in identifying community needs and the best practices for accomplishing such a project. A review of the literature would also validate the method's empirical basis and relevance to social work practice as well as identify potential ethical issues that may emerge in its use. Attending a continuing education event related to the topic to learn the hands-on techniques would also be quite helpful.

It is important to remember that cultures have varying beliefs and customs related to photographs and their uses. In fact, cultural awareness and social diversity are an ethical responsibility to clients. As such, social workers serving as practitioners or researchers should be sensitive to and seek to

understand different cultures and how culture translates into human behavior. Furthermore, diversity includes such factors as age, ethnicity, socioeconomic status, gender identity, sexual orientation, physical and mental abilities, and spiritual beliefs, among others (NASW, 2017). Also, cultural norms should be considered in photographing individuals, groups, or even environments. For example, it is considered unacceptable to photograph a Muslim woman's face. Other cultures do not permit photographs of religious sites or artifacts. In some cultures, it is customary to compensate individuals for taking their photo. To ensure respect for subjects, photographers should research the culture of the intended subject matter and, when in doubt, ask individuals whether they can take the individuals' photo or a photo of a particular site or artifact (Cohen, 2016).

Ethical Responsibilities to the Profession and Broader Society

Engaging in evaluation and research is an ethical responsibility of the social work profession. Social workers who implement photographic methods into their practice should evaluate its effectiveness. For example, take a situation in which a professional utilizes phototherapy by asking a client to photograph items and situations in her life that cause her anxiety. The photos allow the client to more concretely discuss her reactions and coping in the therapeutic sessions. In this case, the social worker should measure the client's level of anxiety at the session and at subsequent sessions to determine if her anxiety is reduced. A specific question can be added to assess whether she believes the use of the photos is beneficial in the process. Similarly, photos can also be used as evidence in evaluation. For example, photos could be used to document changes made to a school that received a grant to add a garden and nutrition program. As mentioned previously, in the case of using photography in research, privacy, confidentiality, informed consent, and conflicts of interest are important considerations.

Photography can also attend to the social worker's ethical responsibilities to the broader society. Advocating for the welfare of society, promoting social justice, and engaging in social and political action can be accomplished through the use of photography. Photos can depict the human experience and condition as well as be a witness to unhealthy physical environments. Allowing community residents to visually portray sewage and trash in a local water supply, for example, could prove to be a powerful campaign to call a city council to action. Photographic methods such as photovoice,

photomapping, and photo ethnography, discussed in Part II, can serve as effective tools in meeting this professional responsibility.

Conclusion

This chapter explored the theoretical underpinnings for photography and how it can serve the mission of social work at the individual, group, organizational, and community levels. The use of the method in social work research was also explored through a number of common applications. In practice and in research, photography has the potential to unlock both the art and the science of social work.

The chapter also examined the ethical considerations in the use of photography in social work. NASW's Code of Ethics (2017) serves as a solid guide for photography's use as a tool in practice and in research. The core values of the profession and its related principles are the basis on which the professional standards can operate. These standards can provide guidelines for social workers who wish to professionally incorporate photography. Most important are the responsibilities of ensuring privacy, confidentiality, and informed consent for clients or research participants when attaining or using their still or video images. In addition, the need for competence in a photographic technique is also a critical responsibility. As our society and profession evolve over time, it is expected that the Code will be revised in future years. Social workers integrating photography or any other tools should stay abreast of these revisions to ensure ethical practice and research.

Glossary

Categorical imperative: An ethical principle concerned with right versus wrong.

Connoted message: The subjective meaning that the viewer gives to a photograph.

Denoted message: The subjective message of the photograph, or the "having been there" aspect of a photograph.

Golden mean: An ethical principle concerned with finding the middle ground between two extremes.

Golden rule: An ethical principle of reciprocity.

Hedonism: Refers to following through with acts because they are pleasurable, without giving thought to the consequences.

Optical consciousness: The ability to remain aware of physical movements from moment to moment.

Principle of utility: An ethical principle that postulates we seek the greatest happiness for all.

Punctum: The detail in a photograph that results in a visceral reaction.

Rephotography: Also known as repeat photography, rephotography is the taking or accessing an existing photograph and then capturing another photograph of the same subject at a later point in time, with the intention of showing change.

Studium: The element of a photograph that creates interest in the photograph and includes the intended meaning of the photographer.

References

Barthes, R. (1980). *Camera lucida: Reflections on photography.* Noonday Press.

Bent-Goodley, T. (2015). The art and science of social work revisited: Relevance for a changing world. *Social Work, 60*(3), 189–190.

Boehm, W. W. (1961). Social work: Science and art. *Social Service Review, 35*(2), 144–152.

Castleden, H., Garvin, T., & Huu-ay-aht First Nation. (2008). Modifying photovoice for community-based participatory Indigenous research. *Social Science Medicine, 66,* 1393–1405.

Chambon, A. (2009). What can art do for social work? *Canadian Social Work Review, 26*(2), 217–231.

Christians, C. G. (2012). *Media ethics: Cases and moral reasoning.* Allyn & Bacon.

Clark, A., & Morriss, L. (2017). The use of visual methodologies in social work research over the last decade: A narrative review and some questions for the future. *Qualitative Social Work, 16*(1), 29–43. https://doi.org/10.1177/1473325015601205

Coemans, S., Raymakers, A. L., Vandenabeele, J., & Hannes, K. (2019). Evaluating the extent to which social researchers apply feminist and empowerment frameworks in photovoice studies with female participants: A literature review. *Qualitative Social Work, 18*(1), 37–59.

Cohen, E. M. (2016). Photographing people in other cultures: How to shoot with courtesy and respect. *Outdoor Photography Guide.* https://www.outdoorphotographyguide.com/article/photographing-people-in-other-cultures-how-to-shoot-with-courtesy-and-respect

Council on Social Work Education. (2015). *Educational policy and accreditation standards.* https://www.cswe.org/getattachment/Accreditation/Standards-and-Policies/2015

Craig, C. (2009). *Exploring the self through photography: Activities for use in group work.* Kingsley.

England, H. (1986). *Social work as art: Making sense for good practice.* Allen & Unwin.

Gray, M., & Webb, S. A. (2008). Social work as art revisited. *International Journal of Social Welfare, 17*, 182–193.

Heiferman, M. (2012). *Photography changes everything.* Aperture.

Heiferman, M. (2014). *School of visual arts masters in photography lecture: Marvin Heiferman.* Retrieved February 20, 2020, from https://www.youtube.com/watch?v=Y215_cvCfs

Huss, E. (2012). What we see and what we say: Combining visual and verbal information within social work research. *British Journal of Social Work, 42*(8), 1440–1459.

Johnston, G. (2016). Champions for social change: Photovoice ethics in practice and "false hopes" for policy and social change. *Global Public Health, 11*(5–6), 799–811.

Kidder, R. (1995). *How good people make tough choices.* Morrow.

Köhn, E. (2006). Kleine Geschichte der Photographie. In B. Lindner (Ed.), *Benjamin-Handbuch: Leben—Werk—Wirkung.* Metzler.

Kriebel, S. T. (2007). Theories of photography: A short history. In J. Elkins (Ed.), *Photography theory* (pp. 3–49). Routledge.

Langmann, S., & Pick, D. (2014). Dignity and ethics in research photography. *International Journal of Social Research Methodology, 17*(6), 709–721.

Lemon, N. (2007). Take a photograph: Teacher reflection through narrative. *Reflective Practice, 8*(2), 177–191.

Lester, P. M. (2018). *Visual ethics: A guide for photographers, journalists, and filmmakers.* Routledge.

Martinez-Brawley, E. E., & Zorita, P. M. B. (1998). At the edge of the frame: Beyond science and art in social work. *British Journal of Social Work, 28*(2), 197–212.

MoMA. (n.d.). *Seeing through photographs: Interview with Marvin Heiferman.* Retrieved April 25, 2020, from https://de.coursera.org/lecture/photography/1-3-interview-with-marvin-heiferman-WwGwK

National Association of Social Workers. (2017). *NASW code of ethics.* https://www.socialworkers.org/About/Ethics/Code-of-Ethics/Code-of-Ethics-English

Novak, D. R. (2010). Democratizing qualitative research: Photovoice and the study of human communication. *Communication Methods and Measures, 4*(4), 291–310.

O'Hara, L., & Higgins, K. (2019). Participant photography as a research tool: Ethical issues and practical implementation. *Sociological Methods & Research, 48*(2), 369–399.

Ozanne, J., Moscato, E., & Kunkel, D. (2013). Transformative photography: Evaluation and best practices for eliciting social and policy changes. *Journal of Public Policy & Marketing, 32*(1), 45–65.

Photovoice.org. (n.d.). *Statement of ethical practice.* https://Photovoice.org/wp-content/uploads/2017/05/Ethical-Statement.pdf

Rieger, J. (2011). Rephotography for documenting social change. In E. Margolis & L. Pauwels (Eds.), *The Sage handbook of visual research methods* (pp. 132–149). Sage.

Russell, A. C., & Diaz, N. D. (2013). Photography in social work research: Using visual image to humanize findings. *Qualitative Social Work, 12*(4), 433–453.

Shore, S. (2007). *The nature of photographs.* Phaidon.

Sinding, C., Warren, R., & Paton, C. (2014). Social work and the arts: Images at the intersection. *Qualitative Social Work, 13*(2), 187–202.

Sitter, K. C. (2017). Taking a closer look at photovoice as a participatory action research method. *Journal of Progressive Human Services, 28*(1), 36–48.

Sontag, S. (1973). *On photography.* Farrar, Straus & Giroux.

Sontag, S. (1977). *On photography* (3rd ed.). Farrar, Straus & Giroux.

Stern, M. (2012). Presence, absence, and the presently-absent: Ethics and the pedagogical possibilities of photographs. *Educational Studies, 48*(2), 174–198.

Teixeira, S., & Gardner, R. (2017). Youth-led participatory photomapping to understand urban environments. *Children and Youth Services Review, 82,* 246–253.

Wang, C., & Redwood-Jones, Y. (2001). Photovoice ethics: Perspectives from Flint Photovoice. *Health Education & Behavior, 28,* 560–572.

PART II
PHOTOGRAPHIC METHODS AND APPLICATIONS

3

Phototherapy

Overview, Key Concepts, and History

What Is Phototherapy?

Since its invention, photography has been used as a vehicle for self-expression. In its ability to allow the photographer to self-select images and tell stories through photos, photography offers an inherent way to facilitate meaning and healing. In its general sense, **phototherapy** involves taking, analyzing, and using photos for personal exploration, growth, and healing (Weiser, 1999). When pairing photos with oral or written narratives, individuals are able to construct, deconstruct, and reconstruct emotions, life events, and other meanings associated with the photos to promote understanding of the self.

Photography, as a therapeutic approach and intervention, can be used in many different ways for a variety of goals. Photography as a therapeutic modality involves a creative process that allows participants to explore and express personal experiences in ways that promote growth, communication, and self-reflection. Although photography as a therapeutic process is inherently creative and personal and can be adapted to achieve a multitude of goals, two main frameworks offer guidelines for approaching therapeutic work. Phototherapy is one framework used to describe a set of techniques that utilize personal photos, videos, images taken by others, and family albums, for example, that hold meaning for the individual undergoing therapy. These tools are used within a therapeutic setting, facilitated by a therapist or counselor, to promote expression of thoughts, feelings, and experiences that might otherwise be difficult to explain verbally (Weiser, 1999). **Therapeutic photography**, a term sometimes used interchangeably with phototherapy, is an approach in which individuals or groups take self-initiated photos without the assistance of a therapist or counselor and not in the context of a structured therapy session. In this approach, taking photos as an activity and reflecting on them as individuals or sharing them in a group

Photography in Social Work and Social Change. Matthias J. Naleppa, Kristina M. Hash, and Anissa T. Rogers, Oxford University Press. © Oxford University Press 2022. DOI: 10.1093/oso/9780197518014.003.0003

provides the therapeutic benefit. Therapeutic photography also can involve viewing, planning for, or posing for photos; visualizing or imaging photos; or discussing photos (Weiser, 1999).

Origins and History of Phototherapy

The first known use of photography for therapeutic purposes can be attributed to a physician, Hugh Diamond. In mid-19th-century London, Diamond took photos of female asylum patients to document their facial expressions, which he believed could be used to diagnose their specific mental health issues. Diamond wrote an article on the subject titled "On the Application of Phototherapy to the Physiognomic and Mental Phenomena of Insanity" (Getty Conservation Research Foundation Museum, 2020).

Since the mid-19th century, photography has been adapted and used in many different clinical and nonclinical settings for a variety of therapeutic goals. As early as the start of the 20th century, clinicians and researchers began to document and write about the use and therapeutic effects of photography, which spurred the development and proliferation of the medium in therapeutic work. Early efforts focused on the ways in which images could promote cathartic processes for patients and clients. Since then, the methods of using photography as a therapeutic modality have been refined and developed, resulting in the proliferation of ways in which photography can be used in a wide variety of settings (Stewart, 1983). For example, in the 1970s, several psychologists developed the modality of phototherapy further, making it a more prominent and structured intervention in psychology programs and the mental health practice, including individual and family therapy. Some of these pioneers include Entin (1981), Krauss (1979), Walker (1982), and Wolf (1976). Throughout the years, the use of phototherapy and therapeutic photography has expanded beyond mental health settings into health and community settings.

Goals of Phototherapy

A major goal of phototherapy is to assist clients in therapeutically expressing their thoughts, feelings, and issues nonverbally (Junge & Levick, 2010). Thus, photographs are used as a mode of communication. In the context of

therapeutic session with a therapist or counselor, photos are used as catalysts to spark and deepen insights (Weiser, 2001). Phototherapy also facilitates the relationship-building process in therapeutic settings. Specifically, trust and rapport in the therapeutic relationship are built between client and therapist by giving clients the choice of how much of their stories to reveal, and how quickly, through the presentation of photographs in therapeutic sessions. By giving clients control over their narratives, clients can develop a sense of safety and comfort in sharing experiences (Stevens & Spears, 2009).

Because photography facilitates creativity and artistic expression, even if that is not the main goal for using the medium, it can help the user view the world and experiences more objectively. Thus, phototherapy is one way to assist clients in developing alternate points of view on issues, problems, events, and relationships. Phototherapy can also prompt clients to pay more attention to their thoughts, feelings, and experiences on a daily basis. Specifically, the process of phototherapy can help clients build observational skills through asking questions, exploring perspective, and being mindful to moments in time that they might otherwise ignore (Gabriel, 2020).

Theoretical Foundations

Because phototherapy can be used within the framework of many different therapeutic modalities and lenses, there is no one theoretical foundation in which phototherapy is based. Rather, phototherapy can be explained and employed through the theoretical foundation of the particular modality the therapist is using, such as cognitive, narrative, Jungian, psychodynamic, or person-centered approaches. Because phototherapy is not art therapy using photos, it can be utilized by therapists trained in any modality or discipline and incorporated into their regular therapeutic modalities (Weiser, 2014).

The theoretical underpinning that phototherapy has in common with all therapeutic approaches is that using photographs to help clients communicate and examine their narratives can be viewed as a way to help them explore their unconscious. Through photographs, clients can explore meanings attached to events that may have been repressed (a Freudian idea). These meanings are brought to the surface, where clients and therapists, within the therapeutic relationship, can delve into the thoughts, feelings, and emotions attached to those events, which may have been too painful to deal with at the time the events occurred. Similarly, photographs may help clients make

meaning of certain aspects of their lives that otherwise have been packed away, unexamined, for whatever reason (Loewenthal, 2013b).

Advantages and Challenges of Phototherapy

Phototherapy can be used for various therapeutic purposes by a wide variety of professionals and non-professionals in many different settings. As such, phototherapy is a versatile method that can be adapted to fit many different needs.

Advantages

One of the main advantages to phototherapy is that is does not require special equipment, skill, or talent to be effectively utilized in therapeutic settings (Star & Cox, 2008). Clients can bring to sessions photographs they have from their phones or other devices or from family albums, for example. Furthermore, clients and therapists can use photographs to build nonverbal understanding in the relationship more consistently, thereby promoting and sustaining trust and rapport in the therapeutic relationship, which is a main goal of phototherapy (Stevens & Spears, 2009). Phototherapy also allows clients to express themselves in creative ways, which may help clients and therapists work around defense mechanisms that can hinder the growth process. Specifically, clients may find it easier to express difficult thoughts and emotions through images rather than words. Through concrete images, photographs can offer representations of complex and difficult to access and articulate thoughts, feelings, issues, and experiences (Star & Cox, 2008).

Challenges

One of the major challenges to phototherapy is that because it is an artistic form of intervention, and it can be used and applied in so many ways, it is difficult to empirically validate its effectiveness in the therapeutic process. Thus, little evidence exists, except through anecdotes and case studies, of its advantages and effectiveness (Pillay, 2009). Nonetheless, phototherapy is still a powerful tool that can be utilized to improve not only the therapeutic

relationship but also the potential benefits and outcomes of the therapeutic process. Another limitation to phototherapy is that it is not necessarily the best therapeutic modality for all clients. Not everyone responds to or works well with visual content, and clients do need to have access to some form of equipment, unless they are working with existing photographs only (Ginicola et al., 2012).

Best Practices: Application of Phototherapy in Various Fields of Practice

This section discusses some of the best practices for phototherapy in social work. The applications of phototherapy in different realms of social work practice are explored.

Applications in Education

Phototherapy may be employed as a technique of self-exploration and self-reflection in learning environments. Educators can use phototherapy techniques to give students opportunities to explore various emotions and experiences associated with learning and to delve deeper into perceived strengths and barriers to students' own learning. Phototherapy techniques require students to be vulnerable to a certain extent because images that students take should reflect their inner experiences as they work with content in their courses. However, the process of self-exploration and self-reflection should, in and of itself, promote students' learning. Furthermore, the process of utilizing phototherapy in the learning process can also help student learn the methods of phototherapy that they can use with others, such as clients in mental health practice (Riley & Manias, 2004).

Applications in Practice

Phototherapy, by definition, is the use of photography in therapeutic practice, but it can be incorporated in all types of social work and other professional practice. Typically, phototherapy is used in micro settings with the goal of improving mental health and well-being. For example, phototherapy

can be used in brief or long-term therapy in all types of settings and with all types of clients. The technique is flexible enough to be used in individual or group contexts held in settings from schools to prisons, health care clinics, and community mental health centers (Loewenthal, 2013a; Mizock et al., 2014; Saita et al., 2019). Phototherapy also can be used with people who are neurodiverse or who struggle with cognitive difficulties such as dementia. For example, phototherapy can be incorporated in reminiscence therapy to allow clients to interact and engage with multimedia in ways that reduce barriers caused by cognitive or motor difficulties (Lazar et al., 2014).

On a macro level, phototherapy can be incorporated in community outreach and engagement. Social workers and other helping professionals might use phototherapy with community members to explore and identify issues in the community, share knowledge and experiences, and develop solutions to improve community well-being. In this approach, community members can take and share photos that help them express their thoughts and feelings about their communities as well as what they are experiencing in daily life. Phototherapy in this context can help bring community members together, improve communication, and increase advocacy among community members to improve community well-being (Warren et al., 2014).

Applications in Research

Social work and other mental health and community practitioners may find phototherapy a useful tool to employ for research purposes. Like other photo techniques, phototherapy can be used to explore client and community issues that can then be used to describe problems, strengths, barriers, and the like for individuals, groups, and communities. Phototherapy can also be used to explore the effectiveness of various interventions, including phototherapy as an intervention itself, to improve mental health and community well-being. For example, clients might take or share existing photos that reflect problems or issues, and after an intervention is employed, clients take or share another set of photos that reflect their growth or change after the intervention (DeCoster & Dickerson, 2014).

Furthermore, phototherapy can be employed to better understand the human condition. By asking people to take photos and describe the thoughts, feelings, and experiences related to the photos, researchers can

gain new insights and knowledge into people's experiences. This approach is grounded in phenomenology, in which researchers and those taking the photographs get to see, interpret, and construct meaning from the images (Riley & Manias, 2004).

A Step-by-Step Process of Phototherapy

Because phototherapy can be incorporated into any therapeutic modality, and likely would not be used as a stand-alone therapeutic intervention, the process of implementing it may look different depending on the goals of the client and specific intervention and theoretical underpinnings of the main interventions being used in therapy. However, in general, the process of phototherapy itself unfolds in specific stages to help build upon and facilitate the goals of therapy.

Overview

The process of phototherapy can unfold in different ways, and there are no specific steps therapists and clients need to take to utilize phototherapy in therapeutic sessions. Rather, the photos that are used within the therapeutic context are therapeutic tools that can be applied at different points in therapy, depending on what is taking place and when the therapist and client judge they may have therapeutic benefit. Both the therapist and the client must agree that using photos in therapy sessions will have benefits, after exploring the goals, advantages, and disadvantages of phototherapy. Although phototherapy helps build the therapeutic relationship, the therapist and client should have had time to build rapport, explore the client's presenting problems and goals for therapy, and assess whether phototherapy would be beneficial in the therapeutic context (Ginicola et al., 2012).

If the therapist and client agree that phototherapy will be incorporated in their work, the therapist directs the client to bring photos to the sessions. It is at this point that the therapist offers guidelines to the client about gathering photos to bring to sessions, including options to take photos or explore photo albums or digital photos, for example. Once the client brings the photos to a session, the work of activating the thoughts and feelings associated with the

photos begins. Specifically, the photos used in therapy contain not only factual details of clients' lives but also symbolic representations of how clients make sense of their lives and experiences; thus, clients choose the photos that are used in sessions and they also provide the interpretations of them, guided by therapists' questions. This process relies heavily on guidance from the therapist, who asks specific questions about the photos and the experiences of the client as the photos are presented. The therapist helps the client delve deeper into the meaning behind each photo through the process of posing specific open-ended questions that prompt the client to explore cognitive and affective meanings associated with the image and emotional impact of the photo. There is no incorrect or objective way to interpret photos, so each phototherapy session will be unique (Ginicola et al., 2012).

The client and the therapist decide how long phototherapy will continue. Photos can be used in one session or throughout the course of therapy, depending on the client's goals. As the phototherapy process unfolds, the therapist does not use the client's interpretations of the photos as a way to diagnose the client. Rather, the therapist looks for themes or patterns in the client's responses to help the client gain insights into issues, emotions, and thoughts. The therapist might point out unusual or symbolic reactions or thoughts about photos or focus on specific aspects of a photo to help the client explore deeper meanings behind certain reactions. The therapist assists the client in exploring visual messages, dialoguing with photos, and gaining different viewpoints from photos and the memories they spark. The therapist also attends to the process that unfolds as the client explores photos, and the therapist helps the client work through that process as sessions unfold (Weiser, 2001).

The phototherapy process is couched in the specific theoretical framework used by the therapist. Specifically, when working with photos, the questions posed by the therapist and the interpretations and meanings that are evoked in the sessions often are guided and framed by the modality that is preferred by the therapist. While the client freely expresses thoughts and feelings that arise when looking at photos, the therapist typically frames those expressions in the context of the therapeutic modality in which the therapist is trained.

The process of phototherapy is unique to each client because each client has unique goals, experiences, reactions to photos, and preferences to the types of photos used in therapeutic sessions. Furthermore, as discussed

Table 3.1 Techniques Used in Phototherapy

Phototherapy Technique	Description
Photos taken by the client	These photos can be physically taken by the client or "borrowed" from another source, such as someone else's photo collection, or from images found on the internet, in magazines, or gathered from postcards.
Self-portraits	These photos are images made by the client of oneself and can be literal or metaphorical.
Photos taken of the client	These photos are taken of the client by other people, either purposefully or spontaneously.
Family albums or photobiographical collections	These photos can come from any collection that tells a familial narrative for the client, whether that be the biological or chosen family. The collection can be from formal albums or informal collections of images from different sources.
Photo projectives	These photos come from any source that holds meaning for or captures the attention of the client or therapist.

Source: Weiser (2001).

previously, each therapist utilizes different therapeutic modalities in which to frame the client's therapeutic experiences. However, the process of phototherapy typically relies on five specific techniques or tools that are used within the phototherapy process; these techniques are described in Table 3.1.

Case Example: The Accident

This case example describes the use of phototherapy in a clinical mental health setting in which the client was seeking therapy to improve symptoms of anxiety and depression.

Description and Background of the Project

Mental health therapy with the client was initiated when the client's daughter called the therapist for help with her father, who she stated was suffering from anxiety and depression. The client, Joel, was a 65-year-old male who had been seriously injured in a work-related accident. Joel had been in a remote area scouting locations for his company's cell towers when he fell and broke his neck. His partner did not find Joel for approximately 20 minutes, at which point his partner called an ambulance for

help. Joel instructed his partner to get his camera and document the incident with photographs. Coincidentally, Joel's main hobby was photography, and he always carried his camera with him.

Joel's partner took photographs as emergency personnel worked to stabilize Joel and transport him to the hospital. Joel spent 3 months in rehabilitation to heal from his injuries and engage in physical therapy to regain his mobility. During his months in rehabilitation, Joel continued to document the process through photography. Joel was not able to fully recover and needed assistance with activities of daily living (dressing, bathing, walking, etc.). Thus, Joel was forced to retire from his job, move into assisted living, and sell all of his photography equipment. Joel also found himself dependent on caregivers and lost connections with his friends and co-workers. Presumably, Joel was struggling to adjust to the situation and the accumulated loss and grief he experienced in such a short time from the accident. Joel began to experience symptoms of anxiety and depression soon after moving into the assisted living facility.

Overview of the Phototherapy Process and Aim

After several months of intensive therapy with Joel to target symptoms of anxiety and depression, the therapist eventually asked if she could see the photographs Joel had taken during the accident and his recovery process. Initially, Joel declined and stated he did not know where the photographs were. Each time the therapist asked, Joel would experience sadness and panic attacks.

A few years into the therapeutic relationship, Joel decided to purchase a new computer. He agreed to log into his online account where his photos were stored. A few months of sessions were spent reviewing photos of the accident and rehabilitation process as well as other photos Joel had taken as a hobby. Joel talked in great depth about the accident, including his feelings and thoughts after he fell. He also discussed his experiences related to the recovery process as he sifted through hundreds of photos. This process continued for about a year, and with each session, the therapist continued to assess and monitor Joel's symptoms of anxiety and depression, which gradually improved.

Results

For at least the first year of therapy, Joel was reluctant to discuss the accident or his losses and grief. The therapy sessions were spent discussing his symptoms and engaging in reminiscence therapy, during which Joel would talk about his past life, his hobbies, and his friends. In fact, Joel denied feeling much grief at all. For the first year, Joel's symptoms of anxiety and depression were unchanged. Joel continued to experience sadness, sleeplessness, panic attacks, and intense dreams. Joel would often wake in the morning in the middle of a panic attack. Joel also refused to use a computer or device and suggested he was unable to physically operate any sort of technology, including a camera.

As Joel began to review photos, both the ones he took as a hobby and those that were part of the accident and recovery process, Joel was able to identify and discuss feelings of loss, grief, and sadness related to his adjustment process after the accident. He was able to express the loss of independence as well as connection to others. His articulation of more complex and deep feelings, thoughts, and experiences improved. Indeed, his overall ability to express himself improved. Over time, his symptoms of anxiety and depression improved until the panic attacks and feelings of helplessness and hopelessness ceased altogether. Toward the end of the therapeutic relationship, Joel had purchased all new computer and photography equipment and was leaving his assisted-living apartment to explore the city and take photos. Joel also opened an account on Facebook to connect with friends and family. Joel even

discussed compiling and publishing his photos in a book and on social media.

Conclusion

Phototherapy is a powerful technique that can be used in the therapeutic process. Whether it is being used in work with individuals, groups, or communities, phototherapy can help people explore thoughts, feelings, and experiences and increase insight, self-exploration, and self-reflection. Phototherapy can be used in virtually any setting, for almost any presenting problem, and with most clients; it is a versatile tool to use in promoting mental health and well-being.

Phototherapy can also be used in education to help students engage in self-reflection and self-exploration during their learning process. Exploring photos that students have taken or gathered can offer students insights into the strengths and weaknesses in their learning of the content and enrich their learning experiences. With regard to research, phototherapy can be used to explore individual and community issues and problems and learn more about the effectiveness of therapeutic interventions.

Glossary

Phototherapy: The taking, analyzing, and using of photos for personal exploration, growth, and healing. As a more specific term, it is the use of techniques in a therapeutic setting that involve personal photos, videos, images taken by others, and family albums that hold meaning for the individual undergoing therapy.

Therapeutic photography: A term sometimes used interchangeably with phototherapy. It is an approach in which individuals or groups take self-initiated photos without the assistance of a therapist or counselor and not in the context of a structured therapy session.

Additional Resources

Canva: https://www.canva.com

ErickKimPhotography:https://erickimphotography.com/blog/how-to-use-photography-as-self-therapy

Fstoppers: https://fstoppers.com

Phototherapy Centre: https://phototherapy-centre.com

The One Project: https://theoneproject.co

References

DeCoster, V. A., & Dickerson, J. (2014). The therapeutic use of photography in clinical social work: Evidence-based best practices. *Social Work in Mental Health, 12*, 1–19.

Entin, A. D. (1981). *The use of photographs and family albums in family therapy.* Brunner-Mazel.

Gabriel, M. (2020). *Can photography be used as a form of therapy?* Retrieved January 27, 2020, from https://contrastly.com/can-photography-be-used-as-a-form-of-therapy

Getty Conservation Research Foundation Museum. (2020). *Hugh Welch Diamond.* Retrieved January 10, 2020, from http://www.getty.edu/art/collection/artists/1805/hugh-welch-diamond-british-1809-1886

Ginicola, M. M., Smith, C., & Trzaska, J. (2012). Counseling through images: Using photography to guide the counseling process and achieve treatment goals. *Journal of Creativity in Mental Health, 7*, 310–329.

Junge, M. B., & Levick, M. F. (2010). *The modern history of art therapy in the United States.* Charles C Thomas.

Krauss, D. A. (1979). The uses of still photography in counseling and therapy: Development of a training model. Unpublished doctoral dissertation, Kent State University, Kent, OH.

Lazar, A., Thompson, H., & Demiris, G. (2014). A systematic review of the use of technology for reminiscence therapy. *Health Education & Behavior, 41*(1), 51–61.

Loewenthal, D. (2013a). Talking pictures therapy as brief therapy in a school setting. *Journal of Creativity in Mental Health, 8*(1), 21–34.

Loewenthal, D. (2013b). Talking pictures therapy: The therapeutic use of photographs in counselling and psychotherapy. In D. Loewenthal (Ed.), *Phototherapy and therapeutic photography in a digital age* (pp. 82–94). Routledge.

Mizock, L., Russinova, Z., & Shani, R. (2014). New roads paved on losses: Photovoice perspectives about recovery from mental illness. *Qualitative Health Research, 24*(11), 1481–1491. https://doi.org/10.1177/1049732314548686

Pillay, Y. (2009). The use of digital narratives to enhance counseling and psychotherapy. *Journal of Creativity in Mental Health, 4*(1), 32–41. doi:10.1080/15401380802705375

Riley, R. G., & Manias, E. (2004). The uses of photography in clinical nursing practice and research: A literature review. *Journal of Advanced Nursing, 48*(4), 397–405.

Saita, E., Accordini, M., & Loewenthal, D. (2019). Constructing positive narrative identities in a forensic setting: A single case evaluation of phototherapy. *International Journal of Prisoner Health, 15*(1), 76–90.

Star, K. L., & Cox, J. A. (2008). The use of phototherapy in couples and family counseling. *Journal of Creativity in Mental Health, 3*(4), 373–382. doi:10.1080/15401380802527472

Stevens, R., & Spears, E. H. (2009). Incorporating photography as a therapeutic tool in counseling. *Journal of Creativity in Mental Health, 4*(1), 3–16.

Stewart, D. (1983). *Phototherapy: Looking into the history of photography.* Charles C Thomas.

Walker, J. (1982). The photograph as a catalyst in psychotherapy. *Canadian Journal of Psychiatry, 27*, 450–454.

Warren, C. M., Knight, R., Holl, J. L., & Gupta, R. S. (2014). Using videovoice methods to enhance community outreach and engagement for the National Children's Study. *Health Promotion Practice, 15*(3), 383–394. https://doi.org/10.1177/1524839913503470

Weiser, J. (1999). *Phototherapy techniques: Exploring the secrets of personal snapshots and family albums* (2nd ed.). PhotoTherapy Centre Press.

Weiser, J. (2001). Photography techniques: Using clients' personal snapshots and family photos as counseling and therapy tools. Retrieved January 22, 2020, from https://www.academia.edu/3173908/PhotoTherapy_Using_Clients_Personal_Snapshots_and_Family_Photos_as_Counseling_and_Therapy_Tools

Weiser, J. (2014). Establishing the framework for using photos in art therapy (and other therapies) practices. *Arteterapia, 9*, 159–190.

Wolf, R. I. (1976). The Polaroid technique: Spontaneous dialogues from the unconscious. *Art Psychotherapy, 3*, 197–201.

4

Digital Storytelling

Anissa T. Rogers, Rebecca Gaudino, and Barbara Braband

Overview, Key Concepts, History

What Is Digital Storytelling?

Digital storytelling is a method of using computer- and technology-based tools to tell stories. These tools allow the storyteller to communicate stories or narratives in rich, interactive ways that engage the listener through the use of different multimedia methods. Like any type of storytelling, digital stories generally focus on a specific theme or topic from the storyteller's viewpoint. However, digital storytelling differs from typical storytelling in that it employs a variety of technological and multimedia tools, such as computer-based text, audio, video, music, animation, and images, to help tell the story (Balaman, 2018). Like other forms of storytelling, digital storytelling can focus on anything from recounting personal stories to constructing narratives about communities, societies, and systems. There are no limits to the stories that can be told using this method. Depending on the specific technological methods being used, digital stories can be as short or long, simple or complex as the storyteller desires. Furthermore, digital storytelling can be used for a variety of purposes, including journalism, personal growth, advocacy, research projects, historical documentation, classroom learning, and efforts toward community and societal change.

A wealth of other terms are used to describe the method and practice of digital storytelling, such as digital documentaries, computer-based narratives, digital essays, electronic memoirs, and interactive storytelling. However, in general, they all involve the idea of combining the art of telling stories using a variety of multimedia, including graphics, audio, video, and Web publishing.

Photography in Social Work and Social Change. Matthias J. Naleppa, Kristina M. Hash, and Anissa T. Rogers, Oxford University Press. © Oxford University Press 2022. DOI: 10.1093/oso/9780197518014.003.0004

History of Digital Storytelling

Storytelling, as a method of communication that conveys human experience, has existed since the beginning of humankind. However, the forms, methods, and functions of storytelling have evolved over time, as our knowledge and resources have evolved. The origins of digital storytelling can be traced back to the 1970s and 1980s when artists and educators in the United States began to reconceptualize the way art could be generated and expressed and the potential identity of the artist. Traditionally, art was only created and consumed by the elite and privileged. This rethinking of what art is and who creates it sparked a movement to make art and its expression accessible to everyone and to utilize it as a form of healing and empowerment (Yilmaz & Cigerci, 2018).

The term digital storytelling was used in the 1980s by Dana Atchley to describe the use of multimedia tools in storytelling processes. A pivotal moment in the growth of digital storytelling occurred in 1993 when a workshop on the method was offered by Atchley. Then in 1998, the Center for Digital Storytelling (CDS) was established in Berkeley, California, and it became the StoryCenter in 2015 (Yilmaz & Cigerci, 2018). Other pioneer digital storytellers include Nina Mullen, Ken Burns, Daniel Meadows, and Joe Lambert, co-founder of the CDS. These individuals told stories through film, documentaries, and photography and introduced the method through workshops and other educational venues in Europe. Since then, digital storytelling has spread worldwide and can be found in every kind of setting, including festivals, workshops, classrooms, businesses, libraries, and community centers (Storycenter.org, 2019).

Goals of Digital Storytelling

The main goals of digital storytelling are to help storytellers fully realize their stories through finding and clarifying their narratives, exploring their feelings about their narratives, identifying the change moment in their stories, and helping them imagine how their stories will be seen and heard by others (Lambert, 2010). These broad goals lend themselves to the many

purposes of digital storytelling, particularly those related to personal growth, advocacy, and societal change.

The process of developing a digital story helps storytellers fully reflect on, visualize and develop their stories in a way that allows deep insight to emerge through self-exploration of beliefs, feelings, thoughts, and experiences. Through this process, storytellers find, cultivate, and give voice to unique experiences that can be shared with others and that can create both personal and societal change (Lambert, 2010).

Theoretical Foundations of Digital Storytelling

Digital storytelling is rooted in constructionism (Papert, 1993) and narrative theories (Fisher, 1985, 1989). Constructionism posits that learning and meaning-making of experiences occur through our personal reconstruction of knowledge as we interact with the world. To learn or grow, we must be engaged in constructing our identities by making "artifacts" or products that can be shared with others. This learning by making is different from constructivism, which involves learning by doing. Thus, learning, growth, and change are more effective if we can construct personally meaningful products on which we can reflect and that we can share (Papert, 1993). Digital storytelling is one method of learning by making. Through the use of multimedia tools to tell stories, we construct a product through a process of self-reflection and sharing with others.

Narrative theory views all human communication as stories. We constantly interpret the world around us in the context of time, culture, and history and create and use symbols in our communication about our experiences. Narrative theory suggests that we use symbolic actions made of words and deeds that have meaning for us in our everyday lives (Fisher, 1985). From a narrative perspective, stories are believable, entertaining, and rememberable, and they become even more so when accompanied and enhanced by visual and auditory aids such as images, music, or voices filled with emotion and expression (Cortazzi & Jin, 2007). Thus, digital storytelling is made more powerful and effective with regard to learning, growth, and change than storytelling alone because it is amplified with multimedia tools.

Advantages and Challenges of Digital Storytelling

Digital storytelling is a versatile and relatively easy method to use for a variety of purposes. Although there are some challenges to using digital storytelling, many can be overcome with a little effort.

Advantages

For digital storytellers, particularly those who are young adults and older, learning and acquiring the skills necessary to work with the method are generally easy and straightforward. Digital storytelling is made even easier if the storyteller has access to a manual or an experienced person to guide the process. Furthermore, the processes used in digital storytelling are flexible and can be adapted for the purpose and storytellers' ability level, and storytellers can work on digital stories virtually anywhere (Wang & Zhan, 2010).

Many storytellers find the digital storytelling process to be particularly enjoyable, engaging, and conducive to learning and growing. For some, digital storytelling allows for the type of self-expression that may be difficult in other ways, such as when storytellers have language or other barriers that make communication difficult (Kasami, 2018). Furthermore, the process allows for time to be spent on reflection, editing, sharing, and personal expression, which many storytellers enjoy and find useful, both personally and in terms of connecting with others (Mellon, 1999). Storytellers may enjoy the level of self-direction and self-authorship the method allows, as well as the variety of methods that can be employed in the process (Rossiter & Garcia, 2010). Moreover, the range of technological tools available for use in digital storytelling is always increasing, making it relatively easy to find the right tools to use in the process (British Council, 2019).

Digital storytelling may be interesting to those who have different learning styles, and those who have technological skills may be motivated by the digital storytelling process. Digital storytelling also is conducive to developing communication and multimedia skills, and finished products can be easily published online (British Council, 2019).

Challenges

One possible challenge to using digital storytelling is that it often requires a set of creative and technical skills that younger storytellers may not have developed yet, even though younger storytellers are often more "tech savvy" than older storytellers. Similarly, these skills could prove to be challenging to some older storytellers as well. It may be that some storytellers have difficulty understanding the point of digital storytelling; do not like the creative, more aesthetic nature of digital storytelling, such as when people are uncomfortable writing, listening to the sound of their voices, or do not feel particularly artistically inclined; or do not have the interest or skill level needed to successfully engage in the digital storytelling process (Wang & Zhan, 2010).

An additional challenge involves technical problems that can occur during the digital storytelling process. For example, audio or video files may get deleted; material may be too large to upload to a computer; the downloading process may be slow; images may be fuzzy or difficult to edit; software may be difficult or time-consuming to learn and use; editing material can be time-consuming and difficult; glitches may occur when attempting to present the final product; or some software, equipment, or internet access may be cost prohibitive or difficult to access (Hamilton et al., 2019; Wang & Zhan, 2010).

Ethical challenges may also occur. Some material that storytellers want to use, such as images, music, or digital characters, could be copyrighted and require permission or a fee for use. Plagiarism could also be an issue if storytellers include text or other content that needs to be either cited or summarized in their digital stories. Thus, storytellers using digital methods need to be careful that they are not engaging in unethical practices.

Best Practices: Application of Digital Storytelling in Various Fields of Practice

As discussed previously, digital storytelling can be used for almost any purpose. Here, we explore applications of digital storytelling for education, practice, and research and provide a summary of some of the multimedia tools that are available for use in any setting and for any purpose.

Applications in Education

In educational settings, the use of digital storytelling is growing dramatically. Elementary school classes, college-level courses, and continuing education programs have been incorporating digital storytelling into the curriculum and utilizing it as a pedagogical method for engaged learning. Although storytelling as an educational tool is not a new concept, multimedia technologies have allowed for innovative new ways to tell stories that support learning.

Digital storytelling advances learning by engaging students in the learning process, requiring students to self-reflect in the digital story process, helping students master technological skills, and providing opportunities for project-based and peer-to-peer learning. Digital storytelling can also be grounded in learning theories and linked to learning objectives and can then be evaluated for its effectiveness in accomplishing learning goals (Wang & Zhan, 2010).

Digital storytelling can be used in the classroom in a variety of ways and for a variety of learning goals. Examples of ways that digital storytelling has been used in educational settings include to help students build portfolios, to build math and computer skills through the use of problem-solving, to improve language and literacy skills, to increase creative and critical thinking skills, to build learning communities, and to build public speaking skills (Papadimitriou, 2003; Skinner & Hagood, 2008).

Applications in Practice

Digital storytelling can be used as a practice modality not only in social work but also in any type of clinical or macro-type practice in other disciplines, such as nursing, psychology, or community-based practice. The digital storytelling process can be used as a therapeutic tool or as a tool for community building, advocacy, or change efforts.

Nurses have used digital storytelling to assess patient pain and ascertain effective intervention modalities (Cercato, 2018). Digital storytelling has been used to highlight social struggle and increase civic participation in many countries facing political, economic, and other strife (Papa, 2017). Others have used digital storytelling in practice with migrant groups, empowering their voices as they work through the trauma of their experiences (Vacchelli & Peyrefitte, 2018). And digital storytelling can be used in individual, group,

family, and community practices and settings, in which it is employed as an intervention to help clients of all ages and with all presenting problems explore issues, gain insights, problem-solve, and set goals for their growth and healing. For example, digital storytelling is used to work with children and adolescents who have behavioral struggles (Sawyer & Willis, 2011) or are diagnosed with various health or mental health issues and trauma (De Vecchi et al., 2016), as well as with families who are developing parenting and problem-solving skills (Rolbiecki et al., 2017).

Applications in Research

Many of the examples discussed previously that highlighted the use of digital storytelling for education and practice can also be used to exemplify the use of digital storytelling for research. Often, digital storytelling is employed in learning or as a therapeutic technique, and then the digital products are analyzed in a larger research project to determine the effectiveness of the digital storytelling project in promoting learning or change. For example, Vacchelli and Peyrefitte (2018) used digital storytelling with a group of migrant women to better understand the lives of the women as well as the experiences of the volunteers who worked with them. In doing so, the digital stories not only empowered the women who produced them but also empowered the researchers, who gained insights, through analyzing the stories, into how the digital stories could effect change.

Digital storytelling also may be used in participatory action or community-based research, where participants in the research develop digital stories as a means to change or improve something in their communities, become empowered in their own experiences, or fight for social justice. The effectiveness of the stories to motivate people to create change is then analyzed (Fotopoulou & Couldry, 2015; LeBlanc, 2017). The case study described later in the chapter offers an example of how digital storytelling can be used for student learning and as a means to evaluate the effectiveness of the stories in their learning.

Useful Tools in Digital Storytelling

The sampling of tools in Table 4.1 can be used for a variety of purposes in digital storytelling. Many of these can be adapted for different settings and skill levels of storytellers.

Table 4.1 Tools Used in Digital Storytelling

Tool	Description
Bookr	Tool to create online books using Flikr photos
Bubblr	Tool to create comic strips from photos in Flickr; can be used to retell stories by adding pictures
Dandelife	Tool to record timelines and improve writing skills; allows for diary keeping and retelling stories
Dfilm	A site where cartoons and dialogues can be created
Voicethread	Collaborative tool for speaking and listening activities. It can be used for brainstorming; giving presentations; asking and answering questions; and publishing writing, images, audio, and video
Zimmertwins	A site where videos can be made; allows for the addition of cartoons
Other presentations tools	bubbleshare, comeeko, flektor, imageloop, photoshow, onetruemedia, slide, sliderocket, padlet

A Step-by-Step Process of Digital Storytelling

Given its flexibility and versatility, digital storytelling lends itself to a variety of approaches in its application. However, Joe Lambert (2010) lays out seven distinct steps in the digital storytelling process that can be a useful guide for those wanting to utilize it in education, practice, or research. A summary of those steps follows, but a look at this cookbook offers the reader a fuller description of the steps and process:

Step 1: Owning your insights: Storytellers begin by clarifying what their stories are about. Questions such as "What's the story you want to tell?" and "What does your story mean?" are helpful to clarify storytellers' intentions.

Step 2: Owning your emotions: Storytellers become aware of the emotional resonance of their stories. Questions such as "As you shared your story, what emotions did you experience?" and "Can you identify where in the story you felt certain emotions?" help storytellers explore affective responses.

Step 3: Finding the moment: Storytellers identify a single moment that illustrates their insight into their experience. Questions such as "What was the moment when things changed?" and "Is there more than one

possible moment to choose from?" can help storytellers identify these moments.

Steps 4 and 5: Seeing and hearing your story: Storytellers find visuals and sounds to bring their stories to life. Questions such as "What images come to mind for this story?" and "Would the use of sound or music highlight the turning point in your story?" are helpful at these steps.

Step 6: Assembling your story: Storytellers assemble their stories by developing scripts and storyboards for the story. Questions such as "How are you structuring your story?" and "Within the structure, how are the layers of visual and audio narratives working together?" help storytellers develop the structure for their stories.

Step 7: Sharing your story: Storytellers revisit the context in which their stories were first described to decide which parts are important to share. Important questions to accomplish this task include "Who is your audience?" and "What was your purpose in creating the story?"

Case Example: Suffering and Death Interview Project

This case example describes a project using digital storytelling for teaching and pedagogical purposes. While implementing the project, the instructors also evaluated the effectiveness of the use of digital storytelling on student learning. Thus, this is an example of how digital storytelling can be used in teaching and research.

Description and Background of the Project

In learning how to be caregivers, undergraduate students from many disciplines, such as nursing, social work, and theology, often face challenges when they encounter persons who are suffering and grieving. Students may lack experience with and exposure to these situations in their personal lives, or they may have lacked support for their own suffering and healing. Wrestling with limited self-awareness and negative emotions that create barriers to making deep and meaningful connections with clients, students limit their engagement and meaningful presence with these clients. When faculty guidance is limited or absent, students' ability to navigate caring encounters can be hindered by overwhelming fear and intimidation (Eifred, 2003; Pessagno et al., 2014; Rudolfsson & Berggren, 2012). The overriding educational hurdle rests in helping and supporting

students acknowledge and understand the profound and complex issues surrounding personal and professional suffering and loss. Overcoming this hurdle creates significant demands on faculty in professional disciplines to create experiences that nurture deep, reflective learning through teaching strategies such as digital storytelling that foster the integration of emotions, critical thinking, reflection, and dialogue (Freire, 2005; Gallagher & Stevens, 2015; Garner, 2014).

A collaborative partnership between social work, nursing, and theology was established in 2012 to implement and evaluate an in-depth interview project in an interdisciplinary course, Theological Dimensions of Suffering and Death, to help students more deeply engage with those who suffer and grieve outside the clinical setting (Braband et al., 2015). Students interviewed and developed a relationship with an individual they knew personally who was enduring, or who had recently endured, a life-impacting issue of suffering or loss. Based on the initial project implementation and evaluation, a Pedagogy of Suffering model emerged in 2015 to guide the pedagogical process and promote deeper student engagement (Gaudino et al., 2017). In 2017, an additional project innovation, based on digital storytelling through the use of photovoice, was embedded in this interview project to further enhance the personal and professional critical reflection process. This digital storytelling innovation was initially implemented and evaluated through a pilot project in a social work course, Living with Grief, Dying, and Death (Rogers et al., 2019). It was later implemented in the Suffering and Death course in 2018, with a comprehensive follow-up evaluation of student learning outcomes related to this innovation in both courses.

Overview of the Digital Storytelling Process and Aims
The aims of this interview project were to help students to assess and process the meaning of and response to suffering for themselves and their clients, to build communication skills to promote deeper and more reflective questions, and to examine sources of hope for those who suffer and grieve (Braband et al., 2015). In a series of two or three interviews with persons whom students knew outside the clinical setting, students applied semistructured, open-ended questions to explore interviewees' stories of suffering based on the interviewees' holistic experiences of mind, body, and spirit. In addition to the interview, students were asked to take a series of photos that reflected their own feelings and reactions before the interview process began and then after each interview experience in response to the following

primary question: "What images capture your feelings and thoughts about interviewing someone who has experienced or is experiencing suffering or grief and loss?" Students also responded to a series of post-interview structured reflection questions in addition to the photo reflections. Formative peer debriefing sessions in small groups were scheduled several times during the semester when each student shared their photos accompanied by short oral descriptions of their lived responses to their interviewee's stories of suffering or grief. Finally, a summative peer-debriefing session was held in small groups at the end of the semester when each student offered a structured 5-minute oral summary presentation based on their personal critical reflection in response to their interviewee's story of suffering or loss. Students shared the photos they had taken before and after each of the interviews, using these photos to reflect on their own responses and learnings.

Results

Both the initial project implementation and its more recent adaptation with digital storytelling have led to promising and positive student outcomes. The interview project and its photovoice component, based on direct encounters with persons who suffer or grieve, have offered students tools that enhance and deepen their critical reflection, both personal and professional. The combined interview and photovoice project offers students a holistic process, supported by contemporary education neuroscience as well as learning theory, for critical thinking, learning, and change (Costa & Costa, 2016; Kirsch et al., 2015). Findings based on the evaluation of the initial pilot implementation of photovoice, within the interview project in the social work class in 2017, indicated three primary trajectories related to students' growth in self-awareness and care for persons who grieve. These trajectories of enlightened self-awareness and confidence represented through photos and digital storytelling included (1) movement from feelings of uncertainty and discomfort to feelings of preparedness and confidence, (2) movement from feelings of aloneness and separateness to feelings of human connection, and (3) movement from intense pain and grief to feelings of hope and possibility (Rogers et al., 2019).

Further findings gained in a mixed-method quasi-experimental evaluation of the 2018–2019 implementation of photovoice in the theology and nursing course also affirmed the rich value of the digital storytelling teaching strategy embedded in the interview project. Qualitative results portrayed how the storytelling promoted both formative and summative

meta-reflection through creative, critical, and abstract thinking. Metaphors, clearly represented by photos in digital storytelling, allowed students to convey their thoughts and feelings in a visual format and, thus, revealed deeper understanding, insights, and meanings related to the vulnerability of suffering. Students shared comments related to the positive impact of photovoice, including the following: "[It] helped me vocalize (in photos) how I was feeling on the inside," "[It] helped me deal with my own pain," "[It] forced me to really consider how the suffering and vulnerability made me feel," "[It] encouraged deep thinking," and "[I] saw how the photos changed over time." In both evaluations of digital storytelling, there was a small minority of students (approximately 16%) who did not view this methodology as supportive of their learning. However, the vast majority of students concluded that the project with the digital storytelling format had a significant positive value on their learning related to palliative care. Supportive student summaries concluded the following: "[The project] was one of the most meaningful assignments of my career," "It was intense," and it was "unlike any assignment I've ever done." Altogether, this digital storytelling project invited students to encounter someone who was suffering and to practice deep reflection that broadened their understanding of their own suffering as well as the suffering of others.

Example: Photos from the Digital Storytelling Project

The photos in this section were taken by students who completed the interview project described in the case example. These photos represented students' feelings and experiences throughout the project as well as their perceived growth throughout the semester. Narratives accompanying the photos described feelings of fear, anxiety, isolation, and pain, along with feelings of growth, connection, hope, and connection.

Conclusion

Digital storytelling is a method of using computer- and technology-based tools to tell stories. Grounded in constructionism and narrative theories, digital storytelling can have a variety of goals that include helping storytellers realize their stories through finding and clarifying their narratives, exploring their feelings about their narratives, identifying the change moment in their stories, and helping them imagine how their stories will be seen and heard by others.

Advantages of digital storytelling include that it can be an enjoyable modality for storytellers, engaging them in the process and offering diverse learners different modalities for reflection, self-expression, and connection with others. Digital storytelling can be relatively easy to learn, and the multimedia tools available to use for storytelling are plentiful and accessible. Disadvantages of digital storytelling could include cost or other accessibility issues of software and equipment, and some storytellers may find their technological skill level challenged when using some of the tools. Some storytellers may not enjoy the creative, artistic style of storytelling, whereas others may encounter technological issues such as deleted files, slow internet connections, or time-consuming editing or uploading processes. Storytellers also must be aware of ethical issues that may occur in the storytelling process, such as plagiarism or copyright issues.

The versatility of digital storytelling means that it can be used in a variety of settings for a variety of purposes and with a variety of tools. Although the storytelling process itself can be done in many ways, a seven-step process designed by Lambert (2010) offers guidance on how to proceed with the digital storytelling process.

Glossary

Digital storytelling: A method of using computer- and technology-based tools to tell stories.

Additional Resources

Association for Progressive Communications: https://www.apc.org/en/project/digital-storytelling

Creative Educator: https://creativeeducator.tech4learning.com/digital-storytelling

Makerspace for Education: http://www.makerspaceforeducation.com/digital-storytelling.html

Storycenter: https://www.storycenter.org

Tech4Learning: https://www.tech4learning.com/digital-storytelling

TechSoup: https://www.techsoup.org/support/articles-and-how-tos/digital-storytelling-toolkit

University of Houston, College of Education: http://digitalstorytelling.coe.uh.edu

University of Wollongong, Australia: https://uow.libguides.com/digitalstorytelling

https://creativeeducator.tech4learning.com/v04/articles/The_Art_of_Digital_Storytelling

https://missouri.campuslabs.com/engage/organization/digital-storytelling-club

References

Balaman, S. (2018). Digital storytelling: A multimodal narrative writing genre. *Journal of Language and Linguistic Studies, 14*(3), 202–212.

Braband, B. J., Gaudino, R., & Rogers, A. (2015). Exploring students' perceptions and understanding of life-altering suffering: An interview project. *International Journal for Human Caring, 19*(1), 49–56.

British Council. (2019). *Digital storytelling.* Retrieved June 29, 2019, from https://www.teachingenglish.org.uk/blogs/editorrachael/digital-storytelling

Cercato, M. C. (2018). Narrative medicine in the oncological clinical practice: The path from a story-telling intervention to a narrative digital diary. *Recenti Progressi in Medicina, 109*(6), 324–327.

Cortazzi, M., & Jin, L. (2007). Narrative learning, EAL and metacognitive development. *Early Child Development and Care, 177,* 645–660. doi:10.1080/03004433070137 9074

Costa, M. J., & Costa, P. (2016). Nurturing empathy and compassion: What might the neurosciences have to offer? *Medical Education, 50,* 271–281.

De Vecchi, N., Kenny, N., Dickson-Swift, V., & Kidd, S. (2016). How digital storytelling is used in mental health: A scoping review. *International Journal of Mental Health Nursing, 25*(3), 183–193.

Eifred, S. (2003). Bearing witness to suffering: The lived experience of nursing students. *Journal of Nursing Education, 42*(2), 59–67.

Fisher, W. (1985). The narrative paradigm: An elaboration. *Communication Monographs, 52,* 347–367. doi:10.1080/03637758509376117

Fisher, W. (1989). Clarifying the narrative paradigm. *Communication Monographs, 56,* 55–58. doi:10.1080/03637758909390249

Fotopoulou, A., & Couldry, N. (2015). Telling the story of the stories: Online content curation and digital engagement. *Information, Communication & Society, 18*(2), 235–249.

Freire, P. (2005). *Education for critical consciousness.* Bloomsbury.

Gallagher, M. R., & Stevens, C. A. (2015). Adapting and integrating photovoice in a baccalaureate community course to enhance clinical experiential learning. *Journal of Nursing Education, 54*(11), 659–663.

Garner, S. L. (2014). Photovoice as a teaching and learning strategy for undergraduate nursing students. *Nurse Education Today, 34,* 1272–1274. doi:10.1016/j.nedt.2014.03.019

Gaudino, R., Braband, B., & Rogers, A. (2017). Entering into suffering: Becoming a transformed and transforming healer. *Journal of Christian Nursing, 34*(1), 2–9.

Hamilton, A., Rubin, D., Tarrant, M., & Gleason, M. (2019). Digital storytelling as a tool for fostering reflection. *Frontiers, 31*(1), 59–73.

Kasami, N. (2018). Advantages and disadvantages of digital storytelling assignments in EFL education in terms of learning motivation. In P. Taalas, J. Jalkanen, L. Bradley & S. Thouësny (Eds), *Future-proof CALL: language learning as exploration and encounters – short papers from EUROCALL 2018* (pp. 130–136). Research-publishing.net. https://doi.org/10.14705/rpnet.2018.26.825

Kirsch, L. P., Urgesi, C., & Cross, E. S. (2015). Shaping and reshaping the aesthetic brain: Emerging perspectives on the neurobiology of embodied aesthetics. *Neuroscience and Biobehavioral Reviews, 62,* 56–68.

Lambert, J. (2010). *Digital storytelling cookbook.* Center for Digital Storytelling.

LeBlanc, R. G. (2017). Digital storytelling in social justice nursing education. *Public Health Nursing, 34*(4), 395–400.

Mellon, C. (1999). Digital storytelling: Effective learning through the internet. *Educational Technology, 39*(2), 46–50.

Papa, V. (2017). To activists: Please post and share your story: Renewing understandings on civic participation and the role of Facebook in the Indignados movement. *European Journal of Communication, 32*(6), 583–597.

Papadimitriou, C. (2003). MythematiCS: In praise of storytelling in the teaching of CS and math. *ACM SIGCSE Bulletin, 35*(4), 7–9.

Papert, S. (1993). *The children's machine: Rethinking school in the age of the computer.* Basic Books.

Pessagno, R., Foote, C. E., & Aponte, R. (2014). Dealing with death: Medical students' experiences with patient loss. *Omega, 68*(3), 207–228.

Rogers, A. T., Braband, B., & Gaudino, R. (2019). Implementing the pedagogy of suffering: A photovoice innovation in students' exploration of grief and loss. *Journal of Social Work Education, 55*(4), 684–694. doi:10.1080/10437797.2019.1633974

Rolbiecki, A. J., Washington, K., & Bitsicas, K. (2017). Digital storytelling: Families' search for meaning after child death. *Journal of Social Work in End-of-Life & Palliative Care, 13*(4), 239–250.

Rossiter, M., & Garcia, P. A. (2010). Digital storytelling: A new player on the narrative field. *New Directions for Adult and Continuing Education, 126,* 37–48.

Rudolfsson, G., & Berggren, I. (2012). Nursing students' perspectives on the patient and impact of the nursing culture: A metasynthesis. *Journal of Nursing Management, 20,* 771–781.

Sawyer, C. B., & Willis, J. M. (2011). Introducing digital storytelling to influence the behavior of children and adolescents. *Journal of Creativity in Mental Health, 6,* 274–283.

Skinner, E., & Hagood, M. (2008). Developing literate identities with English language learners through digital storytelling. *The Reading Matrix, 8*(2), 12–38.

Storycenter.org. (2019). *Our story*. Retrieved June 25, 2019, from https://www.storycenter.org/press

Vacchelli, E., & Peyrefitte, M. (2018). Telling digital stories as feminist research and practice: A 2-day workshop with migrant women in London. *Methodological Innovations, 11*(1), 1–11.

Wang, S., & Zhan, H. (2010). Enhancing teaching and learning with digital storytelling. *International Journal of Information and Communication Technology Education, 6*(2), 76–87.

Yilmaz, R., & Cigerci, F. (2018). A brief history of storytelling. In R. Yilmaz, M. N. Erdem, & F. Resulolu (Eds.), *Handbook of research on transmedia storytelling and narrative strategies* (pp. 1–13). IGI-Global.

5

Photovoice

Overview, Key Concepts, and History

What Is Photovoice?

Photovoice is a community-based method that uses the medium of pho-
tography to identify needs and assets of an environment, with the goal of
creating positive changes. Other names for this method include participa-
tory photography and photo novella. Being a comparatively straightforward
and easy to implement method for engaging community members in the
change process, photovoice is an effective tool for community-based practice
and research. This explains why there has been an increasing utilization of
photovoice during the past two decades in a number of disciplines, including
social work, nursing, nutrition, gerontology, and other health-related fields
(Wang & Burris, 1997).

Origins and History of Photovoice

Although similar ways of using photography for community change have
been used before, photovoice was first formally described by Caroline Wang
and Mary Ann Burris in 1997. They state that photovoice provides

> an effective and vivid way for people to show firsthand their perceived
> strengths and needs, to promote critical dialogue and knowledge about
> their community's assets and concerns, and to reach policy makers through
> images and stories of everyday life to bring about change (p. 382)

Since the publication of their seminal article describing the methodology,
the application of photovoice seems to have grown exponentially. It has been
applied in a wide range of settings and with very different target audiences.
The international literature on community practice is full of examples of

Photography in Social Work and Social Change. Matthias J. Naleppa, Kristina M. Hash, and Anissa T. Rogers,
Oxford University Press. © Oxford University Press 2022. DOI: 10.1093/oso/9780197518014.003.0005

photovoice, pointing to an acceptance of the method more or less throughout the world. Two systematic reviews conducted by Hergenrather et al. in 2009 and by Catalani and Minkler in 2010 each include more than 30 peer-reviewed published photovoice articles from a wide variety of fields. Today, it seems that photovoice is not only well established as a practice and research method but also continuing to grow in its use.

Goals of Photovoice

As a flexible and adaptable method of practice, photovoice can be utilized to achieve a wide range of goals. The three main objectives are (1) to enable people to record and reflect on strengths and concerns regarding their community, (2) to promote a critical dialogue and develop knowledge about important community issues through the discussion of photographs, and (3) to reach policymakers or other key stakeholders in the community to start a change process (Wang & Burris, 1997).

Theoretical Foundations of Photovoice

Several theoretical foundations of photovoice can be identified. First is Paolo Freire's theory of *critical consciousness*. Freire, a Brazilian educator and activist, proposed that investigators and individuals affected by an issue should act as co-investigators in approaching that issue (Freire, 1968/1970). Photovoice builds on Freire's work by initiating a discourse about images, in this case photos, as a tool to build consciousness and empower individuals. Rather than working on someone's behalf, the method focuses on encouraging photovoice group members to engage in advocacy and change themselves, thereby giving them a voice and a place at the table.

At the core of Freire's theory are three levels of consciousness. At the magical level of consciousness, a person silently accepts the status quo. Individuals at this level stay passive and do not undertake efforts to change their social situation. By doing so, they contribute to their own oppression. At the naive level of consciousness, people view their social situation as unfair, but they focus on individual issues and blame others rather than addressing the underlying causes. At this level, Freire considers a person as only partially empowered. Finally, in critical consciousness, a person is

aware of how structures create and maintain oppression as well as what one's own assumptions, behaviors, and roles are. Once individuals attain this level of consciousness, they see their own responsibilities and are open to actively partake in changing their social situation (Freire, 1968/1970). Photovoice can be described as a process of raising critical consciousness (Carlson et al., 2006). It includes three main objectives: "to engage people in active listening and dialogue; to create a safe environment for introspection and critical reflection; and to move people toward action" (Carlson et al., 2006, p. 838).

Wang (1999) states that photovoice has its roots in feminist theory and feminist inquiry. She argues that the approach gives women a voice by focusing on research and action *by and with* the women. Photovoice tries to include and highlight their subjective experience. Thus, it fosters understanding of gender-related experiences and facilitates a discourse on these topics. As Wang describes it, women use the photovoice process to "express, reflect and communicate their everyday lives" (p. 186). They are treated as active participants, not just the object of study (Liebenberg, 2018). Photovoice helps to understand the relationship between gender and geographical space (McIntyre, 2003). As a research method, it falls under feminist participatory action research with its emphasis on "the lived experiences of women . . . the activist stance of the researcher, and . . . social change as an integral aspect of social science research" (McIntyre, 2003, p. 48). In their review of 37 photovoice projects published in the peer-reviewed literature, Catalani and Minkler (2010) found that 78% had primarily female participants.

Raising critical consciousness, participation in the research process, and being an active part of the change process all contribute to *empowerment* of individuals. This empowerment aspect of photovoice is supported by a study by Carlson et al. (2006). Their analysis of photovoice found that the method "was able to generate a social process of critical consciousness and active grassroots participation, thereby facilitating empowerment, by providing multiple opportunities for reflection, critical thinking, and then active engagement" (cited in Catalani &Minkler, 2010, p. 446). Pennie Foster-Fishman et al. (2005) found that the analysis and discourse in photovoice led to an expanded awareness of conditions in the participants' communities. They became more aware of others in their community and were better able to engage in a critical dialogue. Photovoice enhanced their relational networks and made them more aware of what could or should happen to create change.

Experiencing a different role and seeing things from a different perspective empowered them to be more committed to their own community.

Related to empowerment is the issue of social justice. We include this in the discussion of theoretical background because photovoice as a method fosters social justice beyond empowering the individuals in the project or the community. Powers and Freedman (2012) reviewed photovoice projects through a social justice lens. They concluded that the method addresses social justice in several domains. In the domain of *value and worth*, it addresses the concepts of solidarity by working with and on behalf of those affected. It is *inclusive* in that members from different backgrounds are brought together to work toward change. Furthermore, an *ethical treatment* of all people is integral to photovoice. In the domain of *distributive justice*, the method addresses rights to access, allocation, opportunities, and the welfare of all individuals. Through the collaborative process and the balancing medium of photography, it addresses *unequal power* and exchange dynamics. Finally, it includes an explicit *call to action* with the goal of social change and a sense of urgency (Powers & Freedman, 2012).

Photovoice builds on the theoretical concepts from *participatory action research* (PAR). PAR is a way of conducting research that is rooted in the work of Freire on critical conscious raising. We discuss its influence in more detail in the section on research applications. Finally, *constructivism* emphasizes that truth is not an absolute but, rather, centered in how we as individuals construct our world. By focusing on "developing and constructing meaning through experiences," photovoice empowers individuals to learn and engage in change from their own perspective (Hergenrather et al., 2009, p. 695). As a constructivist approach, it enables participants to move beyond the dominance of positivist-based practice and research. Project participants have knowledge about their real live and lived experiences. Photovoice enables them to share this knowledge and empowers them to become part of their own change process.

Advantages and Challenges of Photovoice

In this section, we discuss the advantages and challenges in using the method of photovoice. As a method that spans applications in practice, research, and education, we stay on the more general level but provide examples of some of the benefits and potential shortcomings for different areas of utilization.

Advantages

Wang (1999) summarizes some of the advantages of photovoice in five key concepts. The first concept is that images teach (p. 186). Photos can be interpreted and can contextualize and influence how we see something. Photos visually document an issue, making it easier for someone else to see and understand it. Thus, the image adds to the narrative by creating contextual understanding. The picture also elicits an emotional reaction in a way that a verbal presentation may not be able to achieve. Thereby, it can supplement both narrative and statistical data. A photo can promote empathy and understanding, and it can reveal assumptions, beliefs, and values held by the person who took it. Pictures help "shape our concepts of what is real and what is normal" (Spence as cited in Wang, 1999, p. 186). They humanize the experience depicted in the image and add depth to a discourse (Russell & Diaz, 2013).

Going beyond the fact that images teach, a photo helps empower and build capacity for change. A photo can depict needs and assets and can give voice to them in a way that a narrative on its own cannot. This holds especially true for marginalized and oppressed members of society who may have neither the experience nor the knowledge and skills to have a discourse with those in more powerful positions. In that way, the photo can stimulate a discussion and support their narrative. The fact that an image, even without any additional information, can present a viewpoint and elicit a reaction helps empowering individuals, groups, and their communities.

Wang's (1999) second concept is that pictures can influence policy. As discussed throughout the chapter, the role of the picture in photovoice is more than just illustrating *what is*. Rather, pictures are the starting point of creating meaning and initiating a process of change. At the heart of this are the members of the photovoice group. However, in order to effectively create change, key stakeholder, such as community leaders and policymakers, are an important part of the process. The images themselves do not create policy change, but they help convey how one sees the world, thus influencing stakeholders and the community (Wang, 1999).

The third concept is that "people ought to participate in creating and defining the images that shape helpful public policy" (Wang, 1999, p. 186). This call for a place of participants at the table brings us back to PAR and constructivism. Wang's fourth concept proposes that key stakeholders (policymakers and others with influence) should be included from the onset of a photovoice project. In her writing, she repeatedly highlights the importance and pay-off

of including key community leaders and policymakers from the very onset of photovoice projects (e.g., Wang, 1999, 2006; Wang & Burris, 1997).

Finally, Wang (1999) states that photovoice "emphasizes individual and community action" (p. 186). The focus is on participants' experiences and giving them a way to express their view. It does this in a way that bridges individual experiences and shared aspects of a community. Bringing together the individual and the community action and advocacy element is what sets photovoice apart from other methods.

Another advantage on the practical level is that photovoice requires relatively little training of group participants. A photovoice project may include as little as one initial session to provide an overview of the method and the objectives of the group. Another practical advantage is the low requirements for photography skills and picture quality. Most cell phones and digital cameras provide sufficient quality images; a picture needs to capture the feeling and experience of the photographer but does not need to conform to specific artistic standards. It does not need to have the quality of large print exhibition-style artwork. Finally, the prevalence of cell phones and inexpensive digital cameras, the low cost of printing, and low requirements for the space in which a group meets make the approach fairly inexpensive.

Challenges

One of the major challenges in photovoice is the insider–outsider perspective of participants and the facilitator or researcher. The latter are trying to empower the first to engage in a process that asks them to be open and, to some extent, vulnerable by sharing their experience. Their work in the photovoice group as an insider who stays in the community is different from that of the outsider who moves on after the conclusion of the project. Sharing one's experience with the community and taking action for change can be empowering, but they also expose group members to potential animosity by others in the community. Although this possibility cannot be completely eliminated, one should address it up front so group members are not blind-sided should it occur.

An important set of challenges can be found in the area of ethics and the image. A picture reveals something about a person, place, location, or age, both of the photographer and of those represented in the image. It may also trigger an unanticipated emotional response—for example, by another group member who has strong feelings or a negative experience around something

depicted in a photo. Wang and Redwood-Jones (2001) caution photovoice group members to be mindful of issues regarding the intrusion into one's private space, the disclosure of embarrassing facts, and placing someone in a false light through an image. Intrusion, confidentiality, and possible emotional reaction should be discussed up front at the onset of photovoice groups. They also should be included in an informed consent process of participation (Chapman et al., 2017). The topic of ethics and photography is further discussed in Chapter 2.

Another challenging issue can be the lack of commitment to action—that is, not going all the way. Photovoice can be used to assess a problem, to analyze it for research or other purposes, but stop short of a commitment to the change process. These projects may have a narrow focus on research for research purposes only, thus not taking full advantage of the participatory action element of photovoice. Gubrium and Harper (2013) caution that "the 'user-friendliness' of photovoice can lead to its misuse as a 'quick-and-easy' replacement for long-term ethnographic engagement" (p. 73).

A set of challenges in photovoice relates to the level and length of involvement with participants and the community. Catalani and Minkler (2010) conducted a systematic review of photovoice projects. They found that *low-participation* photovoice tended to be more research focused, typically leading to descriptive research findings and publications. This type of project usually lasts no more than 3 months and often leads to some form of photo exhibit and a publication as final outcome. Approximately one-third of the projects they reviewed followed this approach and did not engage in action for change, despite its centrality to the photovoice method. Projects with *high participation* levels and longer duration of engagement tended to lead to a deeper involvement with the community and stronger partnerships. Catalani and Minkler found that "sharing power . . . meant not just sharing the tasks of implementation and ownership but also developing a shared basis of knowledge and expertise" (p. 44).

Best Practices: Application of Photovoice in Various Fields of Practice

In this section, applications of photovoice in social work education, practice, and research are discussed.

Applications in Education

Photovoice lends itself well to applications in education. The literature provides educational examples as divergent as high school, college, and professional education settings. An example of using photovoice in a school setting is a project that studied the students' perspectives on the food environment in schools (Spencer et al., 2019). A student-centered approach to help teachers understand the link between home and school environment was the focus of a project by McKernan et al. (2020). In another effort of teacher education, Nur Arifah Drajati et al. (2019) looked at promoting teacher's self-reflection on multimodal literacy. Trepal et al. (2020) studied body image resilience among college women. Johnson (2020) used photovoice for service learning among graduate college athletes. Finally, an example from the field of social work is the use of photovoice as a tool to engage social work students in a discussion of social justice (Peabody, 2013).

One of the authors of this book regularly uses photovoice with undergraduate social work college students. Although these courses use an abbreviated version of photovoice (4 or 5 weeks and a focus on the images and the first steps of the process), it is an excellent tool for learning the use of images and for assessment and practice.

An especially large number of photovoice projects have been performed in the area of health education and public health. A study involving Asian Americans and Pacific Islanders focused on assessing and promoting environmental approaches to tobacco control (Tanjasiri et al., 2011). Schwartz and colleagues (2007) used photovoice in a project that centered on family planning for Hispanic immigrants. Other projects have studied health needs of college students (Goodhart et al., 2006), transsexuals' access to health care (Hussey, 2006), and sexual health among African American men (Mamary et al., 2007). Health promotion among a sample of Australian youth was the topic of a study by Dixon and Hadjialexiou (2005). Several projects focused on prevention and treatment of HIV/AIDS (Mitchell et al., 2005; Rhodes et al., 2008).

Applications in Practice

Photovoice has been used in various fields of practice, including public health, health, nutrition, social work, and community practice. With well

over 50 different projects presented in the research literature, we only provide some examples here. A significant number of projects focused on improving and rebuilding communities. Castleden and Garvin (2008), for example, implemented a project that studied health and environment in the Huu-ay-aht First Nation. Wilson et al. (2007) examined community needs and strengths, and they developed a detailed plan for community action as outcome. Other projects include the work on the significance of neighborhood and community in individuals' lives (Nowell et al., 2006) and on the relationship between members of different racial and gay and lesbian individuals in the community (Graziano, 2004). One of the most comprehensive community projects, Flint Photovoice, was carried out with the goal of youth documenting their work and health realities (Wang & Redwood-Jones, 2001; Wang et al., 2004).

Aging is another field in which many photovoice projects have been performed. With few adaptations, it lends itself well to practice and research with this population. As Elaine Wiersma (2011) suggests, using photovoice with persons with Alzheimer's disease can address the reservations some have regarding research *with* versus research *on* such individuals. It enables them to become more equal partners in the research endeavor and gives them an opportunity for self-preservation. At the same time, navigating ethical issues and institutional review boards can be cumbersome when including Alzheimer's disease patients in research. Terry Lewinson et al. (2012) used photovoice with older adults living in assisted living to co-construct their home environment. Others have undertaken projects to assess older adults' perceptions of age-friendly communities in Canada (Novek & Menec, 2014), to explore their experience of leisure and dementia (Genoe & Dupuis, 2013), and to increase cardiovascular health awareness in Asian elders (Fitzpatrick et al., 2012). Neill and colleagues (2011) studied facilitators and barriers to food acquisition and preparation by rural older women. Also focusing on the environment, Gallagher and colleagues (2010) attempted to improve health behaviors by addressing neighborhood factors relevant for walking in older, urban, African American adults.

Applications in Research

In research, photovoice can be classified into PAR and the paradigm of constructivism. PAR methods include four elements: "participation, action,

research, and social change for social action" (Liebenberg, 2018, p. 2). In photovoice, participants are treated as co-researchers and facilitators of change. Being the ones collecting the data (photographs) and conducting the data analysis (discussion of photos and their meaning) gives participants an active role in the research process that few other approaches allow them to have. By reducing the "power dichotomy" between researcher and those being researched (Ponterotto, 2005), photovoice aims at equalizing power by "sharing control of the process" (Sitter, 2017, p. 38). Because photovoice as a research method often involves and is initiated by outside researchers, the way they engage and the length of engagement are important. If the goal is PAR *with and by* those affected as a process of co-learning and collective action (Cornwall, 1996), then members of the group need to be involved in determining the issues and setting the agenda (Sitter, 2017, p. 42).

Sitter (2017) suggests that several questions need to be addressed in order to empower participants and foster social change through photovoice as a research method:

1) What is the purpose of introducing photovoice into the research process? 2) How is this method informed by PAR? 3) What is my own positionality and social location in this research, and how will it inform my engagement? 4) What is the role of the researcher and the participants in the overall process? 5) What form of participation must we embrace in order to best support the population we serve when using this method? and 6) What resources, including time, are required to engage in this process? (p. 45)

Of the photographic methods we present in this book, photovoice is probably the one most used in research. It has been widely used as a method for qualitative research. Providing the researcher with photos accompanied by narratives gives them the rich and deep description they value. Although the methodology lends itself to a research method, merely using it as a form of data collection and data analysis does not take full advantage of the benefits of photovoice. Rather, the aimed for outcome should include a better understanding of the community, empowerment of participants, and, it is hoped, some tangible changes.

The reliance on images makes photovoice an excellent method for PAR with persons who cannot expressed themselves as well with verbal means. Thus, it is not surprising that a significant number of projects include photovoice participants with disabilities. Examples of projects are those by

Baker and Wang (2006) on chronic pain, the work of Carnahan (2006) and Jurkowski and Paul-Ward (2007) with students and individuals with autism, and an effort by Thompson and colleagues (2008) on highlighting issues of living with chronic mental illness.

A Step-by-Step Process of Photovoice

We now turn to a step-by-step description of how to conduct photovoice. The method follows a sequence of eight steps (Table 5.1). Many of these steps are illustrated in the case example presented later.

Table 5.1 Eight Steps of Photovoice

1.	Planning project
2.	Identify issue and recruit participants
3.	Establish and connect with target audience
4.	Equipment and training of participants
5.	Identify and discuss photo assignments
6.	Take pictures
7.	Analyze and discuss pictures
8.	Change efforts and presentation

Step 1: Planning

One of the first considerations in any photovoice project is to establish a relationship with the community. In some cases, members of a community may initiate a project. In other cases, it may be an outside person with an interest in working on an issue. In either case, the participatory nature of photovoice stems from the involvement of the community. Including the community at the onset—for example, by making the project known through a short article in the local newspaper—helps build acceptance and interest, and it is beneficial when attempting to initiate changes later on. Thus, potential participants should be brought on board as early as possible. The more they can contribute to the planning and early implementation of a project, the larger their ownership of the process and the outcome.

Another consideration at the onset of a project is funding and the budget. As in the project described in the case example, you may be able to

implement a project without outside funding and on a small budget. One of the advantages of photovoice is its low-budget approach to making voices of community members heard. The major cost items are the facilitator, space for the group, and possible costs related to printing and exhibiting the photos. In our experience, nonprofit agencies and some libraries provide meeting spaces at no cost.

Next, one should consider the project timeline. Photovoice projects can last from a few weeks to more than 1 year, with only a few projects lasting longer than 1 year (Catalani & Minkler, 2010). How long it takes for a group to move through the picture-taking and analysis phase and the ensuing change process is both topic- and audience-dependent. Thus, the timeline for the group phase of photovoice presented in Table 5.2 is just a sample of what it may look like.

Table 5.2 Sample Timeline for Group Phase

Week 1	Initial meeting and Photovoice training
Weeks 2–8	Individual picture taking
	Weekly group meetings for analysis of photos
Weeks 8–9	Summary of findings and planning change
Weeks 10–16	Work with change agents
Week 16	Final debriefing session

Step 2: Issue and Recruitment

The next step is to identify an issue to focus on and the recruitment of participants. As a participatory action method, topics for photovoice should relate to local or regional issues. Participants should be directly or indirectly affected by the issue. Photovoice projects differ in the way they achieve this step. Some start a project with a preconceived topic, whereas others leave it to the group to come up with what they deem important and relevant to their lives. Thus, the topic can be introduced from the outside and presented by a facilitator, or it may be identified by members of the group. In projects that use the latter approach, recruitment has to be completed before the group can develop ideas for the topic. Choosing a narrow theme enables participants to focus quicker and go more into depth. Many of the research projects described in the literature use such an approach. For example, using a very short three-session timeline, Hafoka and Carr (2018) studied facilitators and barriers to being physically active among people in rural Hawai'i. Starting with broad themes may keep

the project more in line with the participatory approach to photovoice. In such cases, there is time for a longer start-up period in the group phase until topics need to be found. The advantage of this is that the topics emerging from such a process are usually much closer to the participants lived experience.

In their review of photovoice projects, Catalani and Minkler (2010) found that the overall focus was typically decided by others before the onset of the project. However, group members often made the key decisions once the project had started. Somewhat surprisingly, they found that groups tended to broaden the scope of issues rather than narrowing it.

Recruitment for photovoice is similar to that in group work or research projects. There is no one size fits all. Rather, one should keep in mind the intended purpose and hoped for outcomes. Several questions should guide this process. The intended purpose of the photovoice project will have an impact on whether one wants to include members to form a cohesive group around a topic or give preference to a wider range of backgrounds to cover a broader range of aspects. In either case, group members should have some lived experience related to the topic of the photovoice. This may include their cultural background, personal neighborhood and community experiences, or whether they are directly affected by an issue.

Group sizes should be similar to those of other task or community groups. A group should be large enough to cover a range of different views but small enough to be able to work on the issues. Thus, a beneficial group size seems to be approximately six to eight participants. Hergenrather et al. (2009) emphasize the benefits of small group size for work with smaller communities that otherwise would not lend themselves to research and change practice.

Step 3: Target Audience

When we talk about target audience in photovoice, we are concerned with those people or entities that need to be addressed to get the project started. They are the network we involve when we start implementing our efforts for change. Although it is a good tool for applied research, photovoice really has its strengths when it is conducted with an emphasis on actual change in the community or environment. Wang (1999) suggests the target audience should include a broad range of stakeholders who can help the group "with the political will to put participants' ideas into practice" (p. 187), also calling it a *guidance group* for the project (Wang & Burris, 1997).

Thus, when we identify our target audience, it is beneficial to consider the bigger picture: Who in the community might be able to help with the project in any way? Are there groups that are specifically affected? Do certain community leaders focus on the kind of issues that the photovoice group examines? Once we have identified our potential target audience, we need to think about the ability that each of them may have in impacting the outcome. As in the previous step, the timing of identifying the target audience and the level of involvement of the facilitator (versus group members) will vary. In general, the earlier one begins with this networking, the better. Common target audiences in photovoice include community leaders, policymakers, human service agencies, other service providers, and the community at-large.

The concrete task at this point is to build a bridge to the target audience. This includes establishing contact, providing information about the project, and networking meetings to gain support. Depending on the type of project, it may make sense to invite members of the target audience to a meeting to begin creating a dialogue and open exchange. Wang (2006) notes that the order of initial steps in photovoice is interchangeable to some extent, indicating that connecting to the target audience may precede recruitment.

Step 4: Equipment and Training

Training in photovoice should cover technical aspects such as cameras and picture taking, ethical aspects of taking and sharing photos, as well as the process of using the method to create change. The length and depth of training can range anywhere from a few hours to several days spread over the early phase of the group. Projects with higher levels of participant involvement and a stronger focus on community engagement require more training in the realm of working with change agents. Projects aimed at descriptive research, on the other hand, require less in-depth concentration on those aspects of photovoice.

The type of equipment used in photovoice has changed parallel to the transformation of photography. Whereas in the past, project facilitators needed to devote a significant amount of time to ensure participants had the appropriate photographic equipment and the knowledge and skills to use it, today's photovoice projects typically rely on smartphones and digital cameras. Most participants will be skilled in taking pictures with their devices. An advantage of photovoice is that the picture quality required for discussion and analysis is low. Thus, the training for using a camera may be

short and straightforward. Nevertheless, some discussion of how to use the camera should be included. For example, whereas sharing digital pictures is a common activity, downloading them from a smartphone to a printing device may not be. A general decision one should make in planning a group is whether to use printed photos, requiring someone to be in charge of getting the pictures from camera to paper, or to use computer monitors. Although the second option may be quicker and easier, shifting through paper prints and looking at them seems to facilitate a more interactive discourse among participants. Moreover, seating seven or eight participants in front of one monitor in a way that all can see the photos can be challenging.

Training in photovoice sometimes includes a presentation on how to take pictures. In our opinion, the advantages of better picture quality merit this step. Once we begin to focus on what makes for a good picture or how one can photograph certain things, we begin to influence the process of how a person looks at their environment and tries to create their individual visual representation of it. In doing so we have to balance the advantages of better quality with the risk of altering the outcome of their picture taking—that is, change the data they collect.

The process-related training provides an overview of the method of photovoice. Because the aim is to influence change agents in the community, group members should be aware of the importance of images as a tool to document and highlight an issue. Including examples of photos that connect with the viewer and convey a message can be helpful for training, with the aforementioned caution of potentially influencing the outcome. Thus, when selecting such pictures, one has to be mindful not to inadvertently steer group members in a certain direction. After all, the outcome of the participatory method hinges on the ability of each participant to tell their story and make their own voice heard.

Confidentiality and related ethical issues may become relevant when taking photos. Pictures that are to be used for public presentations or exhibits should comply with ethical standards (for more detail on confidentiality and privacy, see Chapter 2). In general, it is a useful approach to take pictures without people or in a way that one cannot identify the person in the photo. If pictures are to include people, the group should examine acceptable ways to approach someone to take their picture. Related to this is the question who can see the picture and how it will be presented to others. In one of our projects, participants occasionally had people in their pictures. For the purpose of group discussion, those pictures were used. However, they were not included in any

activities outside of the group process. Rather, the group selected pictures that conveyed the same or a similar message but without identifiable persons.

Step 5: Photo Assignments

Photovoice groups typically use weekly photo assignments. These assignments are the starting point, so they should be stated in a manner that participants can find their own way and bring their own "photographic" voice to bear. An assignment includes the subject matter or theme and may include some additional instructions on specific things to focus on. Assignments can be open, with little or no guidance regarding the topic, or facilitators can introduce the topics. In the latter case, changing or constant assignments may be used. Constant assignments lend themselves to a topic that is broad and merits a prolonged in-depth focus on different aspects of the same issue. Changing assignments, on the other hand, can be useful when new storylines or narratives evolve through the work of the group.

There is a potential for initial hesitation in this step of photovoice. If the group is not confident about the process, it may be helpful to start with an easy photo assignment. This can also serve as an icebreaker for group members and familiarize them with the process. Some participants may not have worked with groups before, so that alone can feel challenging. In our experience, however, having a common task to work on enables photovoice group participants to join and quickly rally around the process.

Topics for the photo assignments often use contrasting foci. For example, an assignment could be to think about the strengths and the challenges of the environment in which one lives. It could focus on what is easy for participants to do in day-to-day life and what is difficult. One could ask participants to go into their environs and take pictures of what makes them happy. When taking pictures in a community, special considerations should be given to human subjects and their privacy rights. As mentioned previously, asking participants not to include people in their pictures might be useful, especially in settings in which people know each other.

At some point, usually after a topic has crystalized as a focus of attention, facilitators and group members should begin to think in terms of storylines. Part of the change process in photovoice involves convincing others that there is an issue that requires some action. Storytelling with the aid of photos is the narrative used for this purpose.

Step 6: Picture Taking

Most photovoice pictures are taken using a cell phone. Some of the do's and don'ts will have been discussed in the initial training. In general, the more leeway one gives in the photo assignments, the more individual group members are able to express themselves. Picture taking can be an individual activity or accomplished in pairs. The first approach is more common because it enables participants to include more of their own perspective. However, some groups, such as the one we describe later, let pairs of participants collaborate on the photo assignments.

Participants can take as many pictures as they like. However, they are usually asked to select one or two pictures to be included in each group meeting. These photos are the foundation of analysis and discussion during the group session. A task for the facilitator is to ensure that everyone has pictures included in the discussion, not necessarily every week, but over time. As in other forms of group work, some participants are more active than others. Less outspoken group members have as much to share as those who might dominate the group process.

Step 7: Analyzing and Discussing

The primary task during the photovoice group meetings is to analyze and discuss the photos that participants select from their weekly photo assignments. This participatory analysis includes selecting photographs, contextualizing pictures, and codifying them. Discussing the pictures creates what Catalani and Minkler (2010) describe as a "double yield"—data for the project and empowerment of the participants and their communities (p. 443).

In most projects, the facilitator is charged with collecting the photos and converting them to the format used in the group discussion—that is, photo prints or images shown on a computer monitor. This can be supplemented with journaling by the participants. They are asked to take notes about the location of a picture, why they took it, and what they had in mind when they took it. In a way, it is a preparatory step for discussion and analysis. It also serves as data for the narrative used to convince stakeholders.

Main tasks in this step include contextualizing—telling the story about a picture and what it means to the person who took it; codifying—sorting images into categories, themes, or theories; and action—thinking about what can or should be done, based on the information provided in the photograph. Initially,

the acronym VOICE (*voicing our individual and collective experience*) was used for contextualizing and coding in photovoice. Wang and Burris (1997) later began using the acronym SHOWED. Participants are asked to address six basic questions regarding the pictures they selected:

- What do you *see* here?
- What is really *happening* here?
- How does this relate to *our* lives?
- *Why* does this concern, situation, strength exist?
- How can we become *empowered* through our new understanding?
- What can we *do*?

Although SHOWED is used in many photovoice projects, some use variations of this method or work with facilitator-generated questions (Hergenrather et al., 2009). In our projects, we use the three steps of presenting a *description* of the picture and discussing its *meaning*, followed by a collaborative brainstorming of *action* steps that may be taken. This approach seems easier for participants while still covering the same ground.

Step 8: Presentation and Action for Change

This step, collaborative work toward change, is a hallmark of photovoice. Photovoice does not stop with discussing the pictures. The analysis of selected pictures and their accompanying stories is just the starting point. There are several things to keep in mind when implementing such change strategies. First, working with key stakeholders and the target audience may take a significant amount of time. Thus, including a sufficient time window for the change process is essential. Spending effort to include participants as co-researchers and change agents but then running out of time to work on the actual change process would be demoralizing and the opposite of the empowerment that the methods aims for.

Different target audiences and stakeholders require different strategies. Working with formal groups, such as community boards, often requires following more prescribed formats, such as making appointments to connect with council members and getting onto the council's meeting agenda. Less formal target audiences, such as the storekeepers discussed later, leave space for informal interactions and networking.

Another thing to keep in mind is how much change to expect and work toward. Photovoice groups should stay realistic in what they can achieve. The outcomes in photovoice may include minor or major changes. Both can be meaningful. Outcomes, or at least the potential outcomes, should match the expectations of participants, once they get involved in the change process.

Many photovoice projects include a presentation of the photos. These presentations can be given in various formats, from a photo exhibit in a public space to the presentation in front of a specific target audience. Another option is to present the photos with a narrative as a download or in a constant monitor loop in a public space. In Chapter 8, we provide more details on how to organize and present photos.

Part of a presentation is promoting it to the audience of potential listeners or viewers. Because photovoice projects typically involve community settings, the same types of outlets as for other public events can be used, including announcements in local news outlets and papers, word-of-mouth promotion through group members and stakeholders, announcements on bulletin boards, and so on. Social media is becoming more common for promoting as well. Many communities have their own websites and Facebook pages. Regardless of outlet used, a media press release that describes the project and its intended outcome in a concise way can be a helpful tool.

Case Example: Photovoice Project on Mobility and Older Adults

We now turn our focus to a project that illustrates some of the key aspects of implementing photovoice in a community setting. Our photovoice example comes from a project in a rural small town in Germany. For the purpose of presenting the method, we adapted and added to the actual process of the group. The photovoice project took place in a small rural town of 25,000 inhabitants. The town combines traditional elements, such as cobblestoned pedestrian walkways, the narrower layout of an older town, and people who are proud of their traditions, with modern industry and larger box stores on the outskirts. As in many such towns, access to public spaces can be arduous for older adults. This was the case for the old town section in this town. To go shopping, partake in church services, or visit public events, one may have to park outside of the downtown area and navigate a cobblestoned pavement and two small hills. The presenting issue for this project was identified as an

environment that did not cater well to individuals with mobility problems. Consequently, older adults with mobility problems were considered the community members most affected by these environmental features.

The photovoice project was started by volunteers with knowledge of the method and an interest in improving the environment for older adults living in the community. It occurred without outside funding or sponsorship, but it was supported by a nonprofit social welfare agency. The facilitator of the group was a social worker trained in photovoice with a background in working with older adults. He lived in town but had few ties to the local political and service delivery structure. The role of the facilitator was to assist in all phases of the project, from recruiting participants to locating space for the group, facilitating the photo discussion, and coordinating the efforts for changes to the environment.

With the help of a geriatric social worker, participants were selected who fit the target age group (older than age 65 years), had some lived experience in the local environment, and had volunteered to help with senior community events in the past. Although it was a central theme for the project, they were not required to have mobility problems themselves. After a few participants dropped out at the onset, the project ended up with a group of four participants. Their ages ranged from the low to mid-70s. The group included two male and two female participants. All were retired and had varied professional backgrounds. Two were born in town; the other two had spent most of their adult lives there.

The focus of the project was phrased in very general terms as *mobility challenges for older adults in the local community environment*. Weekly photo assignments were given. Participants were asked to focus on challenges in the environment but take the liberty to go any direction with their photos and discussion they deemed appropriate. All four participants were able to take pictures with their smartphones, so no other training or discussion of the use of photographic equipment were needed. The type of pictures to take was left open to individual choice. Due to confidentiality issues of taking pictures in a small-town environment, they were asked not to include any people in their photos.

The photovoice group met for 6 weeks in a room provided by a nonprofit social welfare agency. Meetings lasted approximately 1 hour each. The photo-taking and discussion process (steps 6 and 7) combined individual and group tasks. Individual tasks included going into the community to take photos, self-selecting up to two pictures per week, and submitting

them to the facilitator by the morning of the next meeting to be printed and uploaded to a computer for group discussion. Although the task originally was to take pictures individually, the members decided to pair up for the photo assignments and walk through town together. Group tasks included the weekly discussion of the pictures (description, meaning, and possible action steps) and a preselection of which photographs to use for continued work. Three themes emerged fairly quickly, and the group consequently focused solely on them: (1) There was a lack of places to park bicycles when running errands; (2) there were not enough places to sit and rest in the old town section; and (3) illumination of the central hill was poor, making it difficult to see the paved walkway during evening hours.

Image 5.1 Problem with parking bicycles.

The implementation of the ensuing change strategy highlighted the role of participants as co-researchers and change agents. As is typical for photovoice, the group process did not stop with discussing the pictures. Rather, the pictures and captions and the relating stories from group members served as a starting point for the change process. The main issue that the group worked was the walkway connecting the upper and the lower part of town. Participants summarized the problem as follows: For many older adults, the hill is difficult to navigate; there are no reasonable alternate routes; along the way, there are no places to stop and rest; and the walkway is fairly dark at night.

Image 5.2 Walkway connecting upper and lower old town.

Image 5.3 Walkway at dusk.

A two-prong strategy was taken to influence change agents, with slightly different approaches toward the respective target audiences. Two group participants focused on working with local business owners. Their approach was less formal—that is, stopping by their stores, introducing the project, chatting with them on several occasions, and presenting some ideas for change. The group of business owners included several storekeepers located at the lower hill and in the market square area. Having owned their stores along the hillside for a long time, the owners were aware of the poor lighting situation. They had previously requested additional lights be placed along the hill but without success. Focusing on what they could change themselves, the photovoice group members and two store owners devised a way of using existing store lights to brighten the general environment. For example, one lamp was repositioned from illuminating the outlays to shine onto the ground in front of the store. Another light was turned so it would shine on a carved figurine on the wall of a house on the opposite side, thus providing additional indirect light. Although these measures improved the situation, they did not suffice on their own.

The second target audience was identified as members of the local community council. Here, a more formal approach was taken. The two other group members requested to be formally included in the council meeting schedule and did a presentation of their pictures and findings. The discussion during the meeting was kept fairly short because several other pressing issues were on the agenda. However, enough interest was created to get the project started. After subsequent meetings with individual council members and an illumination expert (the owner of a local lamp store), some funding was released to install LED lights on the lower side of an existing handrail along the walkway. This added enough light to completely change walkability at night. The set of pictures depict the change that occurred. The second picture shows the walkway during daylight. The next photo was taken at dusk to illustrate the problems with lighting. The last picture shows the improvement after LED lights were added to the already existing handrail.

Results were mixed with respect to the other two issues identified by the photovoice participants. They were not able to create any changes with regard to the bicycle situation. However, they successfully convinced the community to add benches to the public space. As part of this process, they took pictures of the few benches and seating options they found. Next, they created a photo map showing where benches were located and

Image 5.4 Handrail illuminating walkway.

where it would be beneficial to have additional benches (see Chapter 6). Overall, the project illustrates that there can be minor and major changes, as well as leads that are not followed. It also shows that changes can be initiated by a small group of community members with a low-resource approach to photovoice.

Conclusion

Photovoice is an approach to community-based practice that has become increasingly popular in social work and related fields of health and human services. Although it requires a time commitment of several months from start to finish, it is a fairly straightforward method that is easy to implement. It does not require extensive training on the part of group facilitators or participants. It also does not require extensive resources, high levels of photographic skills, or fancy camera equipment. Imbedded in Freire's consciousness raising and PAR, its strength is giving a voice to those affected by an issue. The images enable participants who may otherwise not have a voice in the process to present challenges they face in their daily lives. As we have shown in this chapter, photovoice can be utilized with a wide range of participants, issues, and settings.

Glossary

Photovoice: A community-based method that uses the medium of photography to identify needs and assets of an environment, with the goal of creating positive changes.

Additional Resources

PhotoVoice: https://photovoice.org
A UK-based charity that promotes social change through the use of photovoice. It provides resources and online training in photovoice.

Community Tool Box: https://ctb.ku.edu/en/table-of-contents/assessment/assessing-community-needs-and-resources/photovoice/main
The Community Tool Box offers a wide range of free training materials for community-based practice, including a section on photovoice. It is a free service of the Center for Community Health and Development at the University of Kansas.

Public Library Association: http://www.ala.org/pla/education/onlinelearning/webinars/ondemand/photovoice
The Public Library Association is a division of the American Library Association. This website includes training materials on how to create a photovoice project.

Photovoice Worldwide: http://www.photovoiceworldwide.com/index.htm#sthash.00WRMW9G.dpbs
Organization with the goal to help individuals and organizations worldwide use photovoice safely, ethically, and successfully and to create a community for photovoice peer-to-peer support.

References

Baker, T. A., & Wang, C. C. (2006). Photovoice: Use of a participatory action research method to explore the chronic pain experience in older adults. *Qualitative Health Research*, 16(10), 1405–1413.

Carlson, E. D., Engebretson, J., & Chamberlain, R. M. (2006). Photovoice as a social process of critical consciousness. *Qualitative Health Research*, 16(6), 836–852.

Carnahan, C. (2006). Photovoice: Increasing engagement for students with autism and their teachers. *Teaching Exceptional Children*, 39(2), 44–50.

Castleden, H., & Garvin, T. (2008). Modifying photovoice for community-based partici-patory Indigenous research. *Social Science & Medicine, 66*(6), 1393–1405.

Catalani, C., & Minkler, M. (2010). Photovoice: A review of the literature in health and public health. *Health Education & Behavior, 37*(3), 424–451.

Chapman, M. V., Wu, S., & Zhu, M. (2017). What is a picture worth? A primer for coding and interpreting photographic data. *Qualitative Social Work, 16*(6), 810–824.

Cornwall, A. (1996). Towards participatory practice: Participatory rural appraisal (PRA) and the participatory process. In K. De Koning & M. Martin (Eds.), *Participatory re-search in health: Issues and experiences* (pp. 94–103). Zed Books.

Dixon, M., & Hadjialexiou, M. (2005). Photovoice: Promising practice in engaging young people who are homeless. *Youth Studies Australia, 24*(2), 52–56.

Drajati, N. A., Ngadiso, N., & Zainnuri, H. (2019). Promoting photovoice for teachers' self-reflection on multimodal literacy. *English Education, 12*(2), 100–114.

Fitzpatrick, A. L., Steinman, L. E., Tu, S. P., Ly, K. A., Ton, T. G., Yip, M. P., & Sin, M. K. (2012). Using photovoice to understand cardiovascular health awareness in Asian elders. *Health Promotion Practice, 13*(1), 48–54.

Foster-Fishman, P., Nowell, B., Deacon, Z., Nievar, M. A., & McCann, P. (2005). Using methods that matter: The impact of reflection, dialogue, and voice. *American Journal of Community Psychology, 36*(3–4), 275–291.

Freire, P. (1970). *Pedagogy of the oppressed.* Herder & Herder. (Original work published 1968)

Gallagher, N. A., Gretebeck, K. A., Robinson, J. C., Torres, E. R., Murphy, S. L., & Martyn, K. K. (2010). Neighborhood factors relevant for walking in older, urban, African American adults. *Journal of Aging and Physical Activity, 18*(1), 99.

Genoe, M. R., & Dupuis, S. L. (2013). Picturing leisure: Using photovoice to understand the experience of leisure and dementia. *Qualitative Report, 18*(11), 1.

Goodhart, F. W., Hsu, J., Baek, J. H., Coleman, A. L., Maresca, F. M., & Miller, M. B. (2006). A view through a different lens: Photovoice as a tool for student advocacy. *Journal of American College Health, 55*(1), 53–56.

Graziano, K. J. (2004). Oppression and resiliency in a post-apartheid South Africa: Unheard voices of Black gay men and lesbians. *Cultural Diversity and Ethnic Minority Psychology, 10*(3), 302.

Gubrium, A., & Harper, K. (2013). *Participatory visual and digital methods.* Routledge.

Hafoka, S. F., & Carr, S. J. (2018). Facilitators and barriers to being physically active in a rural Hawai'i community: A photovoice perspective. *Asian/Pacific Island Nursing Journal, 3*(4), 160–167.

Hergenrather, K. C., Rhodes, S. D., Cowan, C. A., Bardhoshi, G., & Pula, S. (2009). Photovoice as community-based participatory research: A qualitative review. *American Journal of Health Behavior, 33*(6), 686–698.

Hussey, W. (2006). Slivers of the journey: The use of photovoice and storytelling to ex-amine female to male transsexuals' experience of health care access. *Journal of Homosexuality, 51*(1), 129–158.

Jurkowski, J. M., & Paul-Ward, A. (2007). Photovoice with vulnerable populations: Addressing disparities in health promotion among people with intellec-tual disabilities. *Health Promotion Practice, 8*(4), 358–365.

Johnson, J. E. (2020). Project LEEP (Leadership though Education, Experience and Photovoice): An Embedded Graduate Service-Learning Initiative. *Sport Management Education Journal, 1*, 1–3.

Lewinson, T., Robinson-Dooley, V., & Grant, K. W. (2012). Exploring "home" through residents' lenses: Assisted living facility residents identify homelike characteristics using photovoice. *Journal of Gerontological Social Work, 55*(8), 745–756.

Liebenberg, L. (2018). Thinking critically about photovoice: Achieving empowerment and social change. *International Journal of Qualitative Methods, 17*(1), 1–9.

Mamary, E., McCright, J., & Roe, K. (2007). Our lives: An examination of sexual health issues using photovoice by non-gay identified African American men who have sex with men. *Culture, Health & Sexuality, 9*(4), 359–370.

McIntyre, A. (2003). Through the eyes of women: Photovoice and participatory research as tools for reimagining place. *Gender, Place and Culture, 10*(1), 47–66.

McKernan, C., Gleddie, D., & Storey, K. (2020). Student-centred photovoice as a mechanism for home–school interaction: Teacher perceptions of efficacy. *Health Education Journal, 79*(1), 82–93.

Mitchell, C., DeLange, N., Moletsane, R., Stuart, J., & Buthelezi, T. (2005). Giving a face to HIV and AIDS: On the uses of photo-voice by teachers and community health care workers working with youth in rural South Africa. *Qualitative Research in Psychology, 2*(3), 257–270.

Neill, C., Leipert, B. D., Garcia, A. C., & Kloseck, M. (2011). Using photovoice methodology to investigate facilitators and barriers to food acquisition and preparation by rural older women. *Journal of Nutrition in Gerontology and Geriatrics, 30*(3), 225–247.

Novek, S., & Menec, V. H. (2014). Older adults' perceptions of age-friendly communities in Canada: A photovoice study. *Ageing and Society, 34*(6), 1052–1072.

Nowell, B. L., Berkowitz, S. L., Deacon, Z., & Foster-Fishman, P. (2006). Revealing the cues within community places: Stories of identity, history, and possibility. *American Journal of Community Psychology, 37*(1–2), 29–46.

Peabody, C. G. (2013). Using photovoice as a tool to engage social work students in social justice. *Journal of Teaching in Social Work, 33*(3), 251–265.

Ponterotto, J. G. (2005). Qualitative research in counseling psychology: A primer on research paradigms and philosophy of science. *Journal of Counseling Psychology, 52*(2), 126–136.

Powers, M. C., & Freedman, D. A. (2012). Applying a social justice framework to photovoice research on environmental issues. *Critical Social Work, 13*(2), 81–100.

Rhodes, S. D., Hergenrather, K. C., Wilkin, A. M., & Jolly, C. (2008). Visions and voices: Indigent persons living with HIV in the southern United States use photovoice to create knowledge, develop partnerships, and take action. *Health Promotion Practice, 9*(2), 159–169.

Russell, A. C., & Diaz, N. D. (2013). Photography in social work research: Using visual image to humanize findings. *Qualitative Social Work, 12*(4), 433–453.

Schwartz, L. R., Sable, M. R., Dannerbeck, A., & Campbell, J. D. (2007). Using photovoice to improve family planning services for immigrant Hispanics. *Journal of Health Care for the Poor and Underserved, 18*(5), 757–766.

Sitter, K. C. (2017). Taking a closer look at photovoice as a participatory action research method. *Journal of Progressive Human Services, 28*(1), 36–48.

Spencer, R. A., McIsaac, J. L. D., Stewart, M., Brushett, S., & Kirk, S. F. (2019). Food in focus: Youth exploring food in schools using photovoice. *Journal of Nutrition Education and Behavior, 51*(8), 1011–1019.

Tanjasiri, S. P., Lew, R., Kuratani, D. G., Wong, M., & Fu, L. (2011). Using Photovoice to assess and promote environmental approaches to tobacco control in AAPI communities. *Health Promotion Practice, 12*(5), 654–665.

Thompson, N. C., Hunter, E. E., Murray, L., Ninci, L., Rolfs, E. M., & Pallikkathayil, L. (2008). The experience of living with chronic mental illness: A photovoice study. *Perspectives in Psychiatric Care, 44*(1), 14–24.

Trepal, H., Cannon, Y., & Garcia, J. (2020). Using photovoice to promote body image resilience in college women. *Journal of College Counseling, 23*(1), 44–56.

Wang, C., & Burris, M. A. (1997). Photovoice: Concept, methodology, and use for participatory needs assessment. *Health Education & Behavior, 24*(3), 369–387.

Wang, C. C. (1999). Photovoice: A participatory action research strategy applied to women's health. *Journal of Women's Health, 8*(2), 185–192.

Wang, C. C. (2006). Youth participation in photovoice as a strategy for community change. *Journal of Community Practice, 14*(1–2), 147–161.

Wang, C. C., Morrel-Samuels, S., Hutchison, P. M., Bell, L., & Pestronk, R. M. (2004). Flint Photovoice: Community building among youths, adults, and policymakers. *American Journal of Public Health, 94*(6), 911–913.

Wang, C. C., & Redwood-Jones, Y. A. (2001). Photovoice ethics: Perspectives from Flint Photovoice. *Health Education & Behavior, 28*(5), 560–572.

Wiersma, E. C. (2011). Using photovoice with people with Alzheimer's disease: A discussion of methodology. *Dementia, 10*(2), 203–216.

Wilson, N., Dasho, S., Martin, A. C., Wallerstein, N., Wang, C. C., & Minkler, M. (2007). Engaging young adolescents in social action through photovoice: The Youth Empowerment Strategies (YES!) project. *Journal of Early Adolescence, 27*(2), 241–261.

6

Photomapping

Overview, Key Concepts, and History

What Is Photomapping?

Social workers clearly understand the importance of place and how the physical environment can have a substantial impact on individuals, families, groups, organizations, and communities. **Photomapping** is a method that attends to this concept and view and involves the use of geographic information system (**GIS**) data to map significant events or places or illustrate special connections within a community or geographic area. It is often called **participatory photomapping** (PPM) when it involves collaboration with persons affected by the particular environment, in an effort to give them a voice. According to Dennis et al. (2009), "PPM is built upon successful techniques developed to facilitate public participation in researching, planning and implementing strategies to improve well-being" (p. 467). These techniques push the traditionally quantitative GIS method into more qualitative and mixed methods realms through the addition of tools such as photography, interviews, and focus groups (Dennis et al., 2009; Teixeira, 2018).

Rephotography, or **repeat photography**, is an additional tool and method that is worth mentioning within the scope of this chapter. As the name implies, this involves retrieving or taking a photograph and then taking another photograph of the same subject at a later point in time, with the intention of showing change. It is often used to document social change in particular and to provide insights into the importance of that change (Rieger, 2011). As Rieger specifies, this method is a way to create a "longitudinal, photographic record of a particular place, social group, or other phenomenon" (p. 2), which can then be examined for verification of change or a lack of change. Kalin (2013) suggests that this method allows memories to be actively incorporated into and take part in the present, as one can see how

Photography in Social Work and Social Change. Matthias J. Naleppa, Kristina M. Hash, and Anissa T. Rogers,
Oxford University Press. © Oxford University Press 2022. DOI: 10.1093/oso/9780197518014.003.0006

the past created the present and even offers a glimpse of what may become of the subject in the future. In fact, Kalin notes, "Rephotography asks us to live in the seams of uncertainty, where the layers of past, present, and future overlap" (p. 175).

Origins and History of Photomapping

Social work is a latecomer to GIS technology, but the profession is not new to the practice of mapping, particularly in community work. In fact, Hull House leaders and others used social surveys in conjunction with mapping in the late 1800s and early 1900s to identify social and public health problems in communities. In many ways, GIS technology can be viewed as an updated method to examine human behavior as it relates to the physical, spatial environment (Hillier, 2007). This technology gained acceptance in the 1960s as a tool for spatial analysis, although it could only be accessed on large, mainframe computer systems. The 1990s saw increased use of GIS in social work and other fields as the software became available for use with personal computers. Initially, the tool was used primarily for evaluation purposes but later grew to involve planning and implementation functions (Felke, 2006). As noted by Teixeira (2018), GIS technology and software were once designated for "experts only" and out of the financial reach of many, although recent advances in this area and increased user-friendliness have made it a part of our everyday lives with the capabilities of smartphones and internet resources such as Google Maps.

Goals of Photomapping

The primary goal of photomapping is to locate and visually represent aspects of the physical environment. For the purposes of social work, these aspects can then be used by researchers and practitioners to identify assets, needs, and barriers in the environment by providing relevant geographic and spatial information (Teixeira & Gardner, 2017). As a related tool, rephotography aims to depict change in an environment or among individuals or groups by showing these entities in before and after states (Rieger, 2011).

Theoretical Foundations of Photomapping

In terms of technology, photomapping is rooted in the science of GIS. Although traditionally viewed as a more quantitative, positivistic approach, recent decades have fostered a more qualitative and participatory use of the method, including PPM (Teixeira, 2016). Related to theory, the method has gained interest among those in the field of social work due to its fit with the focus on the importance of the person in environment and the influence of the physical environment on individuals and communities (Council on Social Work Education, 2015; Kondrat, 2008). It also matches well with ecosystems theory, which considers how organisms function within and interact with their environments (Germain, 1981). In fact, GIS and photomapping are similar to the ecomap that is common in social work practice and education, and they both highlight the significance of environmental influences on an individual (Wilson, 2015). In line with these perspectives, Kemp (2011) asserts that "since the profession's earliest formal beginnings, social workers have understood that *where* people live profoundly influences *how* they live, with important implications for equity and social justice" (p. 1200).

Advantages and Challenges of Photomapping

Because it is an emerging method in the field, social work practitioners, researchers, and educators should understand the advantages of and challenges involved in photomapping. With this understanding, the method can be advanced in the field and strive to improve the fit between individuals and their environments.

Advantages

As mentioned previously, as a definite advantage, photomapping fits well with the focus and values of the social work profession, with its tie to the impact of the physical environment on individual and community well-being. Its capacity to assess aspects of communities is also of great benefit, as the method is well suited for integration into projects that map challenges, barriers, and resources of neighborhoods and communities. This is the approach of Kretzmann and McKnight (1993), which outlines a process for

mapping community capacity through asset-based community development and involves engaging community members and geographically identifying needs as well as assets.

According to Teixeira (2015), participatory photo methods such as photovoice and photo elicitation hold the advantages of engaging the subjects of research and their unique perspectives and experiences in projects as well as promoting advocacy and change. Photomapping can also be participatory and can add a spatial component to research that focuses on communities. This method also allows for multiple sources of data to be included and spatially mapped. In addition, when participatory in nature, this type of research can produce "engagement and partnership through photography and mapping" (p. 296). The method also allows for the empowerment of participants and partnerships with participants and community organizations (Teixeira & Gardner, 2017).

Kelley (2011) posits that research that is participatory in nature and utilizes geospatial and multimedia tools is especially beneficial for informing social policies, programs, and decision-making in communities. Results from such projects not only come from the views of community residents and include visual evidence but also include a spatial reality, offering information that is truly useful as well as innovative. Similarly, Kemp asserts that combining these qualitative methods with spatial data allows for more informed community interventions and reinforces the social work commitment to the importance of place and the physical environment as well as populations and communities that suffer from inequities and environmental threats.

Photomapping projects can also include the advantages of being transdisciplinary and participatory (Dennis et al., 2009). This method provides an opportunity to collaborate with other disciplines around an issue or problem. Disciplines such as public health, nursing, urban planning, and geography are natural partners in this type of inquiry. As mentioned previously, photomapping also has the advantage of including the participation of those impacted by the environment of interest. This is what Dennis et al. (2009) call adding the "lived experiences" of participants, and using PPM gives access to three dimensions of experiences: "People can indicate where experiences occurred (via maps), what experience looked like (via photos or drawings) and how experiences unfolded (via narratives)" (p. 468). It also allows participants to investigate issues that are important to them and examine issues and problems in a spatial dimension. Rephotography is also advantageous. According to Rieger (2011), the method has great potential to

effect social change. This is because it allows for visual inspection and comparison of subject matter over time.

Challenges

Photomapping can present distinct challenges. One challenge can be the learning of GIS programs, which may be novel for some social work researchers and practitioners. In participatory projects, it can also be challenging to teach participants and students how to use this technology. Thus, training must be part of any project protocol. Teixeira (2015) suggests that training on the tools and technology involved as well as ethics and safety training of participants are often necessary. In addition to providing adequate training, researchers must also spend considerable time building rapport and trust with the community members and participants involved in any PPM project. Morales-Campos et al. (2015) echo the importance of building community partnerships and training participants and also anticipating technological difficulties. Once the technology is mastered, participants engaged, and photos taken, it can be difficult to decide which photos to select for mapping. Interpreting the photos selected can also produce challenges (Dennis et al., 2009). In PPM projects, participants can serve an important role in selecting and displaying photos to be maps so that their issues are adequately communicated and presented. Even if the project is not participatory in nature, key stakeholders in a community, organization, or group can provide guidance on these matters.

Rieger (2011) notes that a challenge of rephotography is not being able to control the quality of a historical photograph that is used for Time 1. Fortunately, there are many collections (often available online) that house historical images to be used by the public. Prospective rephotography (in which an individual takes both the before and the after photo) may be difficult to accomplish because schedules and commitments as well as changing circumstances can prevent the documentation between timed photographs. It can also be difficult in an objective way to make inferences of change based on photos because "visual change and social change is not simple and linear" (p. 15)—that is, visual change and social change may not occur at the same time. In addition, the strength of the relationship between visual and social change will vary depending on the subject; a significant visual change may not equal a significant social change and vice versa. There is also the chance

that important changes will be missed because they occur and disappear sometime between the series of photographs. Similarly, some visual changes can simply be abnormalities and do not represent social change. The subjects of the photographs can also disappear or become unavailable or obscured.

Best Practices: Application of Photomapping in Various Fields of Practice

According to Hillier (2007), social work has come late to the GIS game in terms of curriculum and research. Teixeira (2018), a social work leader in photomapping, echoes this sentiment by stating that social work could make more use of this technology in assessing contextual aspects of clients' environments, including strengths, challenges, and possible avenues for intervention. Given its strengths and accessibility, GIS technology and mapping can and should be integrated into social work education, at the for-credit and continuing education levels, so that students and professionals can use these tools to improve the well-being of populations that they serve.

Applications in Education

As discussed below, photomapping and GIS have great potential to benefit social work practice and research. To reach this potential, however, education and training are needed in for-credit and continuing education programs for social workers. This would most likely take the form of individual continuing education workshops and specialized units and assignments within courses in the undergraduate and graduate social work curricula. Training in GIS, the underlying technology in photomapping, is a particular need for social workers and is not well (or at all) covered in social work curricula. Although departments of geography in many universities provide coursework in GIS, social work students do not often take advantage of these offerings due to major restrictions, minimal time in their schedules, and/or lack of awareness about such opportunities.

Very few social work programs offer courses or content that link the physical environment with spatial analysis, and those that do exist are often the result of a special interest of an individual faculty member (Kemp, 2011). As one of the few examples, Felke (2006, 2014) describes an elective course in

social work that integrated GIS into its content and then later became a free-standing elective on the method. In addition, a 6-hour training on the technology was provided to faculty of that institution. The focus of the course and training was the use of GIS in planning, practice, and research in the social services. Hillier also teaches GIS mapping for social work students, with a focus on disparities and access to needed services for vulnerable populations, and advocates for content and courses to be taught by social work faculty to for-credit and continuing education students (Knight, 2016). Wier and Robertson (1998) taught GIS in a social work macro practice course and stress that in addition to teaching the how-to of the technology, it is critical to also cover the practical uses of the technology, such as developing and providing social services. Finally, Gjesfjeld and Jung (2014) suggest using GIS and geographic visualization to teach about poverty by demonstrating to social work students the unequal access to grocery stores for a minority population in their community. The authors identify the advantages of using this method for teaching this and other social problems as connecting to the ecological and systems frameworks and identifying needs for community members.

With the software that exists today, photographs of key aspects of the environment can be presented as part of GIS mapping and spatial analysis. One of the authors of this book (Hash) has integrated photomapping into an undergraduate human behavior in the social environment course, in which students use basic GIS mapping technology to produce photomaps of the communities that they assess as part of the course. As a result, students are able to spatially and visually represent key assets within the communities as well as identify gaps in services. Students are also provided with examples and are given the option to present before and after photos (rephotography) of locations of importance to the communities. Examples used in the course are displayed as images and explained later in this chapter.

Applications in Practice

Photomapping can be utilized in practice in a variety of ways, most notably at the macro level. This technology can highlight the needs and assets available to residents in a given community and improve the delivery of services in that area. This type of information can also empower residents and provide evidence to policymakers to more effectively plan and make major decisions

and changes in their communities (Hillier, 2007; Teixeira, 2018). GIS technology, in general, can also identify the need for a new service or organization within a community as well as advocate for a new public policy (Felke, 2006). In addition, Querault and Witte (1998) identified 15 uses of GIS technology for social services, including accessing the socioeconomic characteristics of a community or population served by an organization, discovering trends in an area, providing visual evidence of the need for funding or as a fundraising tool, showing distance of a target population to the location of a service, pinpointing barriers to accessibility and transportation, identifying the distribution of health and social disparities and problems, and locating hazardous sites in relation to certain populations. The research that results from GIS and photomapping can and should inform practice and is discussed in the following section.

In terms of working with clients, sophisticated GIS technology and software are expensive and not always accessible to marginalized groups. For this reason, Hillier (2007) claims that GIS and mapping need social workers. Specifically, "social workers have a critical role to play in ensuring how GIS and other technologies are used to promote the social welfare of all people" (p. 215). Social workers can also represent the interests of the profession on projects in which they are part of a multidisciplinary team to investigate a social or health care problem (Teixeira, 2018).

Applications in Research

Social work researchers are increasingly utilizing GIS and photomapping to investigate the impact of the physical environment and spatial distributions of various client populations and social problems. For example, researchers have used GIS mapping to investigate such issues as access to maternity health care, racial disparities and environmental waste, the strengths and challenges of foster care systems, the incidence of child maltreatment, and the availability of child care (Freisthler et al., 2006; Gjesfjeld & Jung, 2011; Mohai & Saha, 2007; Queralt & Witte, 1998; Rine et al., 2012).

A few social work researchers have also integrated photomapping tools into their inquiry. Teixeira has engaged these tools in participatory projects examining neighborhoods and their impacts on individuals. Using a participatory approach, Teixeira (2015, 2016) examined abandoned properties by integrating GIS data to identify the prevalence of these properties, youth

participant interviews about the meaning of the neighborhood blight, and walk-along tours given and photo maps developed by the youth. This project resulted in an understanding and public advocacy around the meaning and impact of abandoned properties on the residents of an urban, disadvantaged neighborhood. Participants noted juvenile delinquency, social withdrawal, neighborhood stigma, and fear as stemming from the onslaught of abandoned properties. Findings and potential solutions were presented by the participants to board members of local organizations, researchers, and others in the community. As part of this study, maps were also created identifying race and showing disparities in terms of poverty and crime rates for the community compared to the larger city in which it exists (Teixeira & Zuberi, 2016). In a similar study in a different urban community, Teixeira and Gardner (2017) used PPM to examine opportunities and barriers to youth success in their neighborhood environment.

A related field, photomapping has been utilized in public health research. Morales-Campos et al. (2015) used PPM in a study aimed at increasing physical activity among lower income Hispanic girls. The team partnered with a group of girls and their parents as well as community agencies and employed photomapping, photo elicitation interviews, focus groups, and surveys. An intervention was developed that incorporated the environment that influenced the behaviors of the girls (e.g., environmental barriers to physical activity such as poor sidewalks and streets). Photos and their associated narratives were mapped using GIS. The girls also developed photo essays and posters and shared them with community stakeholders. Dennis et al. (2009) applied PPM methods with youth to uncover issues related to health and safety in a community, such as access to nutritional foods and feelings of being welcome or unwelcome in public spaces. The researchers engaged participants in first examining an aerial photograph of their community and identifying locations and then taking their own street-level photographs documenting their experiences. Focus groups were also utilized, and maps resulting from the project were shared with community stakeholders by the researchers and participants.

Rephotography, which has been popular in the natural sciences, can also have social science implications. For example, geographers Burton et al. (2011) used repeat photography to document changes in the levels of recovery of sites after Hurricane Katrina on the U.S. Gulf Coast. They applied this method along with other indicators across 113 sites for 3 years following

the hurricane and showed disparities in the rebuilding process among different communities, with higher levels of damage being associated with lower levels of recovery. The authors also suspected the areas with lower levels of recovery were more vulnerable (in terms of economic and social and political statuses) to begin with and factored into the overall recovery time. This approach is similar to what is called *historical ecology*, which can involve repeat photography of landscapes to show changes in its ecology (vegetation, uses, impacts, etc.) (Santana-Cordero & Szabó, 2019). Repeat photography can also be used to document changes in individuals. This may include progression of the impact of a medical treatment on a condition; the effects of illicit drugs and other substances on individuals over time; or to show the changes in soldiers by photographing them before, during, and after combat and wartime (Bear & Albers, 2017).

A Step-by-Step Process of Photomapping

Before beginning a photomapping project, a basic understanding of available tools and programs is necessary. The ability to take photos that can be geographically positioned is the first consideration. The majority of contemporary cellular phones or smartphones are Global Positioning System (GPS)-enabled. This means that the cameras have the capability to "**geotag**" or assign a longitude and latitude position to photos taken on the device. This technology makes it easy to produce photo maps. It is frequently used by individuals to make photo maps of travel by incorporating vacation photos. This technology can be used for other purposes, however.

Several applications and websites can produce photo maps for many purposes. Perhaps the most accessible and easy to use is Google Maps. Users can create custom maps (using MyMaps) and attach their own photos or search for photos on the Google system. Resulting maps can be edited to include text, points, and highlighting, and they can be easily shared publicly with a weblink. Livetrekker is a free program that is targeted toward travelers but can be used for other photomapping purposes. The program allows for the creation of a journal that integrates text, photos, video, and sound that can be shared in real time. The advantage of this program is that the user can add photos, video, and audio to designated geographical spots. Mapillary is another program that is geared toward travel but can be used for other mapping purposes. It is used with a tool called OpenStreetMap and offers access

to a crowd-sourced photo database and panoramic views. All three programs can be used on a computer, tablet, or cellular phone.

Dennis et al. (2009, p. 468) outline a process for conducting PPM:

1. Participants use digital cameras and GPS devices to take photographs of their community or environment. This may involve the documentation of places or services that they routinely visit or use.
2. Interviews are conducted with individuals regarding these photographs, and the resulting narratives are attached to specific photographs.
3. These images are then mapped as part of a neighborhood or community-level GIS that may include related data (income, crime, health, etc.).
4. Participants identify actions that can be taken and directed at policy and decision-makers.

Regarding data analysis of projects involving photomapping, Teixeira (2018) suggests a "grounded visualization" approach (p. 14). This approach is akin to the qualitative approach of grounded theory and brings together multiple data sources to build a picture of a phenomenon from different realities (spatial maps, participant interviews, etc.). As mentioned previously, Teixeira (2016) integrated and triangulated GIS data, interviews, and photomaps to investigate the impact of abandoned properties on neighborhood residents. A program called ArcGIS was used to analyze and build interactive maps from these various pieces of data.

There are also a few guidelines offered for the method of rephotography or repeat photography. To begin, rephotography can be prospective, where the researcher takes the initial and subsequent photographs with a purpose in mind. This method can also be used retrospectively, where a historical photograph is acquired and a new photograph is taken of that site, group, event, etc. Cross-sectional studies using this method are also possible and valuable. This involves taking photographs at the same point in time but of different stages of a change process. The photos can then be sequenced to show the stages of the change (Rieger, 2011). An old photograph can also be layered on top of a new, modern image of the same scene. This can be accomplished by holding up an old photograph while photographing the new scene or by superimposing the picture digitally, through a process called digital compositing (see the Looking into the Past group on Flickr) (Kalin, 2013).

Rieger (2011) suggests that at least two photos and time periods (Time 1 and Time 2) be used for these types of projects. In addition, he asserts that there needs to be continuity between the photographs, such as the same geographical scene or the same or similar subjects or processes. He also suggests the following steps for rephotography (p. 19):

1. Selecting a subject that will become the focus of the research and developing a theoretical framework that suggests what changes might be expected
2. Determining and identifying visual indicators to be recorded
3. Finding existing documentation or creating such documentation for the initial (Time 1) measurement
4. Carrying out the follow-up (Time 2) documentation when appropriate
5. Analyzing the accumulated evidence

Other decisions involve whether to work with black-and-white or color photography and determining what type of equipment will be needed (tripod, multiple lenses, filters, etc.). Details of the date, time, location, and other relevant information concerning the photos should also be carefully recorded (Rieger, 2011).

Case Example: Photomapping the Services of a Community

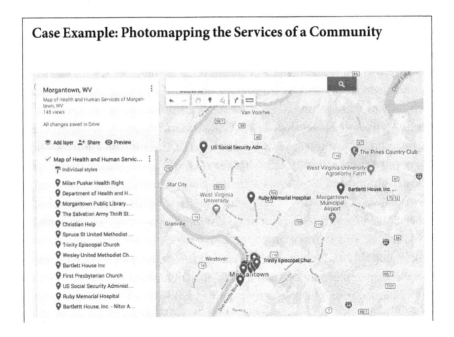

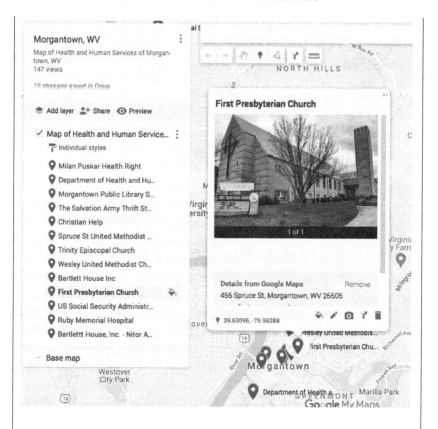

Students in an undergraduate social work course focusing on human behavior in groups, organizations, and communities produced photo maps as part of a community assessment assignment. The maps were designed to highlight assets and needs in communities chosen by students. The majority of these communities were small towns and rural areas. For example, a photo map developed with Google Maps of social and health care services in Morgantown, West Virginia (a college town with a population of approximately 30,000), shows that services for lower income residents cluster around the downtown area. These services include the local department of health and human resources, a free health clinic, a homeless shelter, a clothing closet, a library, and several churches that offer meals and cold shelter. This is important to recognize because many members of the community's homeless population live in and around this area. Having these services geographically central to this population allows for easier access. The full map (using Google Maps) can be found and navigated at https://drive.google.com/open?id=1qR3_EdlmiH_wOd5cWnBWkmVoDBf6L

4DE&usp=sharing. Google Maps is easy to use, and photos can be uploaded to the map or can be added from searchable photos from the internet.

Case Example: Rephotographing a Former Coal Camp

The community of Scotts Run, West Virginia, has a rich history of coal. Seven small communities that were former coal camps make up the area, and by the 1920s their mines produced approximately 4 million tons of coal. During the Depression, the demand for coal decreased dramatically, and this area was left financially devastated. The coal bust drove many out of the area during the Depression. The plight of this small community drew the attention and visits from First Lady Eleanor Roosevelt as well as Walker Evans and other famous photographers who documented the devastation of the area and the lives of those affected (Lewis, 1994). Historical photos of the area can be used to pinpoint where the various camps were situated and the changes to the community in recent years. These photos show the evolution of the community, as what was once a booming coal community is now unincorporated and has far fewer residents and opportunities. The rephoto shown here superimposes a photograph of the community of Osage (Wolcott, 1938), which once had a coal train running through it and many cars and residents walking and driving through the town, into the present-day town. This was accomplished using Adobe Photoshop software. The original photograph was taken by Marianne Wolcott, who was part of the Farm Security Administration. Many of the buildings still stand but are no longer the thriving businesses that sustained this small community during the coal boom.

Conclusion

Although currently an underused method in the profession, photomapping has a rich tradition in social work and social welfare. This tool has historically been and can be used to highlight needs as well as assets in communities and organizations and among groups. When participatory in nature, it can empower those impacted by disparities to produce evidence and inform and influence policymakers to enact desired changes. Mastering the necessary technology, selecting and interpreting photos to map, and training and engaging participants are challenges that can be expected but can be met with adequate planning and preparation. Rephotography or repeat photography is a related method and can be powerful in showing changes in environments or among individuals or groups over time. Both photomapping and rephotography align with the social work profession's focus on the importance of place, the environment, and the needs and assets that they can encompass. As such, these are helpful tools that can and should be more widely utilized in our research, practice, and teaching.

Glossary

Geotag(ging): A process that assigns a longitude and latitude position to photos taken on a device.

GIS: Stands for geographic information system and is a technology that captures, stores, and analyzes geographic data.

Participatory photomapping: A type of photomapping that involves collaboration with persons affected by a particular environment, in an effort to give them a voice.

Photomapping: A method that involves the use of GIS data to map significant events or places or illustrate special connections within a community or geographic area.

Rephotography or **repeat photography**: A method that involves retrieving or taking a photograph and then taking another photograph of the same subject at a later point in time with the intention of showing change.

Additional Resources

ArcGIS: https://www.arcgis.com/index.html

Flickr: https://www.flickr.com

Flickr, Looking into the Past: https://www.flickr.com/groups/lookingintothepast

Geoimgr: https://www.geoimgr.com

Google Maps: https://www.google.com/maps

Livetrekker: https://www.livetrekker.com/LiveTrekker/resources/content/ nglish/static/livetrekker/main/index.html#homeTab

Mapillary: https://www.mapillary.com

OpenStreetMap: https://www.openstreetmap.org

References

Bear, J., & Albers, K. P. (2017). Photography's time zones. In J. Bear & K. P. Albers (Eds.), *Before-and-after photography: Histories and contexts* (pp. 1–14). Bloomsbury Academic.

Burton, C., Mitchell, J. T., & Cutter, S. L. (2011). Evaluating post-Katrina recovery in Mississippi using repeat photography. *Disasters, 35*(3), 488–509.

Council on Social Work Education. (2015). *Educational Policy and Accreditation Standards.* https://www.cswe.org/Accreditation/Standards-and-Policies/2015-EPAS

Dennis, S., Gaulocher, S., Carpiano, R., & Brown, D. (2009). Participatory photomapping (PPM): Exploring an integrated method for health and place research with young people. *Health and Place, 15*(2), 466–473.

Felke, T. (2006). Geographic information systems. *Journal of Evidence-Based Social Work, 3*(3–4), 103–113.

Felke, T. (2014). Building capacity for the use of geographic information systems (GIS) in social work planning, practice, and research. *Journal of Technology in Human Services, 32*(1–2), 81–92.

Freisthler, B., Lery, B., Gruenewald, P., & Chow, J. (2006). Methods and challenges of analyzing spatial data for social work problems: The case of examining child maltreatment geographically. *Social Work Research, 30*(4), 198–210.

Germain, C. B. (1981). The ecological approach to people–environment transactions. *Social Casework, 62*(6), 323–331.

Gjesfjeld, C. D., & Jung, J. K. (2011). How far? Using geographical information systems (GIS) to examine maternity care access for expectant mothers in a rural state. *Social Work Health Care, 50*(2), 682–693

Gjesfjeld, C. D., & Jung, J. (2014). Teaching poverty with geographic visualization and geographic information systems (GIS): A case study of east Buffalo and food access. *Journal of Teaching in Social Work, 34*(5), 531–544.

Hillier, A. (2007). Why social work needs mapping. *Journal of Social Work Education, 43*(2), 205–222.

Kalin, J. (2013). Remembering with rephotography: A social practice for the inventions of memories. *Visual Communication Quarterly, 20*(3), 168–179.

Kelley, M. (2011). Collaborative digital techniques and urban neighborhood revitalization. *Social Work, 56*(2), 185–188.

Kemp, S. (2011). Recentering environment in social work practice: Necessity, opportunity, challenge. *British Journal of Social Work, 41*(6), 1198–1210.

Knight, S. A. (2016). Social services software: Integrating GIS software with social work practice. *Social Work Today, 16* (1), 8.

Kondrat, M. E. (2008). Person in environment. In T. Mizrahi & L. Davis (Eds.), *Encyclopedia of social work* (20th ed.). NASW Press.

Kretzmann, J. P., & McKnight, J. L. (1993). *Building communities from the inside out: A path toward finding and mobilizing a community's assets.* Center for Urban Affairs and Policy Research, Northwestern University.

Lewis, R. W. (1994). Scott's Run: An introduction. *West Virginia History, 53*, 1–6. http://www.as.wvu.edu/~srsh/lewis_2.html

Mohai, P., & Saha, R. (2007). Racial inequality in the distribution of hazardous waste: A national-level reassessment. *Social Problems, 54*(3), 343–370.

Morales-Campos, D., Parra-Medina, D., & Esparza, L. (2015). Picture this! Using participatory photomapping with Hispanic girls. *Family & Community Health, 38*(1), 44–54.

Queralt, M., & Witte, A. (1998). A map for you? Geographic information systems in the social services. *Social Work, 43*(5), 455–469.

Rieger, J. (2011). Rephotography for documenting social change. In E. Margolis & L. Pauwels (Eds.), *Sage handbook of visual research methods* (pp. 132–149). Sage.

Rine, C., Morales, J., Vanyukevych, A., Durand, E., & Schroeder, K. (2012). Using GIS mapping to assess foster care: A picture is worth a thousand words. *Journal of Family Social Work, 15*(5), 375–388.

Santana-Cordero, A. M., & Szabó, P. (2019). Exploring qualitative methods of historical ecology and their links with qualitative research. *International Journal of Qualitative Methods, 18*, 1–11.

Teixeira, S. (2015). "It seems like no one cares": Participatory photomapping to understand youth perspectives on property vacancy. *Journal of Adolescent Research, 30*(3), 390–414.

Teixeira, S. (2016). Beyond broken windows: Youth perspectives on housing abandonment and its impact on individual and community well-being. *Child Indicators Research, 9*, 581–607.

Teixeira, S. (2018). Qualitative geographic information systems (GIS): An untapped research approach for social work. *Qualitative Social Work, 17*(1) 9–23.

Teixeira, S., & Gardner, R. (2017). Youth-led participatory photomapping to understand urban environments. *Children and Youth Services Review, 82*, 246–253.

Teixeira, S., & Zuberi, A. (2016). Mapping the racial inequality in place: Using youth perceptions to identify unequal exposure to neighborhood environmental hazards. *International Journal of Environmental Research and Public Health, 13*(9), 1–15.

Wier, K. R., & Robertson, J. G. (1998). Teaching geographic information systems for social work applications. *Journal of Social Work Education, 34*(1), 81–96.

Wilson, K. O. (2015). Beyond the ecomap: GIS as a promising yet chronically underutilized method in social work. *Social Work and Social Sciences Review, 18*(2), 58–66.

Wolcott, M. P. (1938, September). *Train pulling coal through center of town morning and evening, Osage, West Virginia.* The Library of Congress. https://www.loc.gov/pictures/item/2017753294

7

Photo Ethnography, Documentary Photography, and Photojournalism

Neal A. Newfield and Kristina M. Hash

Overview, Key Concepts, and History

What Are Photo Ethnography, Documentary Photography, and Photojournalism?

Photo ethnography, documentary photography, and photojournalism lie along a continuum that is shaped by context and intent in production. The media are closely related and the photographs may be repurposed and used for news release, documentary, humanitarian, activist, and research purposes. Often, the photograph serves as a starting point for change. The role of the photo informant can range from passive subject, as in a news release, to a collaborative partner in a documentary or photo ethnography or a solo public storyteller such as when digital storytelling (DST) or photovoice are used in ethnographic research. The level of active involvement in the change process can vary substantially among the users of these methods.

Part of the power and frustration of photographs is that they can be multivisual. The photograph described could be considered photojournalism, documentary photography, part of a photo ethnography, or even end up in the family scrapbook as a photo of grandma and grandpa when they were younger. Pink (2007) points this out in detail, elaborating on how her photograph of a female bullfighter's braid was in one instance an ethnographic photo and the cover of her book titled *Women and Bullfighting* (1997) but also in another situation was recognized for a prize in artistic journalistic photography, used to publicize the appearance of a female bullfighter, and became a wall hanging for her informants. This fluidity begs the question of what makes a photograph photo ethnography, documentary photography,

Photography in Social Work and Social Change. Matthias J. Naleppa, Kristina M. Hash, and Anissa T. Rogers, Oxford University Press. © Oxford University Press 2022. DOI: 10.1093/oso/9780197518014.003.0007

or photojournalism. Although it may depend on purpose and context, a few delineations of and differences between the methods are offered below.

Photo ethnography can be a slippery term. Photo ethnography uses images to portray features of a cultural group or is used as a methodological tool for eliciting and examining facets of a cultural group's worldview. It is a subfield of visual anthropology that is both a means of data recording or collection and the resultant narrative and images regarding the cultural aspects of study. What is recorded are artifact and culturally expressed behavioral performances from subsistence practices to craft production, and expressions of the social lives of people, as acted out, are represented in images. Visual anthropology is also a methodology useful in ethnographic interviewing and participant observation research, allowing the researcher to cast a wider net in terms of what is recorded so that it can be reanalyzed at leisure. These products also have an audience, as in the case of films and photos that are viewed by audiences for their educational and entertainment value. This is also visual anthropology (Morphy &Banks, 1997). An example of the latter is the film, *Secrets of the Tribe* directed by filmmaker Jose Padilha (2010), which examines the ethical missteps and failings of a group of anthropologists who studied the Yanomamo Indians of Brazil, who are believed to be the last band of primitive people untouched by civilization.

In regard to photo ethnography, the reader is cautioned to remember that photo ethnography is "**ethnography**," which is also part and parcel of visual anthropology. This field is fundamentally interested in describing aspects of culture so that the theoretical underpinnings of ethnology, a subfield of anthropology, may be advanced. As such, it is a data collection tool for recording artifacts and behavioral sequences that are deemed culturally relevant, and it is also a research methodology. These qualities distinguish photo ethnography from, for example, documentary photography. Sometimes the distinction becomes less clear when photo ethnography is also a product for audiences to view. In such cases, it may merge with documentary photography.

Documentary photography, in contrast to photojournalism, reaches beyond the singular momentary event reported in the newspaper and portrays the matrix or co-arising circumstances surrounding the subject of the photographer's interest. As Kratochvil and Persson (2001) astutely point out about photojournalism and documentary photography, "They are identical mediums sending different messages" (p. 27). For the photojournalist, time is of the essence, and this shapes a great deal of the process. The documentary photographer, in contrast, has time to bask in a subject. As a documentary

photographer, one can develop relationships with one's photo informants, and this shapes the photographs. The photojournalist is a "breaking news" events recorder. A few photos are used to capture what happened, and then the photojournalist moves on to the next event. Although both tell a story, the documentary photographer has the luxury of nuancing a subject and expanding the story. Life and social issues are not one or two moments in time; they are much more complex.

Social documentary photography can be likened to an editorial or series of editorials. Most editorials take a position and ask that action be taken. The intent of social documentary photography is to draw the reader to an issue and move the viewer/reader to action or at least a sensibility on the situation. The photo informant may be recruited, as is often the case, as a partner in the product that is being produced. As in photo ethnography, described by Pink (2007), the photographer may be involved for long periods of time in building these relationships time enough to hear the photo informant's point of view, observe what is happening, and form an opinion as to what is going on and how to visually portray the subject content. The final product is a subjective, visual, and usually textual portrait that due to reflexivity, which we all possess, may at its best approximate the subjective realities or emic worldview of the interlocutor. What distinguishes the social documentary photographer from the photo ethnographer is the lack of the application of an ethnographic research methodology. Social documentary photographers are not applying the scientific method to their craft.

Photojournalism uses photos to tell a story of an issue or event to a contemporary audience (Ingledew, 2013). Photojournalism is determined by whatever the editors decide is appropriate for the current news cycle. The focus is on incidents or events that justify reportage to the news channel, paper, or other outlet to which the photographer is responsible. Editors want unambiguous photographs that are easily interpreted by the readership. Photojournalists often have multiple assignments in a day, which means they are running from photo shoot to photo shoot with little time to develop a relationship with the people being photographed or time to delve into the complexities or back stories of the issues and people on which they are reporting. In the modern/postmodern discussion, photojournalism is positioned as "reportage," which assumes an objective reality that is knowable. There is little time for the reflexive interviewing and relationship building that allow one to enter the world of the "other" and allow one to present the other's point of view, searching for meanings behind meanings.

I do not ~~to~~ Like to MOVE in to town.

Image 7.1 She sweeps the steps to her home built of discarded lumber with a hammer and a chain saw by her parents. They live within 45 minutes of a fancy mall.

*All photographs in this chapter were part of a documentary on Making Ends Meet in West Virginia. This project is discussed in the chapter. Photo informants wrote uncensored, in their own hand, statements concerning the photograph and what they wanted to say about their life. All photos copyright Neal Newfield.

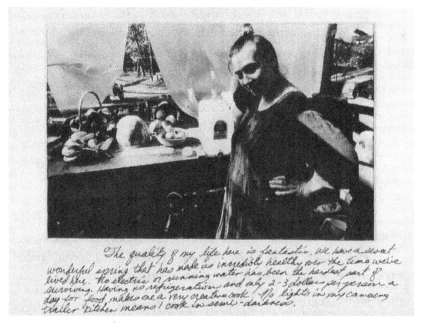

The quality of my life here is fantastic. we have a dead wonderful spring that has made us incredibly healthy over the time we've lived here. No electric or running water has been the hardest part of surviving. Having no refrigeration and only 2-3 dollars per person a day for food makes one a very creative cook. No lights in my camping trailer 'kitchen' means I cook in semi-darkness.

Image 7.2 Poverty can appear idyllic. This mother's caption, in her own hand, says it all. Is there another story behind this story?

Origins and History of Photo Ethnography, Documentary Photography, and Photojournalism

With a basic understanding of the differences between the three related methods, the history and foundations of photo ethnography, documentary photography, and photojournalism can now be examined.

Ethnography and Photo Ethnography

Before discussing the visual or photographic component, it is first important to understand the basic foundations of ethnography. Originating in the early 1900s from the disciplines of sociology and anthropology, ethnography focuses on the study of cultures. A culture can be identified as an ethnic group living in a certain geographic location, or it can involve an online community or a particular organization. Ethnographies have primarily been used for the purpose of research, are qualitative in nature, and involve thick description. They are also immersive, meaning that the ethnographer engages in the lives and environment of those being studied. This

immersion can either be overt or covert, and it occurs over an extended period of time. This is often called fieldwork, and key methods incorporated into this work are participant observation and interviews (Berg, 2008; Fetterman, 2008; Harrison, 2014).

As mentioned previously, a traditional feature of ethnography has been the immersion of the researcher in the culture that is being studied. In the past, this involved anthropologists living among their study participants for a year or more. Malinowski (1922) proposed "going native" or being a participant in the culture rather than an observer. He conducted fieldwork for several years in the Trobriand Islands and is considered a forerunner of ethnographic research. Other classic ethnographic works include Margaret Mead's (1928) 9-month immersion and study of adolescent girls living in Samoa and Erving Goffman's (1961) work that included his 1-year fieldwork in a mental institution. James Spradley (1979), a pioneer in ethnography and the ethnographic interview, provides what might be the essence of ethnographic inquiry:

> I want to understand the world from your point of view. I want to know what you know in the way you know it. I want to understand the meaning of your experience, to walk in your shoes, to feel things as you feel them, to explain things as you explain them. Will you become my teacher and help me understand? (p. 34)

Today, there are a variety of ways in which researchers use ethnographic methods that do not involve such a time or life commitment. Ethnography has also spread to other disciplines, including business, nursing, public health, public policy, education, communications, and social work. Indeed, social work researchers have found ethnography to be a useful approach that fits well with the values of the profession.

Photo ethnography is a more recently developed method and adds a visual component to the traditional ethnographic approach. The term *ethnography* originates from two Greek words: "ethnos," meaning "people, nation, class, caste, tribe," and "graphia," meaning description (Online Etymology Dictionary, n.d.). Derivations of graphia may be found in terms such as graph paper and the toy "spirograph" or used to describe photos as pornographic. The graph implies drawing, description, and images. It is not surprising, then, that ethnographies often involve the use of photographic images. In fact, the use of photos in ethnographies can be traced back to the early 1900s (Ball & Smith, 1992). **Visual ethnography** is a subtype of the ethnographic tradition and its use is growing.

It involves the use of audiovisual media, including photographs, video, film, drawings, webpages, and even virtual reality. Whatever the tool, the visual ethnographer focuses on visual aspects to methodologically investigate, represent, understand, and explain aspects of a culture and the people studied. Although visual methods have been criticized for allowing for too much subjectivity on behalf of the researcher, current practices have involved the use of video and more participatory methods, in which the subjects are asked to provide their reflections on the visual image or the cameras are put in their hands. This participatory piece is called **photo elicitation**, in which subjects are asked to share their understandings and analyses of photos, videos, or other visual data that are presented by the researcher (Berg, 2008; Pink, 2011).

Documentary Photography

Documentary photography has a long history and includes a variety of genres. As early as 1861, Mathew Brady and others began documenting the battlefields of the Civil War and shocked readers with photographs of the Civil War dead. Later, the Civil War photographers became involved with conservation documentary photography as they traveled with the geological surveys and pictured distant landscapes of the West. In the 1850s, ethnographic documentary photography came about with the work of such people as John Beasley, who made photographs of ancient ruins in Nubia. All of these forms of documentary photography have continued and advanced in their sophistication.

Social documentary photography as social commentary is the field most relevant to social work practice and has a rich history in the United States. As Becker (1995) states,

> Documentary photography was one kind of activity around the turn of the century, when great waves of social reform swept the United States and photographers had a ready audience for images exposing evil, and plenty of sponsors to pay them to create those image. (p. 1)

This was the fertile field in which social documentary photography developed. At that time, photographers such as Roy Stryker were hired to show the faces of rural poverty with the assumption that photos would be more powerful than facts and news articles in educating and building public sympathy for this social problem and the efforts to alleviate it. The emotions elicited by these photographs would allow individuals to better understand the plight of their fellow Americans (McDannell, 2004). As Light (2000) explains of these

early documentary photographers, "To remedy a problem, they reasoned, we must first see it. And people of goodwill, once they see it, will work to correct it" (p. 5). Dorthea Lange and others who came before her also provided a real-life glimpse into the lives and work of immigrants and other laborers in the fields of California. The work of Stryker, Lange, and their contemporaries who engaged in social documentary not only transformed the photo as something that could educate and persuade but also shaped the documented memories of significant periods and social problems in history (Street, 2006). As such. the method can document a problem, condition, or event to be understood by viewers in the future and serve as a testament that something did indeed happen and that it was evidenced, and the photographers become witnesses to the times (Light, 2000). Indeed, throughout the 20th century, social documentary photographers have witnessed and photographed major events such as the American civil rights movement, World War II, the Vietnam War, war and human rights violations in Central America, apartheid in South Africa (Light, 2000), and the HIV/AIDS epidemic. Szto (2008) notes that social documentary photographs were also used to promote social and policy change by illuminating the living conditions of immigrants, work conditions of factories, poverty, pollution, and the influence of corporations.

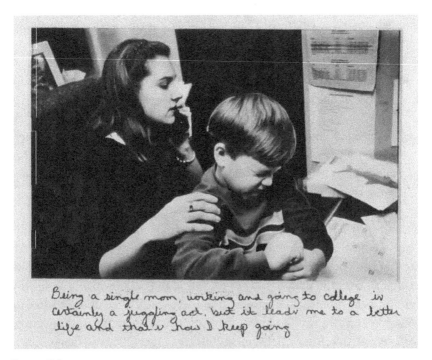

Being a single mom, working and going to college is certainly a juggling act, but it leads me to a better life and that's how I keep going

Image 7.3

I was told to quit College and take a minimum wage job or I would lose my benefits

Image 7.4

I have a brain cyst and get SSI. My daughter is 17 yrs old and makes $175.00 every two weeks. Welfare counts her pay against me and reduces my food stamps. To keep my family going - I have to take her money to help with food expenses.

Image 7.5

Photojournalism

Photojournalism is the wedding of photography to journalism. Throughout its history, photojournalists have been "the eyes on the scene" and in the midst of the action that they photographically report. Robert Capa, who covered the Spanish Civil War, stated, "If your pictures aren't good enough, you aren't close enough" (as cited in Becker, 1995, p. 6). Thus, the history of photojournalism is a developmental history that is an outgrowth, to a large extent, of war and technological advancements. Carol Szathmari, with his 1850 engraving from a photograph of the Crimean War, is often cited by historians as the creator of photojournalism (Towne, 2020). Still others mention Roger Fenton, whose photographs appeared in the *Illustrated London News* as engravings, as being the "first great war photographer" (Estrin, 2018). Nods are also given to James Robertson and Felice Beato as the first war photograhers (Griffin, 1999)

In U.S. history, Mathew Brady photographed the Civil War for *Harper's Weekly,* employing 20 assistants, each with a wagon containing a portable darkroom for wet glass plate negatives, which was the technology of the times. The images made were limited because movement could not be readily recorded due the long exposure times required by the technology. Posed photographs of camp life and the aftermath of battles were used to bear witness to what occurred. The images of the war shocked readers (Griffin, 1999).

It was during the second half of the 1800s that photojournalism began moving from war and disaster reporting to something more. In 1876, Scottish photographer John Thompson published in his monthly magazine *Street Life in London* photographs along with textual accounts by the journalist Adolphe Smith. In 1876 and 1877, Thompson and Smith produced accounts in *Street Life in London* that became a book by that title. The development of flash photography opened up the possibility for less posed photographs and indoor photographs as well. Halftone printing replaced the more laborious process of engraving and opened up photographs as a medium for newspapers (Stewart, 2017).

Photojournalism continued to account for war, conflict, crisis, and major events throughout the 1900s. In fact, the magazines *Life* and *Look* were considered picture magazines that were dedicated to photojournalism during the 1930s–1970s (Stewart, 2017). Today, photojournalism continues its publication in print newspapers, but increasingly it appears in such platforms as

Twitter and Tumblr. This expansion has allowed for professional and non-professional photojournalists to share their work across borders, right to the laptops and smartphones of a global audience (Keller, 2011).

Goals of Photo Ethnography, Documentary Photography, and Photojournalism

Although residing along the same continuum, photo ethnography, documentary photography, and photojournalism have distinct purposes and goals. Photo or visual ethnographies aim to understand and portray the social realities and worlds of people, often from an insider's perspective (Berg, 2008). The goal of documentary photography, is to collect a portfolio of images that represent the breadth and depth of a subject, not just a moment in time. The perspective of the subject portrayed could be that of the photo subjects or that of the photographer. The documentary process creates a record or historical document of a subject interpreted by a viewer. Documentary photography also has a similar purpose as photojournalism in that it often attempts to tell a story and make a difference. Photojournalism, however, tells a story to illuminate an important issue or event to a contemporary audience (Ingledew, 2013). In addition, as Kratochvil and Persson (2001) note, photojournalism records "frozen instances" or events, whereas documentary photography "reveals the infinite number of situations, actions or results" or life (p. 27).

Theoretical Foundations of Photo Ethnography, Documentary Photography, and Photojournalism

Whether including visual components or not, most contemporary ethnographies are rooted in an interpretive tradition, which focuses on how individuals interpret and make meaning from their social worlds. Clustered under the interpretive tradition, the closely connected theories of symbolic interactionism, hermeneutics, and phenomenology also commonly guide ethnographic inquiry. Symbolic interactionism is concerned with shared meanings constructed through interactions between individuals and the importance of social contexts. Hermeneutics and hermeneutic theory deal with

interpretation (of individuals, cultures, history, texts, etc.), and phenome-nology seeks to understand how individuals categorize information received from the senses, most often from everyday social experiences and cultural contexts (O'Reilly, 2009). Indeed, ethnography and photo ethnography at-tempt to provide a glimpse into the social worlds of individuals and how they interact with others and society. Documentary photography and photo-journalism are not typically linked to particular theoretical underpinnings. Both methods do involve interpretation on the part of the viewer, and subject matter commonly includes aspects of social experiences and contexts. On the other hand, photojournalism in particular is thought to be "factual," ob-servable reality, which implies a more positivistic (rather than interpretive) view. Benovsky (2011), however, notes that photography cannot always show us the world in a "factual" or "realist" way because photographs are always framed, taken at a certain angle, and edited by the photographer.

Advantages and Challenges of Photo Ethnography, Documentary Photography, and Photojournalism

Photo ethnography, documentary photography, and photojournalism have been described and differentiated in previous sections in terms of basic definitions, backgrounds, goals, and theoretical underpinnings. These methods also have similar as well as distinct advantages and challenges to their uses, which are detailed in the following sections.

Advantages

The most notable advantage of photo ethnography, documentary photog-raphy, and photojournalism is that the purposes and focuses of these methods align well with the values of the social work profession. Each attends to the importance of human relationships and the impact of the social and physical environments on individuals. When there is an intent to initiate and impact change this is also a goal that fits well with social work.

Photo ethnography provides a medium for eliciting information from eth-nographic informants. In addition, it provides visual evidence to support what is described in text. It also provides voice to often voiceless informants. Documentary photography, although lacking the methodological rigor of

ethnography, can inform the viewer about complex life situations. The view presented may represent solely that of the photographer or reflect the views of informants. Photojournalism or what might be considered momentary event photography gives us a report of "breaking news" and puts our eyes on the scene. Through photojournalism, news events can reach (or potentially reach) large numbers of people and provide views of the world and of issues of which they are not aware. Whether photo ethnography, documentary photography, or photojournalism, a strength is that as visual animals we tend to believe what we see.

Challenges

Although each has a rich history and offer many advantages to the field, the most significant challenge to the use of photo ethnography, documentary photography, and photojournalism is that these methods are not commonly applied in social work. Without visibility, researchers and practitioners would not be familiar with the methods and their potential uses and benefits. Other common challenges to these methods are privacy and confidentiality. These issues are discussed in Chapter 2. Maintaining privacy and confidentiality with these methods in particular can be difficult given the controversial issues that may be depicted in the photographs of individuals and groups of individuals. Given its in-the-moment focus, photojournalism projects often encounter this challenge.

Photo ethnography can also be burdensome to the inexperienced researcher because it requires a familiarity with ethnographic research methods. Ethnographic research methods are not taught in many graduate programs.

Photo ethnography and documentary photography share the common challenge of time, with both requiring long-term or somewhat long-term engagement in an organization, community, or with an issue. Photo ethnography in particular requires a great deal of time to build trust with participants and carry out the project. Of course, this engagement can be advantageous; photojournalism may suffer from having too little time spent with individuals or in a setting. Depending on the level of emersion, photo ethnography projects may also face the challenge of bias in terms of describing culturally held views. Photojournalists may also face this issue because they are often beholden to the entity that is supporting and publishing their work.

Best Practices: Application of Photo Ethnography, Documentary Photography, and Photojournalism in Various Fields of Practice

This section focuses on understanding lives and cultures, eliciting emotion, and promoting change, which make photo ethnography, documentary photography, and photojournalism an excellent fit with social work, including education, practice, and research. Ethnography and photo ethnography have been far better utilized by the discipline, although the other methods have also been applied.

Applications in Education

Documentary photography and photojournalism are subjects and methods that are traditionally taught in the schools of journalism rather than in social work. Ethnographic methods, however, have been taught to social work students for research and practice purposes. Thornton and Garrett (1995) utilized ethnographic tools, including interviews, observations, and document reviews, for social work students to learn about different cultural groups and how to apply the knowledge gained to cross-cultural practice. Sells et al. (1997) developed educational modules on ethnographic research methods for master- and doctoral-level social work students, in which the final module allowed students to use interviews to evaluate clinical practice with a certain client population. As a practitioner, Seeley (2004) made use of and advocates for using ethnographic inquiry in clinical practice, particularly when clients are from a minority culture. She further asserts that the short-term nature of psychotherapy and models of treatment based on Western philosophies can make treatment of this population very challenging. Culturally sensitive clinical tools, then, are of upmost importance for effective treatment. Instead of relying on preconceived and often generalized knowledge about different cultures, utilizing ethnographic methods can uncover a more specific understanding of the experiences, strengths, struggles, and supports of clients. Central to this approach is eliciting an understanding of how aspects of a client's culture may contribute to their difficulties and experiences. This can be discovered through the inquiry of the role that cultural aspects (traditions, language, roles, emotional expression, relationships, social activities, etc.) play in the client's life.

Applications in Practice and Research

Literature related to the use of photo ethnography, documentary photography, and photojournalism in social work practice is nonexistent or not very visible. This is not to say that these methods could not be used in the field, particularly because they are taught in formal programs and used by researchers. Findings from research using these approaches, of course, can be applied to practice settings and populations.

In what has become a classic book, *You Owe Yourself a Drunk*, James Spradley (1970) portrayed the lives of homeless "bums" in Seattle during the 1960s. His ethnographic account raised issues concerning the politics of poverty that impact police, judges, and lawmakers with regard to how they respond to the homeless. *Making It Crazy: An Ethnography of Psychiatric Clients in an American Community* by Sue Estroff (1981) describes what the everyday life of a psychiatric patient is like, presenting points of view on sheltered workshops, medication, problems with rehabilitation, assistance, and the psychiatric patient as an occupation. Although these are ethnographies, they could well have had a photo ethnographic component. How much richer and more effective might our social work practice be if we incorporated the voice and point of view of those we treat as "other" into our practice. What might a photo ethnography on obesity teach us about the fattening of America or how it is that some people use drugs can stop taking them without outside intervention? What are the natural curative factors that are applied that we could use in our social work practice?

Not surprisingly, ethnography has been used by social work researchers in studying the issues and challenges faced by oppressed populations, including persons living in poverty and ethnic and social minorities. Iversen and Armstrong's (2007) ethnographic study discovered that a multilayered condition of lower income parents' work and education, depressive symptoms, and policies and programs impacted the economic mobility of families. Thrasher and Mowbry (1995) studied homeless women and their children using ethnographic interviews to identify the challenges they faced and the great strengths they demonstrated in response to these challenges and in their ability to keep their families intact. In a mixed methods study, Copeland and Snyder (2011) used ethnographic interviews to understand the experiences of and barriers for low-income, African American mothers whose children were receiving behavioral health services. Holleran and Waller (2003) used participant observation, focus groups, and interviews in

an ethnographic study focused on Chicano/a teens and their cultural identity and values and resilience. Breitkreuz and Williamson (2012), through ethnographic interviews, learned how the experiences of welfare to work participants in Canada were effected by the policies that govern the program, and Cleaveland (2007) studied a similar group in the United States. Last, Jennings et al. (2014) used observations and interviews to understand the experiences of older adults who were relocating as well as those of their families.

Social work researchers have also incorporated ethnographic methods to better understand organizations. For example, Bartle et al. (2002) conducted an organizational ethnography utilizing data from a long-term study of an organization, including interviews, focus groups, participant observation, and review of documents, that resulted in a substantially change to more empowerment-based programming for a child development service. Newfield et al. (1990, 1991, 1996) used ethnographic interviews in order to tease out how families made sense of the "unusual behavior" of their therapists while in family therapy and advocated for ethnographic research methods and a clinical science of the humanities. Smith and Spitzmueller (2016) conducted ethnographic interviews and participant observation in a study of two mental health organizations to determine how a specific approach to therapy employed by the organizations was used in contemporary practice.

Although examples from the field of social work are relatively nonexistent, photo ethnography has grown in use among other disciplines and researchers. Schwartz (1989) visited a small community in Iowa, took photos (of locales, events, families, and farm activities), and then conducted photo interviews with residents to elicit what was important to community members across generations. Lenette and Boddy (2014) used photo ethnography to understand the lives, challenges, and resilience of single refugee women in Australia. The researchers used photovoice, photo elicitation, and DST. DST is a method that involves the creation of multimedia personal narratives or stories using photographs, voice, and music. Sarah Pink (2008), a scholar and leader in applied visual anthropology research, has focused on environments and movement through them. These investigations can help inform interventions in these environments. In 2009, she guest edited a volume of a journal that focused on examples of visual anthropology. Within this volume, Jhala (2009) described a collaborative effort by visual anthropologists, government and aid agencies, and residents

in which audiovisual messages were produced to portray "empathy stories" of the victims of an earthquake in India and to promote relief efforts for them. Similarly, Flores (2009) showed the power of collaborative filmmaking in highlighting the lives and identities of an Indigenous group in post-war Guatemala. Stadhams (2009) used visual ethnography and produced a television program to understand the challenges as well as opportunities in promoting tourism as a means to reduce poverty in Gambia.

Documentary photography and photojournalism have received far less attention in terms of social work and related research. In the tradition of social documentary photography, Smolan and Ewitt (2017) present photographs, essays, videos, and music that document the struggle for justice in America during the past 100 years for racial and social minorities. The work highlights how far we have come as a nation, our shortcomings, and how we can take action to combat continued injustices. On an international level, photojournalist Lois Raimondo has studied the impact of war, including the suffering and the hope, in Iraq (2004) and Afghanistan (2002). Social worker and educator Neal Newfield et al. have documented human trafficking and human rights in Vietnam and Cambodia (Newfield, 2007; Newfield et al., 2008, 2013) as well as the pervasive poverty and resilience in rural Appalachia (Newfield, 2004a). In addition, contemporary social documentary photographers have provided glimpses into the problems of homelessness, domestic violence, and living with HIV (Light, 2000). In terms of photojournalism, the first author of this chapter previously wrote a regular column in the magazine *Social Work Today* (e.g., Newfield, 2004b) that included text and photos of contemporary social work issues and practice.

A Step-by-Step Process of Photo Ethnography, Documentary Photography, and Photojournalism

If you want to take up the camera as a social worker photojournalist, documentary photographer, or photo ethnographer, the following is a "punch list" of considerations:

1. Learn to see like a camera. A camera records what is in front of it, not magnifying or ignoring portions of the image due to emotions or thoughts that are focused on by the photo maker. Learn about framing, f-stops, and depth of field; how to take night photographs; panning

and blur; how to use a flash appropriately; whether to use jpg, tiff, or raw digital formats; and what aesthetically constitutes a good photograph. Take hundreds of photographs and have them critiqued by accomplished photographers. Read *The Beginner's Photography Guide* (Gatcum, 2016) or *Digital SLR Cameras and Photography for Dummies* (Busch, 2014), or better yet, take a course in photography.

2. Making technically well-executed photographs will save you post-production time but it still will not get you off the hook. An old dictum among photographers is that half of making a good photograph takes place in the darkroom. These days it is in front of the computer using Photoshop. Learn how to burn and dodge images, erase distracting elements from a photo, or increase the level of detail in a photograph.

3. Good photo ethnography is done by ethnographers who are steeped in anthropological theory and research methodology. Have patience; it is a rather steep learning curve. Take the time to grasp the theories and research method but take heart. Bollinger and Menchaca (2014) have written an excellent primer on ethnographic methods for undergraduate student, and it is a first-rate introduction to the subject for the rest of us as well. The book, *Ethnographic Choices*, discusses what is culture; examines positivist, constructivist (interpretative), and critical research paradigms; and then launches into social observation and autoethnography, ethnographic interviewing, and interpretation and analysis. The book emphasizes the ground theory of Glaser and Strauss (1967) and discusses the divide that has occurred in this methodology. Spradley's two books, *The Ethnographic Interview* (1979) and *Participant Observation* (1980), provide a systematic and gentle introduction to the qualitative research methods of ethnography and tend to have a semantic and linguistic approach to them. Amazon.com has a collection of books focused on "doing ethnography."

4. Taking photographs in public spaces is protected under the First Amendment. In public, you may take photographs without consent or releases. If a photo is not being used for commercial and advertisement, a model release is not necessary. Refer to the American Society of Media Photographers' website for additional details. There are also rules governing minors and exceptions for fine art prints for which you do not need a release (https://petapixel.com/2015/05/20/how-to-prot

ect-your-rights-as-a-photographer-in-the-modern-world). If in doubt, it is best to get a model release or consult an attorney. The Reporters Committee for Freedom of the Press has published a detailed *First Amendment Handbook* that is a useful reference tool (https://www.rcfp. org/resources/first-amendment-handbook). If your photography is for the purposes of research, it is best to get a determination from your institutional review board (IRB) as to whether consent forms and model releases are required. Documentary photography may also be considered as research by the IRB. If you work for an agency that does not have an IRB, IRBs of nearby universities will sometimes review proposals as a courtesy.

Case Examples

Both a documentary photography and an ethnographic case example are presented next. Both are projects with which the first author was engaged.

Documentary Photography

In the summer of 1999, the first author agreed to begin a photography research project for the West Virginia Community Voices Partnership and the West Virginia Center for Civic Life. The resulting photographs were intended to document the lives of West Virginians struggling with issues involved with making ends meet, including housing, childcare, unemployment, food shortages, lack of health care, and family fragmentation. In a series of deliberative forums throughout the state, the changing economy was presented along with the changing job market, growing income gap, shrinking safety net, and the challenges faced in education. Following the Kettering deliberative forum model (https://www.ketter ing.org/content/issue-guides-and-issue-frameworks), participants in a structured manner deliberated on what should be done to support West Virginia working families. Twenty-eight forums were conducted, and the documentary photographs produced for this initiative were on display and used in promotional materials for the forums and in the forum guide (http://www.wvciviclife.org/downloads/issue_briefs/Making_Ends_Mee t_guide.pdf). The conclusions of the forums were summarized and distributed to the state legislature (http://www.wvciviclife.org/downloads/ Making_Ends_Meet_WV_forum_report.pdf).

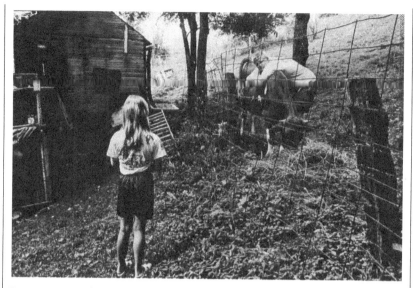

Image 7.6 You become more intimate with your food when you grow it to survive. In galleries viewers were often confused by the caption the boy wrote, "Food".

The goal of this documentary photography project was to take an una-bashed, unflinching look at the struggles of West Virginians making ends meet and foster people to take action. The intent was to develop a visual narrative to invite action to correct the present situation. This was done while following the guidelines of photography that generally lead to aes-thetically pleasing and engaging images. Perspective photo informants were fully "read in" to the intent of the project. Informants were often recruited through snowball sampling, which meant that a neighbor or friends had explained to them the purpose of the photographs and what the experience of being photographed would be like before they agreed to see the photographer. Visits with photo subjects were not conducted without their consent. Perspective informants were contacted through phone calls or those who were already participating in the documentary project would recruit their friends, make introduction, and assure that perspective participants were willing to meet with the photographer. It is best to be introduced, ask permission, and be invited. It is the polite way to behave and safer as well.

When possible, the photographer visited a family multiple times. People were interviewed concerning what their most pressing "making

ends meet issues" were. It was explained that these issues would then be portrayed in photographs. Photo informants were told that this was an opportunity to tell a bit of their story when it came to struggling with issues of making ends meet. The images would tour the state, be incorporated into the deliberative forums, be included in a report submitted to the West Virginia State Legislature, and eventually be archived in a museum.

To be exhibited, each photograph needed to have a mat around it. On this mat, the photo subjects were invited to write anything they wished to say uncensored, even if it was obscene, and it would be put on display. This was their opportunity to frame the picture in a manner that better expressed their view of the issue being portrayed or correct any misperceptions people might have. A fair number of photo subjects took at least an hour to decide what to say and write it on the mat. The overall sentiment of people was gratitude that their voices and predicaments that had been silenced would be put on display.

The bulk of the photo documentary work of this project was conducted between 1999 and 2005. A variety of venues for the photographs meant greater exposure concerning the issues portrayed in the photographs. The documentary photographs were displayed in multiple juried exhibitions, exhibited in digital or print form at 28 forms throughout the state and repurposed in magazine articles for *Social Work Today* (Newfield & Hinkle, 2003, pp. 6–7; Newfield, 2004, pp. 8–9; Spence, 2005, pp. 10–11), covering issues such as inadequate housing and domestic violence. Lohmann and Lohmann also produced the images as a portfolio in their edited book, *Rural Social Work Practice* (Newfield, 2004a). The photographs have been used as part of poverty simulations, used in workshops on photography for social workers, used as posters to raise awareness of issues of making ends meet or to promote social work as a profession, and have been hung in art galleries.

Photo Ethnography

This research case example was not a photo ethnography. Pink (2007) identifies photo surveys, photo elicitation, and informant-produced images as three of a number of ways that photographs can be used in ethnographic fieldwork, and these tools could have greatly enhanced a previous ethnographic study conducted by the first author of this chapter. Photo surveys are basically visual catalogues often of artifacts and can be useful in statistical data collection. For instance, in poor rural areas,

taking a "windshield" survey with photographs of satellite dishes, electrical wires, cars, broken windows, houses with outdoor toilets, the level of disrepair of houses and whether they are painted, the number of "garage sales," garbage management, and road maintenance would give one a quick read on the health and well-being of a community and could be benchmarked for changes over time. In photo elicitation, photographs are taken that are by their very nature ambiguous, and they are presented to an informant almost as a psychologist presents a Rorschach ink blot to a client. What is received from the photo informant is a cultural view/interpretation of what is in the photograph. Last, one can hand the camera over to the photo informant so that they can produce the images. In doing so, the photo informant gains greater freedom to choose what is culturally significant/meaningful to them. In working with homeless men, for instance, the first author found himself being asked to take photos of cardboard, plastic, and newspaper lying in the woods. This was significant to the photo informant because the cardboard was his bed, the plastic kept him dry, and the newspaper was used as stuffing in clothes for warmth. Passing by in the woods, this "camp" looked like a discarded heap of trash. Handing the camera over to the photo informant also gives the ethnographer access to venues in which they would not be welcome or at the very least their presence would disrupt the flow of behavior. In discussing visual ethnographic methods, Linette and Boddy (2013) mention photo elicitation, photovoices, and digital storytelling. Photovoices or shooting back projects basically involve handing the cameras over to photo informants so they can tell their stories.

The study "We Can Tell You About 'Psychos' and 'Shrinks'" is a mini-ethnography of family therapy giving an initial account of family therapy treatment based on strategic and structural therapy models from the insider's view of the families who were going through treatment. How they made sense of what their therapists did and the process they were going through was a main focus (Newfield et al., 1990, 1991). It is a mini-ethnography in that it is limited in scope (Leininger, 1985), the intent being to develop an ethnographic account of family therapy, and is not concerned with giving the broad sweeps of a culture. This investigation was part of a National Institute on Drug Abuse (NIDA) 4-year study examining the effectiveness of strategic and structural therapy in the treatment of adolescent drug abuse (Quinn et al., 1989).

Twelve families were interviewed for more than 76 hours in this opportunistic sample. With a few exceptions, interviews took place in informants' homes in order to foster an atmosphere of intimacy and comfort. IRB consent forms were signed, and interviews were audiotaped and transcribed into text for analysis. Interviews typically lasted 90 minutes, and most family members participating were interviewed two or more times so there was follow-up. Interviews followed the developmental research sequence (DRS) as detailed by Spradley (1979). The DRS is a 12-stage sequence ranging from strategies for locating key informants to discovering culture themes and writing the ethnographic report. For purposes of this chapter, the following steps are briefly touched upon: 4, asking descriptive questions; 5, analyzing ethnographic interviews; 6, making a domain analysis; 8, making a taxonomic analysis; and 10, making a componential analysis. For a detailed discussion of these and other stages, see Spradley (1979).

Asking descriptive questions is tricky because informants have translation competency. For example, if I ask an informant to define "family therapy," the informant is likely to respond using the term "family therapy" even though it might not be their commonly used term or part of their vocabulary. Similarly, the interviewer's answers to questions posed by the informant could elicit/shape the informant's next response in a recursive manner. It is important to begin with general questions so the experience described is reflecting the cultural view of the informant. Had this research been photo ethnographic in nature, we likely would have used the videotapes as a photo-eliciting device. The researcher would have suggested to the informant that they watch a tape together and that the informant stop the tape to identify points of interest. A number of things would have been achieved by doing this. This photo elicitation would be a grand tour of their cultural experience. Culturally relevant scenes would be elicited by the informant. Each of these elicitations could then become a mini-tour. So, for instance, in going through the tape, the informant might mention that his daughter is sitting near his wife. A mini-tour such as this might result in the informant describing how it is determined who sits near whom and the implications that they take from the seating. Along with the tour, the ethnographer would be collecting the "native's" unique vocabulary surrounding events.

From the informant's responses, the ethnographer begins to construct domains. A domain is the relationship between a native category or folk

term as indicated by a cover term and a number of other categories. So, for instance, informants in the NIDA study referred to family therapists most commonly as their "shrink" or "psycho." Under this native category or cover term were included pastors, counselors, psychologists, psychiatrists, and social workers. A further step is to apply taxonomic analysis and examine the subset of relationships within a domain along dimensions determined by the informants. For the domain of "psychos and shrinks," dimensions of contrast included caring, life experiences of the counselor, technical expertise in therapy, being able to address serious problems, and being able to dispense medications.

In examining caring from highest to lowest, informants listed their "shrinks" thusly: pastors, counselors, psychologists, psychiatrists, and social workers. Social workers were rated the least caring of the "shrinks." Stating that social workers are the least caring and pastors are the most caring says everything and says nothing. This is where photo elicitation could have been a valuable tool. All therapy sessions were videotaped. Family members could have been asked to review tapes with the ethnographer. What would they have identified as caring, neutral, and less than caring behavior?

In putting forward common factor therapy, Duncan and Miller (1999) identify alliance as a key component of successful outcomes in therapy. Alliance is based on supporting the client's preferences in counseling ("I feel heard, understood, and respected"); the therapist taking the lead from the client with regard to goals, topics, and purpose ("We work on and talk about what I want to work on and talk about"); and the approach or method of the counselor ("The therapist's approach is a good fit for me") (Duncan, 2011; Miller et al., 2002). Using photo elicitation could have fleshed out what caring behavior looks like to clients. Perhaps the term caring is a gloss for what Duncan and Miller (1999) would describe as alliance factors, or maybe not.

Additional domains of inquiry that emerged from the interviews of informants included settings, characteristics of the counselor, adolescent "bullshitting," and how counseling progresses. Each of these domains could have been enriched through photo elicitation. It would also have been illuminating to chronicle the clash of cultures that goes on between the therapist and the family they are seeing. The therapist's performance is consistent with the cultural guidelines of structural and strategic therapy with which they have been enculturated through their educational

experience, whereas the family members may interpret the behavior in a starkly different way.

Therapists spend a great deal of time focusing on what occurs in the therapy room. However, the bulk of the client's time is outside of the consultation room, and so the therapist must rely primarily on the client's memory and reports of what occurs. It is not uncommon for therapists to ask clients to keep logs of targeted events. Cameras in the hands of clients could cast a broader net and would be less structured and problem oriented, resulting in a more emic approach to what is happening in the client's life. In this ethnography, it would have enriched the ethnographic inquiry had the members of the families documented, through a photovoices project, what happened at home that they deemed significant. It would have been interesting to examine the emic view of what occurred at home with the etic view of the professional therapist and then further learn from the families how they dealt with this difference in view as it was expressed in therapy.

In DST, ethnographic informants use multimedia to narrate their life experience using voiceovers, photos, video clips, and music. These usually are short clips of the person's life created using digital media. As noted by Lenette and Boddy (2013) and Castleden et al. (2008), DST empowers informants, creates a sense of ownership for those involved, and is culturally sensitive. By putting the media production in the hands of the informants, it encourages subtle distinctions and shades of meaning and expression concerning the subject matter being presented. In regard to the ethnography of family therapy, DST could certainly have added a nuanced understanding of the informants' lives and their at-home experience in terms of both struggles and resilience and how these might relate to their therapy experience. The greatest value of DST, however, might be in the service capacity of informing families as to what therapy is like and how it interfaces with their strengths and life challenges.

Conclusion

Photojournalism, documentary photography, and photo ethnography are defined by context and by the intent of the user. Each of the three approaches has utility for social workers. For example, social work photojournalism in public and specialized venues can keep social workers and the general

readership abreast of news events that impact social services. In addition, documentary photography and photo ethnography are in line with social work's emphasis on empathy and understanding the lives of the people who social workers try to help. Social documentary photography may be likened to a visual editorial and historically has been used as a means to rally the public to a call for action and continues to be used as such. Last, photo ethnography is steeped in the theoretical and methodological conduct of ethnographic inquiry found in anthropology. As such, it is well suited as a research method for those inclined to conduct research. All three methods have the potential to impact change as well as to empower the subjects of their inquiry; thus, they should be more widely used and applied by social work researchers and practitioners.

Glossary

Documentary photography: A type of photography that provides a historical record of an issue or event

Ethnography: A researcher method that studies a human culture from the insider's perspective

Photo elicitation: A technique in which subjects are asked to share their understandings and analyses of photos, videos, or other visual data that are presented by a researcher

Photo ethnography: A type of ethnography that uses photographs to understand a culture

Photojournalism: A type of journalism that uses photos to tell a story about an issue or event to a contemporary audience

Social documentary photography: A type of documentary photography that specifically examines and provides a record of social issues

Visual ethnography: A field of ethnography that utilizes photographs, video, film, and hypermedia to understand a culture

Additional Resources

American Society of Media Photographers: https://www.asmp.org

Doc! Photo Magazine: https://blowuppress.eu https://blowuppress.eu/collections/doc-photo-magazine

Maine Media Workshops + College: https://www.mainemedia.edu
MasterClass: https://www.masterclass.com
Photoethnography.com: http://www.photoethnography.com
Social Documentary Network: http://socialdocumentary.net
The Missouri Photo Workshop: http://mophotoworkshop.org

References

Ball, M. S., & Smith, G. W. (1992). *Qualitative research methods: Analyzing visual data*. Sage.
Bartle, E. E., Couchonnal, G., Canda, E. R., & Staker, M. D. (2002). Empowerment as a dynamically developing concept for practice: Lessons learned from organizational ethnography. *Social Work, 47*(1), 32–43.
Becker, H. (1995). Visual sociology, documentary photography, and photo journalism: It's (almost) all a matter of context. *Visual Sociology, 10*(1–2), 5–14.
Benovsky, J. (2011). Three kinds of realism about photographs. *Journal of Speculative Philosophy, 25*(4), 375–395.
Berg, B. L. (2008). Visual ethnography. In L. M. Given (Ed.), *The Sage encyclopedia of qualitative research* (pp. 935–938). Sage.
Bollinger, C. M., & Menchaca, D. A. (2014). *Ethnographic choices: A primer on doing complex social research*. CreateSpace.
Breitkreuz, R. S., & Williamson, D. L. (2012). The self-sufficiency trap: A critical examination of welfare-to-work. *Social Service Review, 86*(4), 660–689.
Busch, D. D. (2014). *Digital SLR cameras and photography for dummies* (5th ed.). Wiley.
Castleden, H., Garvin, T., & Huu-ay-aht First Nation. (2008). Modifying photovoices for community-based participatory Indigenous research. *Social Science & Medicine, 66*(6), 1393–1405.
Cleaveland, C. (2007). Without wages of benefits: Disconnected TANF recipients' struggles to achieve agency. *Affilia, 22*(4), 321–333.
Copeland, V. C., & Snyder, K. (2011). Barriers to mental health treatment services for low-income African American women whose children receive behavioral health services: An ethnographic investigation. *Social Work in Public Health, 26*(1), 78–95.
Duncan, B. L. (2011). The Partners for Change Outcome Management System: Administration, scoring, and interpretation manual update. *Journal of Clinical Psychology, 61*(2), 199–208.
Duncan, B. L., & Miller, S. D. (1999). *The heart & soul of change: What works in therapy*. American Psychological Association.
Estrin, J. (2018, January). *Roger Fenton: The first great war photographer*. Web blog post. Lens. New York Times. Retrieved from https://lens.blogs.nytimes.com/2018/01/18/roger-fenton-the-first-great-war-photographer/#:~:text=Great%20War%20Photographer,-By%20James%20Estrin&text=Robert%20Capa%2C%20the%20archetypical%20modern,the%20Crimean%20War%20in%201855
Estroff, S. E. (1981). *Making it crazy: An ethnography of psychiatric clients in an American community*. University of California Press.

Fetterman, D. M. (2008). Visual ethnography. In L. M. Given (Ed.), *The Sage encyclopedia of qualitative research* (pp. 289–292). Sage.

Flores, C. (2007). Sharing anthropology: Collaborative video experiences among Maya film-makers in post-war Guatemala. In S. Pink (Ed.), *Visual interventions: Applied visual anthropology* (pp. 209–224). Berghahn.

Gatcum, C. (2016). *The beginner's photography guide: The ultimate step-by-step manual for getting the most from your digital camera* (2nd ed.). Dorling Kindersley.

Glaser, B. G., & Strauss, A. L. (1967). *The discovery of grounded theory*. Aldine.

Goffman, E. (1961). *Asylums: Essays on the social situation of mental patients and other inmates*. Anchor Books.

Griffin, M. (1999). The great war photographs: Constructing myths of history and photo journalism war photography and the rise of photo journalism. In B. Brennen & H. Hardt (Eds.), *Picturing the past: Media, history & photography* (pp. 122–157). University of Illinois Press.

Harrison, A. K. (2014). Ethnography. In P. Leavy (Ed.), *Oxford handbook of qualitative research* (pp. 223–253). Oxford University Press.

Holleran, L. K., & Waller, M. A. (2003). Sources of resilience among Chicano/a youth: Forging identities in the borderlands. *Child & Adolescent Social Work Journal, 20*(5), 335–350.

Ingledew, J. (2013). *Photography* (2nd ed.). King.

Iversen, R. R., & Armstrong, A. L. (2007). Parents' work, depressive symptoms, children, and family economic mobility: What can ethnography tell us? *Families in Society, 88*(3), 339–350.

Jennings, T., Perry, T. E., & Valeriani, J. (2014). In the best interest of the (adult) child: Ideas about kinship care of older adults. *Journal of Family Social Work, 17*(1), 37–50.

Jhala, J. (2009). Emergency agents: A birthing of incipient applied visual anthropology in the "media invisible" villages of western India. In S. Pink (Ed.), *Visual interventions: Applied visual anthropology* (pp. 173–90). Berghahn.

Keller, J. (2011, April 4). Photojournalism in the age of new media. *The Atlantic*. https://www.theatlantic.com/technology/archive/2011/04/photojournalism-in-the-age-of-new-media/73083

Kratochvil, A., & Persson, P. (2001). Photojournalism and documentary photography: They are identical mediums, sending different messages. *Nieman Reports, 55*(3), 27–31.

Leininger, M. (Ed.). (1985). *Qualitative research methods in nursing*. Grune & Stratton.

Lenette, C., & Boddy, J. (2013). Visual ethnography and refugee women: Nuanced understandings of lived experiences. *Qualitative Research Journal, 13*(1), 72–89.

Light, K. (2000). *Witness to our time: Working lives of documentary photographers*. Smithsonian Institution Press.

Malinowski, B. (1922). *Argonauts of the western Pacific: An account of native enterprise and adventure in the archipelagoes of Melanesian New Guinea*. Dutton.

McDannell, C. (2004). *Picturing faith: Photography and the Great Depression*. Yale University Press.

Mead, M. (1928). *Coming of age in Samoa*. Morrow.

Miller, S. D., Duncan, B. L., & Johnson, L. (2002). *The Heart and Soul of Change Project*. http://heartandsoulofchange.com

Morphy, H., & Banks, M. (1997). Introduction: Rethinking visual anthropology. In M. Banks & H. Morphy (Eds), *Rethinking visual anthropology* (pp. 1–35). New Haven, CT: Yale University Press.

Newfield, N. (2004a). Imaging West Virginia: A portfolio of 16 photographs. In R. Lohmann & N. Lohmann (Eds.), *Rural social work practice* (pp. 160–168). Columbia University Press.

Newfield, N. (2004b). Putting faces on the facts: Profiles of domestic violence. *Social Work Today: Picturing Social Work, 4*(6), 8–9.

Newfield, N. (2007, March 3–31). *Humans for sale exhibit.* Galerie Brigitte.

Newfield, N., Flamm, M., Goto, M., Hsu, W., & Lainez, N. (2008, October). *Humans for sale.* Morgantown Arts Center.

Newfield, N., Giannin, C., Barnes, A., & Moore, E. (2013). *Heaven and earth: Images of Southeast Asia.* Monongalia Arts Center/Benedum Gallery.

Newfield, N., & Hinkle, S. (2003). Stephanie's story. *Social Work Today: Picturing Social Work, 3*(8), 6–7.

Newfield, N., Kuehl, B., Joanning, H., & Quinn, W. (1990). A mini ethnography of the family therapy of adolescent drug abuse: The ambiguous experience. *Alcoholism Treatment Quarterly, 7*(2), 57–80.

Newfield, N., Joanning, H., Kuehl, B., & Quinn, W. (1991). We can tell you about "psychos" and "shrinks": An ethnography of the family therapy of adolescent drug abuse. In T. C. Todd & M. D. Slekman (Eds.), *Family therapy approaches with adolescent substance abuse* (pp. 277–310). Allyn & Bacon.

Newfield, N. A., Sells, S. P., Smith, T. E., Newfield, S., & Newfield, F. (1996). Ethnographic research methods: Creating a clinical science of the humanities. In D. Sprinkle & S. Moon (Eds.), *Family therapy research: A handbook of methods.* Guilford.

Online Etymology Dictionary. (n.d.). *Ethnography.* https://www.etymonline.com/word/ethnography

O'Reilly, K. (2009). Interpretivism. In K. O'Reilly (Ed.), *Sage key concepts: Key concepts in ethnography* (pp. 119–124). Sage.

Padilha, J. (Director). (2010). *Secrets of the tribe* [Film]. Sideways Film.

Pink, S. (1997). *Women and bullfighting: Gender, sex and the consumption of tradition.* Berg.

Pink, S. (2007). *Doing visual ethnography: Images, media, and representation in research* (2nd ed.). Sage.

Pink, S. (2008). Mobilising visual ethnography: Making routes, making place and making images. *Forum: Qualitative Social Research, 9*(3), Article 36.

Pink, S. (2011). Images, senses and applications: Engaging visual anthropology. *Visual Anthropology, 24*(5), 437–454.

Quinn, W. H., Kuehl, B. P., Thomas, F. N., Joanning, H., & Newfield, N. (1989). Family treatment of adolescent drug abuse: Transitions and maintenance of drug-free behavior. *American Journal of Family Therapy, 17*(3) 229–243.

Raimondo, L. (2002). Long road home: An American photojournalist and her Islamic translator forge a friendship on Afghanistan's front lines. *National Geographic, 201* (6), 82.

Raimondo, L. (2004). Bagdad beyond the headlines. *Smithsonian, 34*(11), 76.

Schwartz, D. (1989). Visual ethnography: Using photography in qualitative research. *Qualitative Sociology, 12,* 119–154.

Seeley, K. M. (2004). Short-term intercultural psychotherapy: Ethnographic inquiry. *Social Work, 49*(1), 121–130.

Sells, S. P., Smith, T. E., & Newfield, N. (1997). Teaching ethnographic research methods in social work: A model course. *Journal of Social Work Education, 33*(1), 167–184.

Smith, Y., & Spitzmueller, M. C. (2016). Worker perspectives on contemporary milieu therapy: A cross-site ethnographic study. *Social Work Research, 40*(2), 105–116.

Smolan, R., & Ewitt, J. (2017). *The good fight: America's ongoing struggle with justice.* Against All Odds.

Spence, B. (2005). "I'd like to have linoleum on the floors." *Social Work Today: Picturing Social Work, 5*(2), 10–11.

Spradley, J. P. (1970). *You owe yourself a drunk: An ethnography of urban nomads.* Waveland.

Spradley, J. P. (1979). *The ethnographic interview.* Holt, Rinehart and Winston.

Spradley, J. P. (1980). *Participant observation.* Holt, Rinehart and Winston.

Stadhams, D. (2007). Look to learn: A role for visual ethnography in the elimination of poverty. In S. Pink (Ed.), *Visual interventions: Applied visual anthropology* (pp. 119–142). Berghahn.

Stewart, J. (2017, June 20). *The history of photojournalism: How photography changed the way we receive news.* My Modern Met. https://mymodernmet.com/photojournalism-history

Street, R. S. (2006). Lange's antecedents: The emergence of social documentary photography of California's farmworkers. *Pacific Historical Review, 75*(3), 385–428.

Szto, P. (2008). Documentary photography in American social welfare history: 1897–1943. *Journal of Sociology and Social Welfare, 35*(2), 91–110.

Thornton, S., & Garrett, K. J. (1995). Ethnography as a bridge to multicultural practice. *Journal of Social Work Education, 31*(1), 67–74.

Thrasher, S. P., & Mowbray, C. T. (1995). A strengths perspective: An ethnographic study of homeless women with children. *Health & Social Work, 20*(2), 93–101.

Towne, R. (2020, February). A brief history of photojournalism. Retrieved from https://www.lightstalking.com/a-brief-history-of-photojournalism/

PART III
TECHNICAL ASPECTS AND FUTURE DIRECTIONS

8

Cameras, Photographs, and Presentation

In this chapter, we present the technical knowledge that is useful for photo-
graphic projects. We discuss the camera and the photograph, and we pro-
vide an introduction to basic aspects of picture taking and composition.
We also include a short overview of photo management and storage, color
management, and guidelines for preparing for print. Because presenting
photographs is a key part of photographic practice and research methods
such as photovoice, we discuss ways of presenting photos. Special attention
is given to preparing an exhibit. Because the focus of this book is on methods
of photography for social work and social change, we only cover some of the
basics. Readers who are interested in more advances skills should refer to
publications solely dedicated to photography.

The Camera

We discussed the development of the camera in Chapter 1. Here, we dis-
cuss cameras that are in current use, including some less common or unique
options that may lend themselves to interesting photo projects. For a com-
prehensive review of camera types, we refer the reader to Todd Gustavson's
Camera: A History of Photography (2009).

Any camera, even the most basic one, has three parts: a box or body that is
light-tight, a hole or lens through which light can enter, and an image plane
or something that captures the light. Changes and innovations of these three
components have led to improvements in photography over time. The body
of the camera, often made out of wood in the early days, is made of composite
materials in advanced digital cameras or cell phones. The body contains the
mechanics that capture and transform what "the camera sees" into an image
that can be viewed. A shutter opens, light comes in, and a surface is changed
by the light. Some types of modern cameras, such as mirrorless and cell
phone cameras, do not contain a traditional shutter. Rather, an "on and off"
switch lets light in or not. The hole, as in pinhole cameras, has been replaced

Photography in Social Work and Social Change. Matthias J. Naleppa, Kristina M. Hash, and Anissa T. Rogers,
Oxford University Press. © Oxford University Press 2022. DOI: 10.1093/oso/9780197518014.003.0008

by a lens. Lenses vary in size, how much light they let through, and so on. However, the lens is the heart of any camera. Finally, the image plane—the light-sensitive surface that captures the picture—has evolved from a glass plate to a negative film to a digital sensor in current digital and cell phone cameras.

Here, we discuss some of the cameras potentially used in photo projects. The *pinhole camera* is one of the oldest camera types, dating back to the first efforts to capture light in the 17th century. A pinhole camera is a light-tight box with a hole on one side and a parallel surface inside to which paper or film can be attached. Light enters through the hole, and when it hits the light-sensitive surface, it creates the image. The film or photo paper is then dipped into a developing chemical that makes the image permanent. Pictures crated by pinhole cameras are fuzzy and low in detail. However, they can be used in some of the projects we discussed in this book. For example, in group work with children and youth, building a pinhole camera and taking pictures with this self-built device can be fun and rewarding. All one needs is a small box that can be made light-tight, a needle to punch a whole into the box, a way to attach the photo paper inside, and the appropriate photo paper and liquids to stabilize the image. Do-it-yourself plans for building pinhole cameras can be found on the internet.

Instant cameras, usually referred to by the dominant manufacturer as Polaroids, produce immediate photos. Polaroids consist of a photo nega-tive that is covered with a developing chemical. After a picture is taken, the chemicals reacts with the just-produced negative to instantaneously develop the photograph. The process of instant photography was developed in 1947. Use of Polaroid cameras peaked in the 1970s and 1980s. The ability to im-mediately view a picture taken on a digital or cell phone camera has led to the declining usc of Polaroids. However, they are still available from several manufacturers. Instant cameras lend themselves well to applications in ther-apeutic settings and group work. The immediate availability of the printed picture makes it useful for photomapping, photovoice, and digital story-telling. Because it is from the 20th century, one can also envision its applica-tion in reminiscence and life review projects with older adults.

The next group of cameras are referred to as 35-mm cameras because the longest dimension of film rolls they use is 35 mm. This group includes the rangefinder single-lens reflex cameras that dominated the market for a long time. *Rangefinder cameras* were the most used consumer cameras for much of the 20th century. In a rangefinder camera, a viewer sits on top of or

is integrated into the camera body. When taking a picture, the photographer looks through this viewer to see the frame of the photo. The mechanics of the camera are separate from the viewfinder. This straightforward and sturdy design, combined with the use of fairly inexpensive 35-mm film roles, enabled a point-and-shoot approach to taking pictures and made it the go-to camera for consumers throughout the world.

The *single lens reflex* (SLR) camera lets the photographer look directly through the lens before taking a picture. In an SLR camera, the picture frame is deflected to the viewfinder through a system of prisms. It enables the photographer to exchange lenses—for example, use a wide-angle or a zoom lens—and still see the exact same frame as in the final shot. When taking the picture, the mirror that deflects the frame through the prisms moves out of the way, and the shutter opens and closes to let light hit the film and create a photo negative. SLR photographers often work with a set of lenses: Wide-angle, standard 50-mm, and zoom lenses are switched depending on whether the focus is on landscape, portrait, street photography, and so on. Although most SLR cameras use 35-mm film rolls, larger film formats exist and are often used by professional photographers. Rangefinder and nondigital (analog) SLR cameras are becoming less common, yet they are still used and participants in photo projects may show up with such a camera in hand. They can be used in any type of photo work. However, one needs to keep in mind that film roles need to be developed and printed, thus adding a few extra days to the process.

Digital cameras use a digital sensor, rather than film, to capture the picture. They can be digital SLR (DSLR) or digital rangefinder cameras. They work similar to their regular SLR or rangefinder counterparts. Many of the supporting functions, such as focus, aperture, and selecting the appropriate light sensitivity, are automatic or semi-automatic and computerized on digital cameras. Most include a small screen on the back of the camera body for quick viewing of the pictures taken. Digital cameras have changed the way photographs are taken because they allow the photographer to take a basically unlimited number of pictures and select afterwards which ones to keep. By automatizing many of the functions, they also enable the effortless taking of high-quality pictures. Exchangeable lenses continue to be used on DSLR cameras; however, zoom lenses (e.g., 24–105 mm) have become common for the average user.

Mirrorless cameras are a more recent design innovation. In mirrorless cameras, the mechanics of the mirrors inside a DSLR that enable one to *look*

through the lens while taking a picture are replaced by a digital image of what one would see. The electronics of the camera eliminate the mirrors inside the body and their need to be moved out of the way when a picture is taken. Thus, the mirrorless camera is smaller, lighter, and quieter than a DSLR. Relying on the battery for more functions, its battery life may be slightly shorter. Especially among amateur photographers, mirrorless cameras are becoming increasingly popular. Exchangeable DSLR lenses can be used on higher end models of mirrorless cameras.

Cell phones have become the most widely used way of taking pictures. Virtually all cell phones have at least one lens. Models with up to four lenses are available, enabling the user to take photos with a three-dimensional quality. Taking a picture is straightforward. Although the user can change some setting, the camera is set up for point-and-shoot, delivering fairly high-quality and sharp pictures every time. Cell phones are by far the most used type of camera these days, and the applications are endless. Most approaches to photography for social change can be implemented using cell phone photographs. Even some well-known photographers have used them to create exhibition-quality photographs. The cell phone is especially well suited for approaches such as photovoice, photomapping, or digital story-telling, in which mobility and the ability to take photos quickly are more important than the final picture quality.

One may not encounter them much in the context of photography in social work, but here we mention *three-dimensional (3D) cameras.* These cameras use at least two lenses and sensors to capture a picture. Software then combines the two or more images to create a 3D-looking picture. Its current application seems to be primarily as an integrated technology (e.g., in self-driving cars) or as a consumer gadget. However, as 3D technology is making its way into cell phone cameras, one can expect an increase in its use.

The last type of cameras we discuss are *action cameras,* often referred to by the name of the dominant manufacturer as GoPro cameras. Action cameras are very popular among younger and outdoor-oriented users. They are usually mounted to a helmet or other sports equipment (bike frame, ski boot, skateboard, etc.) to capture action-style activities. GoPro is more of a video than a photo camera. Its feature of easy viewing on cell phones or computer monitors may make it a useful tool in work with some audiences. However, like the 3D camera, its application is limited in the context of the approaches presented in this book.

Taking a Photograph

Digital and cell phone cameras let you take photographs without thinking too much about things such as the lens, aperture, shutter speed, and so on. Cameras have built-in software that will "do the thinking" for you and create consistently good pictures. Regardless of this, a little background of the different parts that interact to create a picture may be useful.

Any photograph, be it an art print at a gallery or a picture on a cell phone screen, is a work of light. Some even refer to photography as "painting with light." Several devices inside the camera are at play when taking a photograph: the lens, the light meter guiding exposure, the shutter and aperture, and a light-sensitive surface (film or digital sensor).

Pictures are created by the light that goes through a *lens* and hits the film or sensor inside the camera. Several factors contribute to the amount on light that enters the camera. The first is how much light is in front of the camera. On a sunny day, more light is available, whereas overcast skies, dawn, or dusk provide less light. We have only some influence on these factors—for example, by choosing the time of day that we go out, the amount of artificial light we add when we take pictures, or the use of shinny reflectors to guide light to a certain part of the picture.

The lens guides or focuses the light that enters the camera onto the sensor or plane. Whereas the frame is determined by the width of the lens opening, the actual amount of light is determined by the aperture or how wide open or closed the lens is. The *mm* (millimeter) describes the width of a lens. Wide-angle lenses (24–35 mm) create a wider picture. Thus, they are common for landscape photography. A 50-mm lens is considered standard. It has a frame that is very similar to the view of the human eye (approximately a 45-degree angle). It is often used in portrait and street photography and as a basic go-to lens. Extreme telelenses (up to 800 mm) are used for sports and wildlife photography. Finally, zoom lenses (typical 24–105 mm or 70–200 mm) combine the advantages of a wide range of uses and no need to change a lens with a reduction in light sensitivity. They are standard in most DSLR camera sets.

An *aperture* functions similar to the iris in the human eye: It regulates how much light can enter the camera. The aperture of a lens is described by the f-stop, with a typical range from as low as f/1.2 up to f/22 on better lenses. A small f-stop (e.g., f/2) lets more light in than a larger one (e.g., f/22). In addition to the amount of light entering the camera, the aperture or how far the lens opens also impacts on the depth-of-field. Using a high aperture (e.g., f/

22), more of the picture will be sharp (more depth). Using a small aperture (e.g., f/1.2) will create a focal point that is sharp but renders other parts of the picture blurry. Taking a portrait, one may use such a small aperture to create a face that is in focus, with a soft and blurry-looking background. On the other hand, one might choose a larger aperture to create a landscape photograph in which all the details can be seen, from the lake in front to the mountains in the back.

The *shutter* is a movable part in the camera located between the lens and the film or digital sensor. When you push the shutter release button, the shutter opens, light enters the camera, and then the shutter closes. In most cases, this happens within a fraction of a second. Shutter speed settings typically range from 1/1,000 of a second to 1 second. In the early days of photography, taking a picture was a slow process, taking hours for the light to create an image on a light-sensitive surface. Obviously, this limited the potential objects that could be photographed because no image could be created from anything that moved.

Exposure is the amount of light hitting the film or digital sensor. A light meter, integrated into the camera, measures how much light enters the cameras and thus aides with the decision of the shutter speed needed. Although you can manipulate the shutter speed—for example, if you want to over- or underexpose a picture—cameras have automatic settings that will make this decision for you. Modern lenses also have an image stabilizer that counteracts some of the movement and shaking of camera parts while taking a picture. Note, however, that 1/30 to 1/60 is the longest exposure time that can easily be held by hand. Anything longer than that requires the use of a tripod or a stable surface on which to rest the camera.

In the days of analog 35-mm photography, film was available with different levels of sensitivity, measured by an ISO number. A lower numbered film, such as ISO 100, was less sensitive, meaning it required more light. A more sensitive film, such as ISO 800, required less light. The higher the ISO number, the longer the shutter time or smaller the f-stop; the lower the ISO, the shorter the shutter time or larger the f-stop. However, lower ISO created crisper images. The ISO number is still an important factor in creating a photo with digital cameras. In a digital camera, the photographer can select the ISO on the camera body before taking a picture. If a smaller number is selected (ISO 100), the sensor creates a crisper and sharper picture. Typically, this is the preference of the photographer. However, when taking pictures in low-light conditions, such as a cityscape at night, one may select a higher ISO

number (e.g., ISO 1000) to enable enough light exposure of the sensor. The drawback is that the higher the ISO, the more blurry a picture becomes.

When images are captured by a digital sensor, the sensor is often described by the number of megapixels. This is in indicator of how many individual light-sensitive units a sensor has. In general, a higher megapixel sensor will create more detailed pictures. When viewing a picture on a smaller screen, the impact is usually not very noticeable. However, when enlarging a photo for printing, it will make a difference. Sensors with more megapixels will create better prints, especially poster-size prints. Yet, a higher number of pixels alone does not make for higher quality photographs. Rather, a combination of several design qualities factor into the quality of photographs. Furthermore, the quality of the lenses continues to be one of the major factors in creating high-quality images. Most cameras these days, including cell phone cameras, have more than 10 megapixels.

Storage, Management, and Software

JPEG is the most common type of data file for photos. It has the advantages of easy sharing, compression to a small file size, and being a format that most devices can open for viewing. One disadvantage is quality. The file is not lossless. As it gets compressed anew every time it is opened and then saved again, it loses some of its quality. Another disadvantage is that there are not as many options in terms of editing the data file. *RAW files* are much better for later work on photos. They are the raw and unadulterated data captured by the sensor of a digital camera. Being just raw data, they require an extra step of conversion and developing by software. They also differ between manufacturers; for example, Canon and Nikon cameras use different data formats. However, RAW data are much better for editing photos and producing long-lasting high-quality picture files. Programs such as Adobe Lightroom and Photoshop work with the raw file format. They are the most common software used by professional and advanced amateur photographers. Android and iPhones usually save their photos as JPEG. Screenshots, because they often contain larger amounts of text, are often saved in the lower quality PNG file format.

A wide range of software is available to work on digital photo files. There are three different groups of software: software such as Adobe Photoshop and Adobe Lightroom, used by professionals and advanced users; cell phone

programs for Android and iPhones; and a host of specialized and freeware programs.

Adobe Lightroom (LR) is a program that lets you develop and edit, organize and store, and prepare photo files for print and presentations. It has some similarity with the development of analog photos (negative film). One of the unique features of LR is that the original RAW data file stays intact and unchanged—that is, it is a nondestructive program. When one edits a photo—for example, crops and sharpens it and adjusts the colors—the original file stays intact and the information about the adjustments get saved in a parallel file. This enables the user to go back one or more steps and redevelop the photo in a different way if the user does not like what was created.

Another widely used program is *Adobe Photoshop* (PS). This is a more complex program with a higher learning curve. In PS, one also does not change the original picture. The creative editing work is done on layers that are superimposed on the original photo. When someone adds text to a photo, it is not put into the picture but, rather, a layer that is clear and see-through with the exception of the text is stacked on top of the picture. Thus, the final edited picture has several layers that together create the photograph. Although both programs have advantages and disadvantages, professional photographers may do some of the work in one and the rest of it in the other program. With every new edition of LR and PS, however, it seems that increasingly more features overlap and become available in both programs.

Although PS and LR can be used to edit cell phone pictures, many users rely on phone editing apps. These apps—including Snapseed, VSCO, Enlight, and Photomate R3—can be used to edit, crop, sharpen, improve color, or apply creative filters to a photograph. Although a few work only with Android or with iPhone pictures, most can be used for both. Some of the online photo-sharing social media include photo editing and developing features. In Instagram, for example, filters and editing tools can be applied before sharing a photo online. Other common photo-sharing sites, each with different audiences and sharing approaches, include Facebook, Flickr, Snapfish, Shutterfly, and 500px.

Cell phone photographs are usually downloaded to a computer using factory-installed programs. These programs all include basic tools for cropping, sharpening, working on color, and so on. They are becoming increasingly sophisticated. There are also a number of freeware options. The ease of using only one or two programs for all the work on a photo, including

the built-in features of storage, organization, creating posters, prints, or slideshows, may make programs such as Lightroom worth the fairly low cost.

Presentation

Three basic steps are involved in creating a picture: (1) taking the picture and composition (camera), (2) developing and editing (computer), and (3) viewing and presenting it (print or monitor). One of the major changes in moving to digital photography is the ability to take charge of all steps of this workflow. We already discussed the camera, as well as software and apps. The final step is preparing the photograph for presentation.

Printing

If you are using a computer monitor to prepare your pictures for printing, it helps to calibrate the computer for color and brightness using calibration software. Regardless of whether you do so, submit your pictures to the printer with slightly more brightness than your preference on the computer monitor. Photo prints almost always turn out darker than they look on a backlit monitor.

Amateur photo printers have become high quality and may suffice, at least for smaller prints, flyers, and brochures. Similar to the digital sensor, the amount of pixels will increase the sharpness of the photograph. Color and photo printers create the image by mixing several colored inks. A printer with more different colored inks will, in general, create more accurate colors than one with less. The quality of paper used for printing also has a considerable impact on the final product.

Larger size photographs and high-end promotional materials should be printed using professional-grade photo printers. Online photo printing outfits, such as WhiteWall or Mpix, will produce high-quality prints with a fairly quick turnaround time. When you upload files for printing, you will have to make several decisions. How large? What surface (paper, glass, aluminum, etc.)? Framed or not? Having different-sized photographs may work well for an exhibition. With regard to surface and frame, however, consistency will look more pleasing to the viewer. Have one photo test printed to

see how it turns out before submitting all of them for printing; different providers can produce very divergent results.

Online Presentation

Online or screen presentations may be a good alternative or a supplemental approach to presenting photographs from your projects. In this case, all steps of preparing the photographs can be accomplished on a computer. Keep in mind that different monitors and screens may show colors in a different way. It is a good idea to calibrate your monitor with a tool such as the X-Rite ColorMunki.

Adobe Lightroom and Photoshop include professional tools for creating photo presentations. Several freeware programs, such as KineMaster and Movavi, enable you to add music and create more video- or YouTube-like presentations with your picture. Photo sharing sites, such as Flickr, Snaphfish, Shutterfly, and 500px, include tools for creating an online presentation. The common software programs used for presentations, such as Microsoft PowerPoint and Prezi, also enable you to create slideshows with your photographs.

The next question is where to present the photographs online. Because many projects will be connected to an agency, community organization, or nonprofit provider in some way, you may have access to their websites. This could be an easy and straightforward approach to showing the pictures. However, because agency websites are typically not ranked very high in terms of visitors, you still need to consider marketing to get visitors to the website. Depending on the web administrator and other factors, it may take 1 or 2 days or several weeks to upload your project and photos. Thus, we recommend determining early on during your photo project how much time to reserve for this task. The time it takes to do final editing of text and photos is often underestimated, so give yourself plenty of time for this step.

Blogs are a good alternative to agency websites. Programs that help with creating and hosting blogs, such as Wix, WordPress, or Jimdo, are inexpensive or free and provide all the tools needed to create a website. You will get a URL for your website, and they will host your project blog. The learning curve is comparatively short and a nice-looking website for a photovoice or photomapping project can be created in less than a day.

Exhibitions

For some projects, such as photovoice, an exhibition can be an important part of the process. This can take many forms, from a small presentation in a public space to a larger scale presentation in a public art space or similar venue. The methods of photography presented in this book that may include an exhibition—documentary photography, photovoice, or group photo projects—typically will rely on smaller scale community-based approaches. The exhibition is usually part, but not the primary purpose, of the undertaking.

Preparing an exhibition may take a significant amount of time for planning, often 4–6 months or longer. Thus, the exhibition should be planned at the same time that one begins a project. A number of issues need to be considered when preparing an exhibition. These are summarized in Box 8.1.

Box 8.1 The 12 Steps of Preparing an Exhibition

Finding space
Contacting owner of space
Looking at a space (lighting, means for hanging pictures, amount of space, number of pictures)
Setting dates (opening, length of time)
Pictures (prints, amount, themes, descriptions)
Framing (glass, forex)
Hanging pictures
Creating additional information (about project, pictures, photographers)
Printing catalog and flyers
Working with the press (community groups, papers, radio, social media)
Opening
Closing and reflection

Based on Haltenhof (2018).

One of the first activities when creating an exhibition is to select potential venues and contact their owners for permission to use the space. Key considerations are easy access for the target audience and a match of the space with the intended way of exhibiting. If your photo project is agency-based, using a

space within the agency's building may be easiest. At the same time, your intended target audience may not frequent this space. Public buildings such as town halls or community centers may have higher foot traffic. You may also benefit from the willingness to share space and already existing means for hanging pictures. Additional options include stores and storefront windows, malls, and educational and medical facilities.

When looking at the space, think about access, lighting, means for hanging pictures, amount of space, and the number of pictures you could hang. Are frames and options to hang pictures already available? How many pictures can you present? How many in portrait and landscape orientation? How well is the space lit and will you have influence on the light sources? Which pathways will visitors use and how will that impact on the order of your photographs? What are the hours of access? It may be helpful to hang a few photographs in approximately the size you intend to use (they need not be part of the project) to see how they look when hung in the space. You may find that they are too small or too large for the intended space, which will help you determine the sizes of the project photos to print.

The next consideration is selecting the dates for opening the exhibit and the length of time it will remain open to visitors. Allow for enough of a buffer between expected time of having your photographs ready and the start of an exhibition. Unforeseen delays are possible in any project. Moreover, the time it takes to select photos, hang them, and finalize the opening event is often underestimated. Think about what times of the day and week work best for your intended viewing audience. How many weeks will you make the exhibit available? A shorter time frame of 2–4 weeks may be enough. It also reduces the amount of time you have to staff the exhibition.

Obviously, the most important consideration is the selection and printing of photographs. How many picture do you want to hang? What is the best order to get your intended message across? Is there a good way to present your main theme? Sometimes, less is more. Leaving the viewer with some gaps to fill in their mind may be more powerful than overdoing a specific theme. Is it more powerful to let the photographs speak for themselves or do you want to guide the viewing process with a text narrative? The importance of such additional information cannot be overstressed. Include enough information about the project that the viewer will look at the pictures with that in mind. Keep it short and straightforward. Several blocks of information spread throughout may be easier to read and digest than one long text that no one reads to the end. The coordination of pictures and narrative is an

important tool in your messaging strategy. After all, your exhibit may be an effort to create changes in the mind of community members or your local political representatives. Include information about the photographers, and include credit for all of the pictures that are part of your exhibit.

With regard to printing, your budget may impact how many photos can be printed and which type of print you will use. Keep in mind that bigger is not always better. Some pictures come across better using a smaller format. Aside from the size, you also have to decide on the surface of your print (e.g., on paper, aluminum, acrylic, or glass).

If you want to hang a photograph, it needs to be framed or printed on a material that can be hung directly. A frame should not take away from the picture. Simple frames work well for many of the social change photography projects we present in this book. Most sturdy frames are made from wood or aluminum. Using frameless prints (i.e., printed directly onto aluminum, glass, or composite surfaces) is another option that lets the message of the photograph stand out. Some spaces may already have frames that can be used. If they fit your approach to presentation, this can save time and money. It usually also means that a system for hanging frames already exists. For frames and photographs in standard sizes, you can usually take a do-it-yourself approach. For odd-sized pictures, having them professional framed is a better approach. Although it may add significantly to your budget, cutting a good-looking passe-partout requires experience and skill. Another decision you have to make concerns the type of glass for your frames. Non-reflective glass makes it easy to see the pictures; however, it can change color and brightness. Regular glass is the least expensive option. In good lighting situations, it may suffice. Museum-grade glass can be expensive, but it combines the advantages of non-reflection and true to color.

Once you have selected you pictures and have them printed and framed, it is time to consider how to hang them. Command hooks, screws, or nails are common approaches for hanging pictures. Because they leave holes in walls, obtain approval for their use from the owner of the space. Using hanging systems is probably the best way to hang pictures. However, they also are the most expensive. Another option is to use movable pin boards that are common in public spaces and schools. Although they may be less pleasing to the artist's eye, they have the advantages of being low cost (no need for expensive framing), easy to move around in the room, and quick in terms of hanging and taking down the pictures. Once you finalize the technical part of hanging, it is time to begin your composition. Which pictures go where?

What is the best order? Do you want them close together or spread out? Keep your audience in mind. Often, picture are hung too high for a younger or older audience to see well. Each picture should have a small printed card with the title of the photograph, the name of the photographer, and the year taken. Sometimes information on camera, lens, aperture, and printing process used is included as well. Give yourself at least a week for the hanging of the pictures. It often takes longer than anticipated, and a buffer can come in handy.

Providing visitors with something to take home is an important part of getting your message out. Your project (and budget) may or may not call for a printed catalog. However, even a basic printed flyer with some information about the project and a few photo examples may be sufficient. A link to a project website with additional information and more pictures may also help. In order for your exhibition to be successful, potential visitors need to be aware that you are doing it. Work with the press, community groups, radio, social media groups, and anyone else you can think of on getting the word out. Provide a press kit with additional information and text that can be used or adapted. The basics that you should always include are when, where, your theme, who you are, and the dates of the opening. Make it as easy and user-friendly as possible. The less work required, the more likely someone will include a write-up on your project and exhibition. Sometimes, an invitation to visit before the official opening will enable local news to cover it the day of your opening rather than afterwards.

Once everything is completed, you are ready for opening (and most likely a few small glitches). The best times for an openings are weekday late afternoons or early evenings. Make sure you are not competing with other community events. It is common to have some drinks and snacks available for your opening. Prepare a few remarks about your project and the exhibition. If possible, include group members in this as well. Think about what to say to key stakeholders (political, news media, etc.) ahead of time. Every visitor is a potential catalyst; treat them all the same and be available to answer questions. Walk around with visitors and explain the pictures.

If it is a group project, such as in photovoice, the photographers should stand in the area of their picture(s) and be available to provide additional information.

The closing on the last day of the exhibition is not the end. Pictures need to be taken down and stored. If they were sold, they need to be packed and delivered to their new owners. More important, it is a time to reflect on how

it went and what to learn from it for the next time. Also, if the exhibition was part of a community or participatory action project, it is a tool for informing people and changing their minds. Thus, follow-up with key stakeholders to work on possible action steps should begin immediately after the exhibition closes.

Many of the steps discussed here also apply to other formats of presenting photographs, such as in photo books (e.g., reminiscence work) or online presentations (e.g., photovoice or photomapping). In one of our projects, a community-based photovoice endeavor, we presented the photos on a large monitor placed in a storefront window. Photographs and accompanying narrative were shown in a constant nonstop loop. This had the advantage of reaching a large audience 24 hours a day.

References

Gustavson, T. (2009). *Camera: A history of photography from Daguerrotype to digital.* Fall River Press.

Haltenhof, M. (2018). *In 15 Schritten zu deiner eigenen Fotoausstellung* [In 15 steps to your own photo exhibition]. Retrieved April 25, 2020, from https://www.matthiashaltenhof.de/blog/eigene-fotoausstellung-organisieren

9

The Future of Photography in Social Work

Introduction

The 1800s and 1900s saw the use of photographs in exposing social injustices
(Squires, 1991), and today they are increasingly being utilized in therapy,
policy advocacy, and various forms research (e.g., Craig, 2009; Teixeira, 2016;
Wang, 2006). The purpose of this book was to provide a comprehensive over-
view of the application of photography in social work practice and research
as well as feature original applied content and include multidisciplinary
perspectives, state-of-the- art case examples, and user-friendly resources. It
sought to introduce readers to the theory, methods, ethics, technical aspects,
and cultural considerations of photographic practice and research and to
bridge theory and knowledge with applications that can be replicated by
students, practitioners, and researchers.

The previous chapters highlighted the existing and potential uses for pho-
tography by social work practitioners and researchers as well as interdiscipli-
nary partners (e.g., in public health and nursing). This final chapter provides
a summary of the information that was presented in previous chapters.
Future directions and considerations for the use of photography in social
work close this chapter and the book.

Part I: Photography in Social Work

In Chapter 1, we discussed the history of photography in social work and
social change. We also reviewed some practical considerations for practice,
education, and research that include the use of photography. Photography
has enjoyed a long history as a tool for social change. From the work of Roy
Stryker's Photographic Unit of the Farm Security Administration to the
child labor movement with photographer Lewis Hine, Kellogg's Pittsburgh
Survey, and the civil rights movement, photographs have played a pivotal
role in social change. Yet, although there is a tradition of incorporating

Photography in Social Work and Social Change. Matthias J. Naleppa, Kristina M. Hash, and Anissa T. Rogers,
Oxford University Press. © Oxford University Press 2022. DOI: 10.1093/oso/9780197518014.003.0009

photographic methods, they have not always been at the forefront of the discussion of practice and research methods in a way that it would merit. Today, however, we are seeing social work and other health and human service professionals and researchers increasingly harnessing the potential of photography as a tool.

In Chapter 2, we introduced key concepts of research as they relate to photography in social work. We discussed how it helps to contextualize and humanize research findings. It also aides in increasing the participatory and collaborative nature of research projects. Parallel to an exponential growth in the use of social media, there has also been a growing application of photography as a tool for research. The expanding literature on photovoice, photomapping, and ethnographic as research methods underscores this development.

We discussed the ethics of photography and how they are embedded in the context of their application. One encounters ethical decision-making as a practitioner, a researcher, a project participant, and a photographer, just to name a few. Each of the hats one wears brings with it specific ethics. And although many of them overlap, one needs to be conscious of which one is central at any given time. Social work already has a code of ethics that provides guidance for these uses, as does the field of professional photography. Both provide guidance for ethical photographic practice in the context of social change.

Part II: Photographic Methods and Applications

The second part of the book examined the most common applications of photography in social work and social change. These are summarized briefly here.

Phototherapy is an approach and intervention used for a variety of therapeutic goals. The process of phototherapy involves taking, analyzing, and using photos for personal exploration, growth, and healing. Often, the photos are paired with oral or written narratives with the goal of allowing individuals to construct, deconstruct, and reconstruct emotions, life events, and other meanings associated with the photos to promote understanding of the self. Phototherapy is a creative process that allows participants to explore and express personal experiences in ways that promote growth, communication, and self-reflection.

Digital storytelling allows individuals to tell stories through the use of computer- and technology-based tools. These tools allow the storyteller to communicate stories or narratives in rich, interactive ways that engage the listener through the use of different multimedia methods, such as computer-based text, audio, video, music, animation, and images. Digital storytelling can focus on anything from recounting personal stories to constructing narratives about communities, societies, and systems, and it can entail every-thing from short, simple to long, complex stories. Digital storytelling is often used for a variety of purposes, including journalism, personal growth, advo-cacy, research projects, historical documentation, classroom learning, and efforts toward community and societal change.

Photomapping offers tools that attend to the person-in-environment perspective that is near and dear to the social work profession. In fact, the practice of mapping (without photos) was accomplished early on in the pro-fession by Hull House leaders, who used the method to uncover aspects of the environment that were adversely affecting community members. The im-pact of the physical environment on individuals and populations, in partic-ular, can be illuminated using this method. Using geographic information system technology, significant locations within an area or community can be mapped to highlight assets, needs, and other aspects. The method can also be used by research participants as part of participant photomapping, where they can capture and map key features of their environment to share with decision-makers and others who can influence change and promote well-being. The related method of rephotography or repeat photography involves retrieving or taking a "before" and "after" photo of the physical environment, an event, or even an individual or groups of individuals to show change (or even lack of change) from Time 1 to Time 2.

Photo ethnography, documentary photography, and photojournalism are closely related and differ based on their context and intent. In fact, the same photo or series of photos could be used for each of these purposes. The three methods each seek to promote understanding and make a difference, both of which align well with the social work profession. Photo ethnography grew out of the well-established ethnographic as well as the newer visual an-thropology traditions and is often one of several tools (including interviews and participants observations) used together to richly describe the culture of a population, community, or organization from an insider's perspective. It often involves prolonged engagement in a setting. Documentary pho-tography attempts to tell a story and has a long history of capturing major

national and world events. It has been and still is used to influence policy and other changes by exposing the conditions and experiences of individuals or populations. Documentary photography projects involve spending time and building relationships with subjects, and the products are often meant to "document" a situation for later viewers. Social documentary photography is particularly appealing for social work because it provides a record of social issues. Photojournalism is similar to documentary photography in terms of telling a story, but it attempts to do so and persuade viewers in the present. Photojournalism is also subject to the influence of editors, and photographers typically do not have a great deal of time to invest in a story or subject.

The community-based approach of photovoice has gained a strong following since it was first developed in 1997 by Caroline Wang and Mary Ann Burris. It is an easy to implement and fairly low-cost approach that includes those affected by an issue in collecting and analyzing data as well as implementing relevant change strategies. The method does not require extensive training for group participants or facilitators. Photovoice was originally developed as a participatory action method for small community groups, but it has been adapted to an array of settings and issues. Although photovoice projects often include a research component, they can also be used as a tool for community or group work practice. Of all the photographic methods discussed in this book, photovoice may be the most prevalent because it continues to be applied and adapted by social workers, community organizers, and other health and human service professionals.

Part III: Technical Aspects and Future Directions

In Part III of the book, we discussed some technical aspects of photography and various ways to organize, present, and disseminate project images. As the speed of technological developments and the acceptance of the visual as mode of communication continue to increase, so will the use of the image to convey one's messages. The future holds even better and affordable cameras and, more important, a persisting integration of cameras into our everyday lives, from cell phones and online meetings to home safety and home appliances. We are also witnessing a change in the way we disseminate images that seems to be at lightning speed. What used to take days or weeks (taking a picture, having it developed and printed, and being able to show

it) now takes only a few quick seconds (uploading directly from a device to the internet). With ongoing improvements in the speed and ease of use, we will see an increase in the range of potential participant groups (e.g., younger children, older adults, and persons with disabilities) and the possibilities for the photography-based methods presented in this book.

Future Directions

Digital photography continues to pervade society, and the quality, simplicity, and inexpensive nature of the tools (including the cameras on and photo editing apps for cellular phones) will continue to fuel the growth of its use. The exposure and influence once reserved for professional photographers are now shared by novices of all ages and backgrounds. Social media platforms (e.g., Instagram and TikTok) have promoted edited photos and videos to an everyday phenomenon that is widely shared by users. In addition, these tools and platforms used by novices have the potential to reach international audiences.

Social workers can use photo methods for a variety of professional purposes, spanning micro, mezzo, and macro interventions. As we are rediscovering the community as a focus of intervention, we will continue seeking out methods that work in community-based practice. The outlook for photography, as an easy-to-use approach to include the voices of those affected by an issue, will therefore remain strong.

Education, too, has a place in the future of photography. Educators in social work and related fields can and should integrate photography into undergraduate and graduate coursework. We have incorporated digital storytelling, photomapping, and photovoice into human behavior in the social environment, community-based practice, and social work intervention courses. Our experiences have been positive throughout. The use of photo methods in practice can also offer useful and unique content for continuing education for social work and health and human service professionals.

Social workers and other human service professional are exceptional candidates for integrating photo methods into practice and research. Those with an educational background and experience in these fields have a solid understanding of individuals, groups, organizations, and communities, as well as the ability to understand and predict human behavior.

These qualities and talents would allow for the anticipation of individuals' reactions in terms of capturing a powerful photograph that has the potential to influence people, elicit emotion, and impact change. Social workers also have skills in engaging individuals and groups, which would go a long way in facilitating their involvement in participatory methods (e.g., photovoice or photomapping).

As we have discussed at various points throughout the book, photography is an outstanding tool for research. This is especially helpful with the increasing utilization of visual methods by researchers. Qualitative methods, including participatory action research, are increasingly attempting to include the voices of those who are affected by the issues being researched. In this context, photographic methods can help achieve what Novak (2010) calls a democratizing of the research process through the use of images. Photographs, he states, can help move "away from a research structure dominated by the researcher" (p. 292). And although earlier in the book we lamented the difficulties in getting images published in peer-reviewed journals, we should also acknowledge that a growing number of them, especially in the realm of qualitative research, are opening up to the possibility of including photographs.

Final Thoughts

Considering the visual turn that we currently are witnessing, we expect that the inclusion of photography-based methods will continue to expand. In closing the book, we remind the reader of some of the benefits of using photographic images in research, practice, and education. A photograph

- visually documents;
- elicits emotional reaction;
- promotes empathy and understanding;
- creates contextual understanding;
- reveals assumptions, beliefs, and values;
- supplements narrative and statistical data;
- focuses on participants' experience;
- fosters understanding of age-, gender-, and culture-related experiences; and
- facilitates discussion

These advantages can be put to use in countless ways and with a wide range of settings and target audiences. There is a strong prospect that the applications we presented will be joined by other photography-based methods. This is why we are confident that photography is here to stay and will grow as a method of social work and social change.

References

Craig, C. (2009). *Exploring the self through photography: Activities for use in group work.* London: Jessica Kingsley.

Novak, D. R. (2010). Democratizing qualitative research: Photovoice and the study of human communication. *Communication Methods and Measures, 4*(4), 291–310.

Squires, C. (1991). The long search for hope: The unending idealism of the committed photojournalist is as strong as ever. *American Photo, 2,* 58–61.

Teixeira, S. (2016). Beyond broken windows: Youth perspectives on housing abandonment and its impact on individual and community well-being. *Child Indicators Research, 9,* 581–607.

Wang, C. (2006). Youth participation in photovoice as a strategy for community change. *Journal of Community Practice, 14*(1–2), 147–161.

About the Authors and Contributors

Authors

Matthias J. Naleppa, PhD, MSW, is Professor at the Waldron College School of Social Work of Radford University in Virginia. Before assuming this position, he was a Professor in the School of Social Work at the State University of Baden Württemberg, Stuttgart, Germany. In the past, he held positions as Chair of Clinical Methods and International Social Work at the University of Bern, Switzerland, and as Associate Professor in the MSW and PhD programs at the Virginia Commonwealth University School of Social Work. He earned his PhD from the University at Albany in New York and his MSW from the Catholic School of Social Work in Munich, Germany. He is a John A. Hartford Geriatric Faculty Scholar. His research interests include gerontology, international social work, and media and photography in social work.

He has taught courses in research, aging, and social work practice methods and theories at the bachelor's, master's, and doctoral levels. Most recently, his teaching included courses on photography in social work and on social work and social media. He studied photography at the Prager Fotoschule in Kefermarkt, Austria. His areas of specialization include using photography for social change and also people and street photography. He has implemented photovoice as a community organizing tool in with the goal of making public spaces more accessible for older adults. His most recent photo project, "Tokyo and New York: A New Year," is a collaborative work chronicling people and street life.

Kristina M. Hash, PhD, LICSW, is a Professor in the School of Social Work, Eberly College of Arts and Sciences, at West Virginia University. She holds a PhD in social work from Virginia Commonwealth University; an MSW, graduate gerontology certificate, and graduate certificate in health professions education from West Virginia University; and a bachelor of arts degree from St. Catherine University. Her work has been published in leading journals in social work and gerontology as well as in edited books. She is co-editor of *Aging in Rural Places* (Springer, 2015) and co-editor of *Annual Review of Geriatrics*

and Gerontology: Contemporary Issues and Future Directions in Lesbian, Gay, Bisexual, and Transgender Aging (Springer, 2017).

During the past 18 years, she has taught and developed courses on human diversity, health and aging, rural gerontology, social gerontology, social work practice, social work research, and human behavior in the social environment. She has integrated the methods of photomapping, photo oral histories, and digital storytelling into her major course assignments. Her current research and service projects include historical photo ethnographies in a local community and the use of photos as part of reminiscence therapy with older adults who have mild and moderate dementia. She has received several teaching and professional awards at the university, state, and national levels.

Anissa T. Rogers, PhD, MA, MSW, LCSW, is a licensed clinical social worker, with more than 20 years of higher education experience. She currently is Professor of Social Work at California State University, San Bernardino.

From 1999 to 2019, she was Professor of Social Work at the University of Portland and served as the Director of the Social Work Program and Co-Director of the Gender and Women's Studies Minor. She teaches courses across the social work curriculum, including courses on gerontology, human sexuality, gender and the body, death and dying, and international social work in Ecuador. Her research has mainly focused on mental health and other issues for lesbian, gay, bisexual, and transgender (LGBT) older adults.

She earned her MSW and PhD in social work at the University of Utah and an master's degree in psychology at Ball State University. She is a licensed clinical social worker in the state of Oregon with an active private practice in animal assisted therapy with older adults and hospice patients. In addition, she has been involved in various community-based clinical and research projects with the older LGBT community in Portland and is author of *Human Behavior in the Social Environment,* currently in its fifth edition (Routledge, 2019).

While working on her PhD, she worked with Utah State's Administration on Aging to develop mental health assessment tools for community-dwelling elders. In New Hampshire, she worked with the statewide Elder Network to identify aging-related legislative priorities. More recently, she has been developing pedagogical methods, including photovoice tools, to support students' learning of skills in working with people who are suffering. In addition, she has been involved in various community-based clinical and research projects with the older LGBT community in Portland. She served

on the board for Oregon's chapter of the National Association of Social Workers, is a Hartford Faculty Scholar, and was the recipient of the Mit Joyner Gerontology Leadership Award in 2005 and the Innovative Teaching in Social Work Education Award in 2017—both national awards given by the Council on Social Work Education. She also has been involved with various national organizations, such as the Eldercare Workforce Alliance, the Gero-Ed Center, and the Association for Gerontology Education in Social Work.

Contributors

Barb Braband, RN, EdD, CNE, recently retired as a certified nurse educator in undergraduate and graduate nursing programs at the University of Portland following specialization in teaching and research related to graduate nursing education, population and integrative health, evidence-based nursing, and palliative care. Her educational background includes a Bachelors' degree in Nursing, an MA degree in agency counseling, an MSN degree in nursing education, and a doctoral degree in Healthcare Professions Education. Her primary scholarship focuses on innovations in nursing education, suffering pedagogy, and childhood grief.

Rebecca Gaudino, PhD, MDiv, MA, is an ordained minister, teaches biblical studies and theology at the University of Portland. One of her courses, designed for nursing students, is Theological Dimensions of Suffering and Death, a course that prepares nursing students to accompany patients in their suffering.

Alyssa Guerry is an aspiring photographer and student at Morgantown High School in Morgantown, West Virginia. Her photographs are used in Chapter 6.

Neal A. Newfield, PhD, MSSW, LICSW, ACSW, is Associate Professor Emeritus with the West Virginia University School of Social Work. He pursued a graduate degree in anthropology before becoming a social worker and completing a doctorate in family therapy. He was a Contributing Editor of *Social Work Today* magazine for 7 years and wrote a column titled "Picturing Social Work." He has also written an occasional column for *Tuổi Trẻ*, a newspaper in Vietnam with a readership of 400,000. In Vietnam, he is an advisor to the Pacific Links Foundation, an international nongovernmental

organization that advocates for the rights of women and combats human trafficking. In that capacity, he has photographed human trafficking in Thailand and Cambodia. He has taught forensic photography, and his documentary photographs have been exhibited in multiple galleries both as documentary photographs and as fine art. He is currently documenting *Making Ends Meet in West Virginia*. He contributed to Chapter 7.

Photo Credits

Chapter 1

Image 1.1 Photo by J. Riis.

Image 1.2 Photo by L. Hine.

Image 1.3 Photo by L. Hine.

Image 1.4 Photo by W. Evans.

Image 1.5 Nancy Stone/Chicago Tribune/Tribune News Service via Getty Images.

Image 1.6 Charles Moore Photographic Archive, e_clm_0372, The Dolph Briscoe Center for American History, The University of Texas at Austin.

Image 1.7 Photos by M. Naleppa.

Chapter 3

Image 3.1 OgnjenO/iStockphoto.

Image 3.2 kali9/iStockphoto.

Image 3.3 Photographer and videographer/iStockphoto.

Chapter 4

Image 4.1 Photo by E. Larson.

Image 4.2 Photo by J. Zaragoza.

Image 4.3 Photo by D. Nguyen.

Image 4.4 Photo by N. Mathew.

Image 4.5 Photo by S. Cook.

Image 4.6 Photo by N. Mathew.

Chapter 5

Image 5.1 Photo by M. Naleppa.
Image 5.2 Photo by M. Naleppa.
Image 5.3 Photo by M. Naleppa.
Image 5.4 Photo by M. Naleppa.

Chapter 6

Image 6.1 Photo by K. Hash.
Image 6.2 Photo by A. Guerry.
Image 6.3 Photo by K. Hash.

Chapter 7

Image 7.1 Photo by N. Newfield.
Image 7.2 Photo by N. Newfield.
Image 7.3 Photo by N. Newfield.
Image 7.4 Photo by N. Newfield.
Image 7.5 Photo by N. Newfield.
Image 7.6 Photo by N. Newfield.

Index

For the benefit of digital users, indexed terms that span two pages (e.g., 52–53) may, on occasion, appear on only one of those pages.

Tables and figures are indicated by *t* and *f* following the page number